RECODINGS
Art, Spectacle, Cultural Politics

RECODINGS
Art, Spectacle, Cultural Politics

HAL FOSTER

Bay Press
Seattle, Washington

Bay Press
115 West Denny Way
Seattle, WA 98119

Library of Congress Cataloging in Publication Data

Foster, Hal.
Recodings – art, spectacle, cultural politics.

Includes bibliographic references and index.
1. Postmodernism. 2. Avant-garde (æsthetics) – History – 20th century.
3. Politics in art. 4. Arts and society – History – 20th century. I. Title.
NX456.5.P66F67 1985 700'.1'03 85-70184
ISBN 0-941920-03-8
ISBN 0-941920-04-6 (pbk.)

Caledonia type set by Walker & Swenson, Port Townsend, Washington

For Sandy Tait

Published in the last five years, these essays appear here in revised form. My debt to the artists and critics addressed in them is enormous, and I hope my citations will suffice as acknowledgements. Certainly the project in which they are involved — a critical consideration of contemporary and modern culture — is too important to neglect. As for editors, I must mention my friends at *Art in America*, in particular Elizabeth Baker, Nancy Marmer and Craig Owens, all of whom helped me to sharpen these texts in many ways. Thanks also to Jonathan Crary and Charlie Wright for their critical readings of some of the essays, and to Thatcher Bailey for his insightful editing of them all. The National Endowment for the Arts supported this project with a 1985 critic's grant. Sandy Tait supported its writer in every other way.

Credits

Versions of these essays have appeared previously:
"Against Pluralism." *Art in America* (January 1982), originally titled "The Problem of Pluralism."
"Between Modernism and the Media." *Art in America* (Summer 1982).
"The Expressive Fallacy." *Art in America* (January 1983).
"Contemporary Art and Spectacle." *Art in America* (April 1983), originally titled "The Art of Spectacle."
"Subversive Signs." *Art in America* (November 1982).
"(Post)Modern Polemics." *New German Critique* 33 (Fall 1984) and *Perspecta* 21 (1984).
"For a Concept of the Political in Contemporary Art." *Art in America* (April 1984), originally titled "For a Concept of the Political in Art."
"The 'Primitive' Unconscious of Modern Art, or White Skin Black Masks." *October* 34 (Fall 1985).

Photography Credits

Baskerville + Watson Gallery, New York: Sherrie Levine after Egon Schiele (*Self Portrait Masturbating*), p. 58, after Walker Evans, p. 167, and *Untitled*, p. 174.

Rene Block Gallery, New York: Joseph Beuys, *I Like America and America Likes Me*, p. 22.

Irving Blum Gallery, Los Angeles: Andy Warhol, *Campbell Soupcans* (detail), p. 165.

Mary Boone Gallery, New York: A. R. Penck, *Ereignis in N.Y.*, p. 47; Jean-Michel Basquiat, *In Italian*, p. 50; David Salle, *Seeing Sight*, p. 57, and *Brother Animal*, p. 135; Matt Mullican, *Untitled*, p. 75; Julian Schnabel, *The Exile*, p. 135.

Leo Castelli Gallery, New York: Robert Morris, *I Box* (open), p. 12, and *Untitled*, p. 97; Donald Judd, *Untitled*, p. 21; Frank Stella, *Protractor* (Collection of Sears Bank and Trust Company), p. 21.

Barbara Gladstone Gallery, New York: Jenny Holzer, plaque from the *Living* series, *Inflammatory Statements*, and selection from *Truisms*, p. 116.

Marion Goodman Gallery, New York: Gerhard Richter, *Ohne Titel* (568-1), p. 65.

Metro Pictures, New York: Walter Robinson, *Phantom Firebug*, p. 27; Thomas Lawson, *Don't Hit Her Again*, p. 55; Cindy Sherman, *Untitled*, p. 67; Jack Goldstein, *Untitled*, p. 78; Robert Longo, *Empire* (detail), p. 85, *Now Everybody*, p. 89, *Rock for Light* and *We Want God*, p. 94.

Gallery Nature Morte, New York: Gretchen Bender, *Revenge of the Nerds*, p. 75.

Holly Solomon Gallery, New York: Ned Smythe, Drawing for *The Tree of Life* (detail), p. 26.

Sonnabend Gallery, New York: Vito Acconci, *Raising the Dead (And Getting Laid Again)*, p. 165.

Sperone Westwater Gallery, New York: Sandro Chia, *Genova* and *Man and Vegetation*, p. 43; Francesco Clemente, *Three in One*, Diego Cortez, *Young Woman* and *Give Wait*, p. 43; Gerhard Richter, *Ohne Titel* (568-1), p. 65.

John Weber Gallery, New York: Victor Burgin, *Olympia* (detail), p. 10; Robert Smithson, *Map of Broken Glass (Atlantis)*, p. 22; Hans Haacke, *MetroMobiltan*, p. 107.

Willard Gallery, New York: Susan Rothenberg, *Pontiac*, p. 27.

Victor Burgin. *Olympia* (detail), 1982.

Introduction

The essays in this book present a constellation of concerns about
the limits and myths of (post)modernism, the uses and abuses of
historicism, the connections of recent art and architecture with
media spectacle and institutional power, and the transformations
of the avant garde and of cultural politics generally. As a hetero-
geneous text which for better or worse often takes on a negative
cast, it may be easier to say what this book is not. Though it records
one reading of recent developments in North American and West-
ern European art and criticism — specifically, the conjunction of
(post)modernist art and (post)structuralist thought — it is not strictly
a history *or* a theory (a telling distinction in any case). Nor is it
meant to signal the close of any cultural moment (such closure is
usually the critic's own). However seduced I am by ideas of histor-
ical ruptures and epistemological breaks, cultural forms and
economic modes do not simply *die*, and the apocalypticism of the
present is finally complicit with a repressive status quo. At the
same time, the socioeconomic preconditions of the modern no
longer obtain, at least not in original configuration, and many of
the theoretical models of modernism and some of the "great narra-
tives" of modernity are in doubt, at least as originally conceived
(Jean-François Lyotard cites these: "the dialectics of Spirit, the
hermeneutics of meaning, the emancipation of the rational or
working subject, or the creation of wealth.")[1] It may even be, as
Theodor Adorno once remarked, that late-capitalist society is so

1

irrational as to make any theory of its culture difficult. Yet rather than reject theory (on the grounds that it is always phallocratic – or simply useless) or refuse history (on the grounds that it is always exclusive – or simply irrelevant), one may argue the necessity of counter models and alternative narratives. And rather than celebrate (or mourn) the loss of this paradigm or that period, one may seek out new political connections and make new cultural maps (and perhaps, given the will to totality of capital, to "totalize" anew, from the "other" side, in such a way that these terms are transformed). Such a need is often expressed in these pages, but this book is no more blueprint than it is theory or history. Rather it is conceived, as in fact each essay was written, as a critical intervention in a complex (generally reactionary) present.

Beyond this, I cannot be a very acute critic of my work, blind as I am to my blindnesses and insights alike. What is conflicted, repeated and disavowed in this book must remain obscure to me, which is to suggest that the critic, commonly mistaken as the reader who completes the artistic text, also writes to an other who supervises his meaning, and that his work also exists as a sign and a symptom, a specimen text of its time. Yet why then does the critic assume a privileged voice of truth, as if he alone can make of the cultural object a reflexive text? However much this voice is heard in these pages, my experience is finally the one suggested by Paul de Man: I do not demystify the work which I discuss so much as I am demystified by it.[2] This is not to say that evaluation, critique or method is irrelevant to my project, but that for me the task of criticism is not primarily to judge its object æsthetically according to a more or less subjective taste or conservative norm, or to assess it for ideological probity according to a more or less predetermined political agenda (though I am aware of this tendency); nor is it, as in humanist hermeneutics, to complete or enliven the object by interpretation (as if it were deficient or dead) or in structuralist fashion to (re)constitute it in a critical simulacrum that would clarify its logic.[3] Rather, criticism for me enters with its object in an investigation of its own place and function as a cultural practice and in an articulation of other such psychosocial

representations; as it does so, it seeks to separate these practices critically and to connect them discursively in order to call them into crisis (which is after all what criticism means) so as to transform them.

Thus rather than make a fetish of theory, it seems legitimate to me (though legitimacy is not the issue) to engage different objects with different tools as long as the critical specificity or "sectoral validity"[4] of each method in the present is kept in mind. My sympathy with this idea of theory as a "toolkit"[5] is also a situational necessity: though written in suites, these essays were occasional in first form, mostly conceived in the midst of polemical debate (they often remain more ethical than analytical). Yet I prefer to see in this critical pragmatism a "theoretical indiscipline"[6] concomitant with the indiscipline of critical art and theory regarding its traditional proprieties and institutional affiliations. The example of such work has impelled me, tendentious as these essays often are, to speak out of place, "to generalize exactly at those points where generalizations seem impossible to make."[7]

If one considers the evacuation of criticism today – its lack of a social function – this desire becomes a necessity. There are two basic conditions of practical criticism as we know it: the Enlightenment separation of practice and knowledge into autonomous spheres and disciplines, and the bourgeois public sphere with its ideals of critical opinion and free speech (in resistance to the absolutist state).[8] Whereas the first bestowed upon each field (e.g., æsthetics) its own rationality (e.g., norms of beauty, questions of taste), the second provided the expert of this field with a social function and a financial base (e.g., journalism). This provenance clearly aligned the critic with the interests of the bourgeoisie – an affiliation that is all the more direct in the case of art criticism associated as it is with connoisseurship, a "science" of attribution which serves as a guarantee of property and propriety. Today, however, all these preconditions are eroded or transformed. To Jürgen Habermas the Enlightenment project, enacted so that each discipline might develop its logic and so enrich the "life-world" with its cognitive potential, has issued in a "culture of expertise"

3

that has left each field remote from "the hermeneutics of everyday communication."[9] Though æsthetic autonomy was more scripted than this scenario suggests, it is this "autarkical sphere" of art that the avant garde rejects. Yet clearly the present decay of the Enlightenment project is due less to artistic transgression (which Habermas dismisses as so many "nonsense experiments") or critical deconstruction (now too often an academic exercise) than to "the colonization of the life-world"[10] by the economic and bureaucratic, technical and scientific spheres, the former thoroughly instrumental, the latter not value-free so much as value-oblivious. In this administration both art and criticism become marginal; indeed, this is their function: "to represent humane marginality."[11] And so they are treated as essential but superfluous, as luxuries or nuisances to indulge or dispense with.

This erosion in the place and function of art and criticism is no less due to the erosion of the bourgeois public sphere. Criticism emerged in this sphere as a form of resistance and consensus — of bourgeois class consolidation.[12] When, in the face of the demands of other classes, the bourgeoisie had to forego its own public values as political liabilities (cf. "Readings in Cultural Resistance"), this sphere was given over to capital and the state (to the point of our own "corporate public sphere"). This simultaneously reduced the role of culture as a form of mediation between private and public interests and expanded it as a form of consumption and control, the ultimate effect of which is that today art is regarded mostly as entertainment or spectacle (of interest to the public primarily as a financial item) and criticism as so many opinions to consume (cf. "Against Pluralism"). In effect, the bourgeoisie abandoned its own avant-garde artists and cultural experts (whose competence is now often dismissed if it does not fit the political agenda). Though federal governments may offer token support, art (at least in the United States) is today the plaything of (corporate) patrons whose relation to culture is less one of noble obligation than of overt manipulation — of art as a sign of power, prestige, publicity. Apparently, as Jean Baudrillard suggests, mastery of accumulation is not enough for this class; it must control signification as well (cf. "Readings in Cultural Resistance").[13]

How can the committed critic respond to this state of affairs? Not so long ago it was a political stand to refuse the role of taste-maker and value-producer (i.e., an encoder of elitist commodity-signs). Now this refusal may be largely ceremonial, for in a system mostly given over to a (manipulated) marketplace "critique" is no longer needed: the commodity is its own ideology (Adorno), the market its own accreditation. In this situation the committed artist must not only resist this commodification of culture and "implosion" of meaning in the media but also seek out new publics and construct counter representations, and the committed critic, historically suspended "between an inchoate amateurism and a socially marginal professionalism,"[14] must use this out-of-placeness to speak precisely, impertinently out of place.

Again, this critical indiscipline parallels the indiscipline of recent art and theory, as it must if one believes that critical cognition develops contingently with its object.[15] Given this premise, it may be useful to sketch briefly the recent interdevelopments of art and criticism that determine these essays.

"Has anything changed?" Roland Barthes asked in 1971 regarding his model of ideology (or "myth") presented in *Mythologies* (1957). Not the social order, he replies, nor its reliance on myth. "No, what has changed these fifteen years is the *science of reading* under whose gaze myth, like an animal long since captured and held in observation, does nevertheless become a *different object.*"[16] In 1957 Barthes defined myth in a Marxian way as the inversion of a cultural, historical signified (of a class, sex, race) into a natural, universal signifier; to counter this inversion, he argued, the ideological sign had to be righted or mythified one more time. This "mythoclasm" became one operation of critical art (especially since pop) that has employed devices of "appropriation and montage."[17] By 1971, however, Barthes feared that this demystification had ossified into denunciation (with its own mythical projection of centered subject and scientific truth); it thus became necessary no longer simply "to purify symbols" but "to change the object," to dislocate the sign. This theoretical challenge to the symbolic is

5

matched in contemporary art by an "allegorical impulse,"[18] and the "operational concepts" of the (post)structuralist science of the signifier — "citation, reference, stereotype"[19] — have become familiar devices of the (post)modernist art of the same (cf. "(Post)Modern Polemics"). Has anything changed in the *last* fifteen years? Apart from a tilt to a notion of ideology as the "interpellation" of the subject in social institutions, and/or a model of its production in language, (post)structuralism has come under attack (especially in its deconstructionist aspect) as a philosophy of textual æstheticism. This critique holds for much (post)modernist art as well, for clearly any truly critical practice must transform rather than merely manipulate signification, (re)construct rather than simply disperse structures of subjectivity. Yet as (post)structuralism no less than (post)modernism develops as its own deconstruction, these subsequent positions tend to remain within its initial presuppositions. This is not the case, however, with feminist art and theory with its challenge to the tyranny of the (phallocentric) signifier. Nor is it the case with the Baudrillardian critique of the political economy of the sign, which, no less than feminism, points to a significant change in the development of the cultural object and the possibility of its cognition in the last fifteen years. Essentially, what Barthes announced in 1971 as a "science of the signifier," Baudrillard diagnosed in 1972 as a "fetishism of the signifier"[20] — a passion for the code not a critique of it (cf. "Readings in Cultural Resistance"). In a complex analysis he argued that (post)structuralism with its bracketing of the referent and the signified (to the point where they become mere effects of the signifier) is the very epitome of the logic of political economy with its bracketing of use value (to the point where it becomes a mere projection of exchange value). For Baudrillard the differential structure of the sign is one with that of the commodity, and the (post)structuralist "liberation" of the sign one with its fragmentation. This fragmentation, manifested in many ways in recent art and architecture, may thus accord with the logic of capital, which suggests that capital has now penetrated the sign thoroughly. These considerations are crucial to a grasp of

the present effectivity of art, function of criticism and place of culture today, and it is issues like these that I take up in the essays that follow.

"Against Pluralism" discusses pluralism in art in terms of the corruption of modernist definitions and the consumerism of the culture industry; it is in these terms too that the "demise" of the avant-garde and the advent of a pop-historicist art and architecture are framed. "Between Modernism and the Media" considers through analyses of five art practices (among them graffiti and neoexpressionism) the mediation of modern art to the point where its styles and figures return as pop images and types; here too the functions of the avant garde, past and present, are sketched. For its part "The Expressive Fallacy" seeks to deconstruct expressionism as a language operative not only in recent art but in both our metaphysical tradition and our popular culture. "Contemporary Art and Spectacle" addresses the "becoming-spectacle" of art, here discussed in terms of the pervasive irreality of contemporary culture; it also suggests why historical forms are so obsessively recycled in art, architecture, fiction and film today. Finally, "Subversive Signs" points to several art practices of "situationist" intervention and feminist critique that effectively resist many of the conditions remarked upon in this first section of essays.

The second section extends in a theoretical and historical way the insights of the first. "(Post)Modern Polemics" argues that "postmodernism" not be regarded as either a mere style or a grand episteme but as a heuristic term in the periodization of late-capitalist culture;[21] here I present the two basic positions on postmodernism (termed "poststructuralist" and "neoconservative") which, however opposed in cultural politics, may disclose an historical identity. "For a Concept of the Political in Contemporary Art" discusses the import for art of basic changes in social formation and political theory; intimated here is a new moment in the dialectic of modernism and mass culture and the need for a redefinition of the avant garde in terms of resistance rather than transgression. "Readings in Cultural Resistance" elaborates on this argument both historically and politically; it suggests that today we are

socialized less through indoctrination into a consensual tradition than through a consumption of mass-cultural images and commodities. Finally, "The 'Primitive' Unconscious of Modern Art, or White Skin Black Masks" discusses the formation of modern western culture *against* its other or outside — and the stake when this limit is transgressed or rejected as it appears to be now.

I want to remark on one blind spot of this book in particular.[22] Though it has inflected this book in significant ways, there is no single essay on the (mostly British) feminist art involved with (Lacanian) psychoanalysis. This art (I have in mind work by Mary Kelly, Victor Burgin, Yve Lomax, Marie Yates, Ray Barrie, Silvia Kolbowski...)[23] is said to be a mere template of psychoanalytic theory, or to misadapt its linguistic or filmic premises to the static image, or to replicate rather than wreck, in its frequent montage of seductive photographs, the fetishistic nature of representation and the sexist codes of subjectivity which it supports. As for the first objections, the engaged theory deals precisely with issues of representation, of Imaginary investments and Symbolic determinations; it is thus crucial that it be addressed in visual art. (The fidelity of this practice to a masterful, phallocratic discourse like Lacanian psychoanalysis is another issue *when* it is an issue: an artist like Mary Kelly uses the discoveries of feminism to argue with the tenets of psychoanalysis and vice versa.)[24] As for the charge of complicity, this strategy is a necessary one of any deconstruction. If this work elicits our desire for an image of woman, truth, certainty, closure, it does so only to draw it out from its conventional captures (e.g., voyeurism, narcissism, scopophilia, fetishism), to reflect back the (masculine) gaze to the point of self-consciousness. Thus Marie Yates and Yve Lomax stress the absence of woman as a subject in her own right in a phallocentric culture which defines woman in terms of lack; in the fragmentary photo-texts of these artists, our desire for a fetish-image, fixed identity or narrative closure is checked. So too, Mary Kelly refuses any image of woman even as she explores the construction of the

mother (*Post-Partum Document*) and of the middle-aged woman
(*Interim*); if the first work considers the possibility of *female* fetishism
and so "corrects" received psychoanalytic ideas, the second ex-
poses the social repression of the fact of (female) aging. Finally, in
photo-texts "devoted" to famous fictions of woman (Manet's Olym-
pia, Shakespeare's Portia, Freud's and Jensen's Gradiva, Hitch-
cock's Madeline), Victor Burgin, who is often charged with fetish-
ization, in fact works to deconstruct its processes.

My reservation regarding this work is posed differently. Due to
its adversarial stress on the Lacanian definition of the Œdipus
complex in terms of the Name-of-the-Father, the specificity of
patriarchy as a social formation and as an everyday practice is
sometimes lost. This is not usually true of Ray Barrie or Mary
Kelly, both of whom explore the mediations between representa-
tions of sexual difference and institutions of the sexual division of
labor. Nor is it always the case with Victor Burgin, who in the past
has investigated the mutuality of libidinal and institutional ap-
paratuses (e.g., in his controversial piece *Zoo 78* in which a peep-
show is presented in terms of the panopticon). Yet often in this
work such connections are not made: a psychoanalytic demonstra-
tion may be performed for its own sake, and representations of
sexual difference may be mapped onto the social and/or the histori-
cal with little mediation. In addition, woman is occasionally treated
in this work as "a token for all markers of difference,"[25] and her
subjection comes to represent and thus to obscure other forms of
oppression.

Due to this intermittent lack of mediation, a potential contradic-
tion arises in this work between its political desire to transform
social institutions and its historical pessimism regarding patriarchy.
So too, due to its "juridical" conception of the "law as constitutive
of desire,"[26] a possible conflict emerges between its will to disrupt
phallocentric structures of subjectivity and its fatalism regarding
linguistic subjection (which no notion of *jouissance* or the blissful
loss of identity can reconcile). This art does indeed demonstrate
that the subject is produced socially, but it is not enough to say
that its patriarchal structures are thus "subject to change" when

no strategies for change are offered and when these structures are presented as all but transhistorical and urpsychological.

Finally, beyond deconstructive complicity there is sometimes exhibited in this work a fascination with the representations which it impugns — a fetishism rather more than a "dephallicization" of the signifier (cf. "Readings in Cultural Resistance"). Such a passion for the code is as problematic today as is the old essentialist identification of woman with nature. And just as it may no longer be the "naturalism" of myth that ideological criticism must expose so much as the abstract operations of the political economy of the sign, so too it may be "woman as artifice" rather more than "woman as nature" that feminism must now contest.[27] Yet in all this, in its theoretical advances as well as in its practical contradictions — its suspension between the transformative and the deterministic, between defiance and fascination — this practice remains extremely important. In its refusal of a positive image, it makes clear the necessary negativity of critique (at least in *this* conjunctural focus), which these essays seek to partake in. If in doing so it must often forego an active role in the construction of another order, then in this too it is a significant comment on the limits of committed artistic practice in the present.

I. SIGNS AND SYMPTOMS

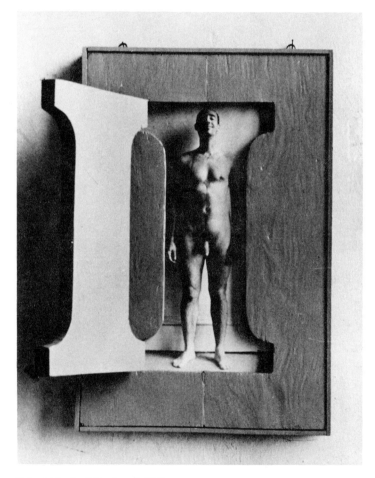

Robert Morris. *I-Box* (open), 1962.

Against Pluralism

Art exists today in a state of pluralism: no style or even mode of art is dominant and no critical position is orthodox. Yet this state is also a position, and this position is also an alibi. As a general condition pluralism tends to absorb argument – which is not to say that it does not promote antagonism of all sorts. One can only begin out of a discontent with this status quo: for in a pluralist state art and criticism tend to be dispersed and so rendered impotent. Minor deviation is allowed only in order to resist radical change, and it is this subtle conformism that one must challenge. My motive here is simple: to insist that pluralism is a problem, to specify that it is a conditioned one subject to change, and to point to the need for cogent criticism.

Pluralism is not a recent condition. In 1955 Lionel Trilling could bemoan the "legitimation of the subversive"[1] in a pluralist university, and in 1964 Herbert Marcuse could even condemn pluralism as a "new totalitarianism."[2] Yet the visual arts are a special case: in the '50s abstract expressionism seemed monolithic, and in the '60s the visual arts had an order that American culture otherwise lacked. In the '60s self-criticism centered these arts radically. In (schematic) retrospect the major art and criticism of the period constitute a highly ethical, rigorously logical enterprise that set out to expunge impurity and contradiction...only to incite them as countertactics. For if minimalism was the apogee of modernism, it was also its negation.

Late modernism was literally corrupted – broken up. Its self-critical impulse was retained, but its ethical tone was rejected. This rejection led to an æstheticism of the non- or antiartistic. Such a reaction (much conceptual art is representative) allowed for many new modes of art: hybrid, ephemeral, site-specific, textual. It also fostered an "institutional theory" of art – namely, that art is what institutional authority (e.g., the museum) says it is. This theory pushed art into a paradoxical position: for if it was true that much art could be seen as art only *within* the museum, it was also true that much art (often the same) was *critical of* the museum – specifically, of the way the museum defined art in terms of an autonomous history and contained it within a museological space. But this impasse was only apparent; and art continued to be made both against the institutional theory and in its name.

The problem of context was only part of a greater problem: the very nature of art. Late-modernist critics (Clement Greenberg preeminent among them) held that each art had one nature – one set of givens – and that the imperative of each was to reveal its essence, expunge the extraneous. Such an æsthetic was reflected in art that was pure and centered (i.e., one did reflexive painting or sculpture, nothing else). Against these norms new imperatives soon arose: the perverse and the marginal were privileged. (Apparent in early happenings, such attitudes were crucial to early performance art.) At first extremely tactical, these imperatives in time became all but conventional as the anti-æsthetic forms were recouped in repetition and as "alternative" spaces were rendered institutional. Thus, what was initiated as a displacement of specific art forms led to a dispersal of art in general – a dispersal that became the first condition of pluralism.

In practical terms pluralism is difficult to diagnose, yet two factors are important indices. One is an art market confident in contemporary art as an investment – a market that, recently starved by "ephemeral" modes (e.g., conceptual, process, site-specific art), is again ravenous for "timeless" art (read: painting – especially, image painting – sculpture and art photography). The other index is the profusion of art schools – schools so numerous

and isolate as to be unaware that they constitute a new academy. For the market to be open to many styles, the strict criteria of late modernism had to be dismissed. Similarly, for art schools to multiply so, the strict definition of art forms had to break down. In the '70s these conditions came to prevail, and it is no accident that a crisis in criticism, ensuant upon the breakdown of American formalism, occurred then too. In its wake we have had much advocacy but no theory with any collective consent. And strangely, few artists or even critics seem to feel the lack of cogent discourse — which is perhaps *the* signal of the concession to pluralism.

A State of Grace?

As a term, pluralism signifies no art specifically. Rather, it is a situation that grants a kind of equivalence; art of many sorts is made to seem more or less equal — equally (un)important. Art becomes an arena not of dialectical dialogue but of vested interests, of licensed sects: in lieu of culture we have cults. The result is an eccentricity that leads, in art as in politics, to a new conformity: pluralism as an institution.

Posed as a freedom to choose, the pluralist position plays right into the ideology of the "free market"; it also conceives art as natural, when both art *and* freedom consist entirely of conventions. To disregard this conventionality is dangerous: art seen as natural will also be seen as free of "unnatural" constraints (history and politics in particular), in which case it will become truly autonomous — i.e., merely irrelevant. Indeed, the freedom of art today is announced by some as the "end of ideology" and the "end of the dialectic" — an announcement that, however naïve, makes *this* ideology all the more devious.[3] In effect, the demise of one style (e.g., minimalism)[4] or one type of criticism (e.g., formalism) or even one period (e.g., late modernism) tends to be mistaken for the death of *all* such formulations. Such a death is vital to pluralism: for with ideology and dialectic somehow slain, we enter a state that seems like grace, a state that allows, extraordinarily, for all styles —

15

i.e., pluralism. Such innocence in the face of history implies a serious misconstrual of the historicity of art and society. It also implies a failure of criticism.

When formalism prevailed, art tended to be self-critical. Though it was seldom regarded in historical or political context, it was at least analytical in attitude. When formalism fell, even this attitude was largely lost. Free before of other discourses, art now seemed free of its own discourse. And soon it appeared that all criticism, once so crucial to art practice (think of Harold Rosenberg and abstract expressionism, Michael Fried and color-field painting, Rosalind Krauss and site-specific art), had lost its cogency. Obviously a critical art — one that radically revises the conventions of a given art form — is not the imperative that it once was. We are free — of what, we think we know. But where are we left? The present in art has a strange form, at once full and empty, and a strange tense, a sort of neo-now moment of "arrière-avant-gardism." Many artists borrow promiscuously from both historical and modern art. But these references rarely engage the source — let alone the present — deeply. And the typical artist *is* often "foot-loose in time, culture and metaphor":[5] a dilettante because he thinks that, as he entertains the past, he is beyond the exigency of the present; a dunce because he assumes a delusion; and a dangling man because historical moment — our present problematic — is lost.

Modern art *engaged* historical forms, often in order to deconstruct them. Our new art tends to *assume* historical forms — out of context and reified. Parodic or straight, these quotations plead for the importance, even the traditional status, of the new art. In certain quarters this is seen as a "return to history"; but it is in fact a profoundly *a*historical enterprise, and the result is often "æsthetic pleasure as false consciousness, or vice versa."[6]

This "return to history" is ahistorical for three reasons: the context of history is disregarded, its continuum is disavowed, and conflictual forms of art and modes of production are falsely resolved in pastiche. Neither the specificity of the past nor the necessity of the present is heeded. Such a disregard makes the return *to* history also seem to be a liberation *from* history. And today many artists do feel that, free of history, they are able to use it as they wish.

Yet, almost self-evidently, an art form is specific: its meaning is part and parcel of its period and cannot be transposed innocently. To see other *periods* as mirrors of our own is to turn history into narcissism; to see other *styles* as open to our own is to turn history into a dream. But such is the dream of the pluralist: he seems to sleepwalk in the museum. To be unaware of historical or social limits is not to be free of them; one is all the more subjected. Yet in much art today the liberation from history and society is effected by a turn to the self — as if the self were *not* informed by history, as if it were still opposed as a term to society. This is an old plaint: the turn of the individual inward, the retreat from politics to psychology. As a strategy in modern art, extreme subjectivity *was* critical once: with the surrealists, say, or even the abstract expressionists. It is not so now. Repressively allowed, such subjectivity is the norm: it is not tactical; indeed, it may be worse than innocuous. So it is that the freedom of art today is *forced* (both false and compelled): a willful naïveté that masquerades as *jouissance*, a promiscuity misconceived as pleasure. Marcuse noted how the old tactics of (sexual) liberation, so subversive in a society of production, have come to serve the status quo of our society of consumption: he termed this "repressive desublimation."[7] Similarly, pluralism in art signals a form of tolerance that does not threaten the status quo.

If pluralism seems to dismiss the need of a critical art, it also seems to dismiss old avatars like the original artist and the authentic masterwork.[8] But this is not so: as pluralism is without criteria of its own, old values are revived, ones necessary to a market based on taste and connoisseurship, such as the unique, the visionary, the genius, the masterpiece. Photographic procedures as well as collage and the readymade have tested these terms throughout 20th-century art, only, by and large, to be transvalued by them (as the photograph acquires an aura through age, or the Duchamp urinal comes to be regarded as a gesture of genius). All these values depend on one supreme value now revived with a vengeance: *style*. Style, that old bourgeois substitute for historical thought, is preeminent once again.

Early modernists sought to free style from traditional conven-

tions. A few (e.g., Malevich) went further and sought to purify art of style. Yet, paradoxically, style (specifically, the persona of the artist and the aura of the art work) became inflated, so much so that by the time of abstract expressionism a charismatic notion of style had all but subsumed the other subjects of art, and artists (like Robert Rauschenberg and Jasper Johns) were again impelled to efface or debunk it. The '60s saw much art devoid of "personality," mute to both individual and art history — in short, much art that renounced style and history as the grounds of meaning.[9] (Minimalist art is the obvious example.) Ironically, just as the formal purity promoted by criticism in the '50s issued in a textually "impure" art in the '70s, so the repression of stylistic and historical reference in the '60s is recouped by the blithe return of the same in much '80s art.

To forego historical references is often to forego references to given conventions too, the absence of which does not necessarily free meaning. Indeed, meaning only tends to return (by default, as it were) to the person of the artist and/or to the material of the work (which then stands as "its own" truth). This occurred often in '70s art, with the result that the self became the primary ground of art once again. In the form of autobiography, the self provided content (e.g., diaristic art); and in the form of style, it became an institution of its own — *and thus its own agent of conformity*. As the modern reflex to violate or transgress conformity still held, the self, perceived as style, was attacked even as it was embraced. Thus alienated from each new style, the self only produced more styles. (This antagonism of self perceived as style is most pronounced in an artist such as Robert Morris.)[10] There seemed no way out of such (non)conformity: it became institutional too. Which is to say that art became skittishly stylish — everyone had to be different... in the same way.[11]

We tend to see art as the issue of a conflict between the individual artist and the conventions of an art form. This notion is also a convention, one that persists even in the face of art that revises it: not only '60s art that would efface "personality" (again, minimalism) but also contemporary art that regards the individual

as constructed in language, the artist as absorbed by conventions. Thus many artists today assume media roles in order to elucidate such conventionality – and perhaps to reform it. It is only in such critique that the individual term can be strengthened. This is not well understood, for throughout the art world the artist as individual is championed – even though, as Theodor Adorno remarked, "the official culture's pretense of individualism... necessarily increases in proportion to the liquidation of the individual."¹² Meanwhile, the conventions of art are not in decline but in extraordinary expansion. This occurs on many fronts: new forms, whose logic is not yet understood, are introduced, and old codes, with the "decorum" of distinct mediums broken, are mixed. Such art can pose provocative contradictions, but more often the mix is promiscuous and, in the end, homogenous (e.g., the many painting/sculpture amalgams).

Artistic conventions are also established precisely where they seem rejected – for example, with artists who assume subjects and processes alien to art, only to render them "æsthetic." Such rejection of the artistic is rhetorical; i.e., it is understood *as* a rejection and so must be timely, tactical – aware both of the present state of its institutional antagonist and of its own anti-æsthetic tradition. For if not specific, this Duchampian strategy can be conventional; indeed, today it tends not to contest the institutional so much as to turn the avant-gardist *into* an institution (Andy Warhol is a case in point). Meanwhile, art that simply rejects the conventional is no less subject to conventionality. Such art (characteristically expressionistic) is an art of "effect"; it wishes to be immediate. Yet what effect is *not* mediated, (e.g., not ironic, naïve, etc.)? What effect *is* innocent (e.g., even bad painting becomes "Bad Painting")? Such work cannot escape its own condition of hysterical futility. It strains for effects only to degenerate into postures, and these postures have no relief: they emerge flat and ephemeral.

Then too there is art that rejects Duchampian rejection, art that concedes to a given conventionality. Alienated from new mediums, these artists return to old forms (many simply dismiss "'60s politics" and claim the "legacy of abstract expressionism"). Yet rarely

19

are these old forms newly informative: painting in particular is the scene of an often vapid revivalism. Moreover, such art cannot *project* its own contradictions; its solutions are to problems that are no longer entirely pertinent. This is troublesome, for though the habit of the historicist — to see the *old* in the new — remains with such art, the imperative of the radical — to see the *new* in the old — is lost. Which is to say that this art retains its historical (or "recuperative") aspect, even as it loses its revolutionary (or "redemptive") aspect. The victim here is not the historicist model of an autonomous, causal line of "influence," but rather the dialectical model that demands radical, materialist innovation. It is *this* history that tends to be denied, only to be replaced by history as a monument (or ruin) — a store of styles, symbols, etc., to plunder. Art that regards history so does not displace the given as much as *re*place it.

Such a view of history is basic to much postmodern art and architecture. The program of such work is often a pastiche that is *partial* in the sense of both fragmented and partisan. [13] (Thus many painters today cite expressionism, with its now safe stress on the primitive; and many architects allude to neoclassical monuments — i.e., to an *architecture parlante* that speaks mostly of an authoritarian tradition.) Even when an art-historical innocence is affected, it is conventional, for the innocence is seen as within the tradition of the *(faux) naïf*. Indeed, our awareness of "art history" is such that any gesture, any allusion, appears already known, always given. Such sensitivity to style, however, hardly suffices for a critical art. Rather than explore this condition of clichéd styles and prescriptive codes (as critics like Roland Barthes and Jacques Derrida have done), many artists today merely exploit it, and either produce images that are easy to consume or indulge in stylistic references — often in such a way that the past is entertained precisely as publicity. The artist innocent today is a dilettante who, bound to modernist irony, flaunts alienation as if it were freedom.

Frank Stella. *Protractor*, 1973.

Donald Judd. *Untitled*, 1967. (Photo: Rudolph Burckhardt.)

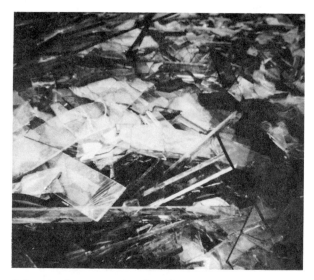

Robert Smithson. *Map of Broken Glass (Atlantis)*, 1969.

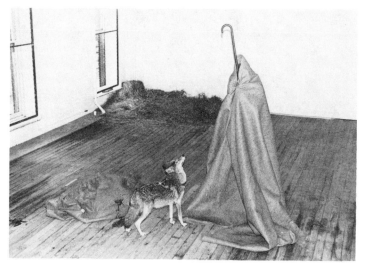

Joseph Beuys. *I Like America and America Likes Me*, 1974. (Photo: Lorraine Senna.)

An Arrière-Avant Garde?

Today one often hears that the avant garde is dead, but few observers draw any conclusions, and yet they are there to be read. Contemporary art is governed less by the conflict of academy and avant garde than by a collusion of privileged forms mediated by public ones. More and more, art is directed by a cyclical mechanism akin to that which governs fashion, and the result is an ever-stylish neo-pop whose dimension is the popular past. An arrière-avant garde, such art functions in terms of returns and references rather than the utopian and anarchic transgressions of the avant garde.

As a prophetic force, the avant garde presented a critical edge; as a subversive force, it claimed a political idealism: one could not retreat to the certainties of past practices. (It is, however, with the avant garde, not with its demise, that art is understood primarily in its conventionality: without this recognition, the present ransacking of its history would not be possible.)[14] Now such a stance does not hold, or at least not so strictly. Regressive art is openly entertained: "I don't have a progressive notion of art — one step after another. Thinking you can change history — that's not something minor artists can think about."[15] This remark by Italian painter Francesco Clemente is symptomatic in two respects: it confuses avant-gardism with the ideology of progress, and it dismisses the transformative desires of political modernists as absurd. Such an antimodern attitude suggests how today the critical is often evacuated by the merely risqué. This is the fate of many critical terms in pluralism. As judgment is suspended, language is neutered, and critical orders fall in favor of easy equivalencies.

The many postures of pluralism suggest a cultural stalemate, an assured status quo — they may even serve as a political screen. We believe (or did) that culture is somehow crucial to political hegemony; as such, we insist (or did) that the avant garde be adversarial. And yet how render art impotent but through dispersal, the franchised freedom of pluralism? (That the bourgeoisie is no longer culturally coherent hardly means that its forces no longer dominate.)[16] Pluralism may also serve as an economic screen. Again,

culture is not merely superstructural: as Adorno stressed, it is now an industry of its own, one that is crucial to our consumerist economy as a whole. In such a state art is seldom adversarial and so tends to be absorbed as another consumer good – an ultimate one. (This is why important galleries, auction-houses, magazines, museums, as beneficiaries of such consumerism, actively promote pluralism.) With the avant garde reduced to an agent of formal(ist) innovation – to the "tradition of the new" – the art world was assured a steady line of obsolescent products. Now in lieu of the historical sequence we confront the static array: a pluralist bazaar of the indiscriminate replaces the showroom of the new. As anything goes, nothing changes; and *that* (as Walter Benjamin wrote) is the catastrophe.

> Here the whole ideology of fashion is in question. The formal logic of fashion imposes an increased mobility on all distinctive social signs. Does this formal mobility of signs correspond to a real mobility in social structures (professional, political, cultural)? Certainly not. Fashion – more broadly, consumption – masks a profound social inertia. It is itself a *factor* of social inertia, insofar as the demand for real social mobility frolics and loses itself in fashion, in the sudden and often cyclical changes of objects, clothes and ideas. And to the illusion of change is added the illusion of democracy. . . . [17]

Fashion answers both the need to innovate and the need to change nothing: it recycles styles, and the result is often a composite – the stylish rather than style as such.

Such is the style of much art today: our new tradition of the eclectic-neo. Ten years ago Harold Rosenberg saw the advent of such art: he termed it *dejavunik*, by which he meant art that plays upon our desire to be mildly shocked, piqued really, by the already assimilated dressed up as the new. [18] This was an early sign that modernism was dead: for how else could it be so *repeated*? Such revivalism is profoundly unmodernist; it is akin rather to 19th-century revivalism. That revivalism and our own are different in origin (the former fostered by a century-long pursuit *of* history – of cultural precedents to ramify bourgeois rule; the latter by a supposed century-long flight *from* history), and yet they are alike in ideology

24

—namely, the legitimation of the patron class. Nineteenth-century revivalism posed its patrons as the *heirs* of history. Our revivalism, more retrospective, presents its patrons as *collectors* — of history as reified objets d'art. The current revivalism in art and architecture, then, was almost to be expected, to say nothing of the continual appropriation of subcultural (ethnic, regional, popular) forms. Faced with such recuperation on both these fronts, one feels the need all the more urgently for a historically redemptive, socially resistant cultural practice.

Early modern art was partly adversarial: whether a dandy or a criminal (the two modern types as seen by Baudelaire), in pseudo-aristocractic withdrawal or radical transgression, the avant-gardist was posed against bourgeois culture. Yet this pose was largely assumed, and it rarely represented any real collectivity. Thus as the bourgeoisie gradually discarded its social values and cultural norms as *political* liabilities, it was in a position, especially after World War I, to reclaim avant-garde culture as its own. One result was that the two antibourgeois types, the dandy and the criminal, became bourgeois heroes. They are with us still, in various forms, often in the same artist. Recently, after years of the criminal (literal "outlaws" like Chris Burden and Vito Acconci as well as less literal ones like Robert Smithson), we are in a time of the dandy, of withdrawal from the political present. But with a difference: in a pluralist state such withdrawal is no transgression; the dandy is everyman's pose.

We have nearly come to the point where transgression is a given. Site-specific works do not automatically disrupt our notion of context, and alternative spaces seem nearly the norm. This latter case is instructive, for when the modern museum retreated from contemporary practice, it largely passed the function of accreditation on to alternative spaces — the very function *against* which these spaces were established. Today ephemeral art works are common, as are ad hoc groups and movements. All seek marginality even though it cannot be preserved (thus the pathos of the enterprise). Certainly, marginality is not now given as critical, for in effect the center has invaded the periphery and vice versa.[19] Here a strange

double-bind occurs. For example, a once marginal institution proposes a show of a marginal group: the museum does so to (re)gain at least the aura of marginality, and the marginal group agrees... only to lose its marginality.

The marginal absorbed, the heterogeneous rendered homogeneous: one term for this is "recuperation." In modern art recuperation often occurred when the non- or antiartistic was made æsthetic. Such recuperation is not now what it was for Duchamp, for the space of the æsthetic has changed (indeed, the very category is in doubt). Shock, scandal, estrangement: these are no longer tactics against conventional thought – they *are* conventional thought. As such, they need to be *re*thought. Only, *that* process too is in many ways conventional: as Barthes noted, such demystification is now the norm. [20] This is not to say that it is useless – only that such criticism is subject to the very "mythologizing" that it would expose. (Art too is subject to this conventionality of the critical and may act in its name precisely when it least intends it. An index to such quasi-critical art is the degree to which it becomes a fashion of its own.) The problem of critical methods (like demystification) rendered conventional, emptied of meaning, is fundamental to the problem of pluralism, for pluralism is a condition that tends to remove art, culture and society in general from the claims of criticism and change.

Ned Smythe. Drawing for *The Tree of Life* (detail of capitals), 1984.
(Photo: D. James Dee.)

(Left) Susan Rothenberg. *Pontiac,* 1979. (Photo: Roy M. Elkind.)
(Right) Walter Robinson. *Phantom Firebug,* 1982.

Jonathon Borofsky. Installation at the Los Angeles County Museum in *The Museum as Site: Sixteen Projects,* 1981.

Pop History

Like the avant garde, modernism seems to have few mourners, and this is not because its death is only rumored. Antimodernism is rampant now: indeed, the consensus is that "modernism" was so "pure" as to be repressive. Such a sentiment is pronounced among postmodern architect/ideologues, Robert Stern and Charles Jencks chief among them. Alienated from modern alienation, they would address the public; awakened from modern "amnesia," they would recall the past – all with a pop-historical imagery. This is a blindered view – a tactical reduction of modernism to a putative formalism that, due to its own ahistoricity, is easy enough to displace. In this way such "postmodernism" often covers for an anti-modernist agenda.

In postmodern architecture references to historical examples do not function formally so much as they serve as tokens of a specific architectural tradition. Architecture thus tends to a simulacrum of itself (often a pop-ish copy), and culture is treated as so many ready-made styles. Though parodic, postmodern architecture is instrumental: it plays upon responses that are already programmed. In effect, architectural signs become commodities to be consumed.[21] Another kind of "consummativity" is often active in art that uses images from popular culture. Art that is made popular by clichés *exploits* the collapse of art into the mass media; the cliché renders the work historical to the naïve and campy to the hip, which is to say that the cliché is used to codify response (e.g., the art-historical references of Julian Schnabel). On the other hand, art that *exposes* clichés plays upon them critically. Such art stresses, even rehearses the collapse of art into the media in order to inscribe – against all odds – a critical discourse there. In such art the clichéd response is elicited, only to be confounded. (The stereotypical subjects of Sherrie Levine and the banal images of David Salle serve to implode the cliché.)

Such a tactic – the cliché used against itself[22] – points to a specific problem in modern art. As is well known, modern art styles are exploited commercially. Such exploitation has now become a

pretext for much contemporary art — art that not only reclaims de-graded images from old low-cultural forms (e.g., '40s pulp fiction, '50s movies) but also steals popular images from present mass-cultural forms (e.g., TV, magazine ads). Such art steals representations from the very culture which had heretofore stolen from it. But the use of such images remains problematic, for the line between the exploitive and the critical is fine indeed. This holds true for the use of art-historical images, many of which are so often reproduced as to be almost mass-cultural.

The problem of the art-historical as cliché is most acute in postmodern architecture: for there the use of such images is justified as "egalitarian," a rhetoric that is only implicit in postmodern art. Does this architecture use its historical references critically or "naturally"? That is, does it seek to renew its form through these references *or* to establish its form as traditional by means of them? (Even parodic references propose a tradition to debunk.) Proponents of such architecture (like proponents of such art) tend to argue in two ways. They say that historical references are given, that they are so blank as to be merely ornamental and not ideological at all; or they say that it is precisely the confusion of such references that makes this usage both timely and tactical.[23] But both arguments are too easy. Historical images, like mass-cultural ones, are hardly innocent of associations: indeed, it is because they are so laden that they are used. This is clear; what is not clear is that these images are not all equally given or public: they are not the "democratic signifiers" that they are claimed to be. It is argued that postmodern architecture draws on so many styles and symbols that everyone is suited.[24] Precisely: *fixed* — by class, education and taste. The confusion of references is superficial: often the references encode a simple hierarchy of response. Such architecture stratifies as it juxtaposes, and condescends as it panders (some will get this, it says, some that). Though it may wish to paper over social differences, it only pronounces them — along with the privileges that underlie them.

Today one often hears of a new freedom of reference in art and architecture. But this freedom is restricted: it is not truly eclectic

(as noted above, usually only one tradition is quoted); no more is it truly egalitarian. And it certainly is not critical: often an old modern idiom is simply revived – or a rhetorical attitude that is modern-trite (e.g., the abstract/representational ambiguity in new image painting). Rarely does this art or architecture expose the contextual contradictions of the styles upon which it draws. Instead it tends to dismiss these contradictions as trifling or to defuse them in the stylish or even to delight in them as historical vaudeville. Not a "new dialectical high,"[25] such confusion is an old static irony – and bad faith to a public that is not initiate, the very public that such art would entertain. The choice is dismal: in taste, either elitist order or a false vernacular, and in form, either modern amnesia or false consciousness.

There are other dismal either/ors that pluralism only seems to solve; the two most troublesome are the either/ors of international or national art and of high or low art. Here pluralism becomes an overtly political issue, for the idea of pluralism in art is often conflated with the idea of pluralism in society. Somehow, to be an advocate of pluralism is to be democratic – is to resist the dominance of any one faction (nation, class or style). But this is no more true than the converse: that to be a critic of pluralism is to be authoritarian.

In art since World War II, the "dominance of any one faction" has meant American art, specifically New York art. We are, by now, sensitive to the chauvinism here.[26] Yet, however supported by cultural representations, this dominance is based on a mode of production and information (often termed "late-capitalist" or "post-industrial") that is multinational. It is this hegemony that is to be resisted; and though hegemonic control is mostly a matter of low culture, it is sanctioned by high culture, by art – thus the importance of resistance in its realm. Such resistance does exist (the artists, international in number, are too diverse to list), but it is weakened by a false resistance – by a newly promoted art of local sentiments and archaic forms. This art (it is not specific to Italian or German or American art) constitutes a disavowal not only of radical art but also of radicality *through* art. (This is not to say that

such art lacks logic. For if old myths of the artist as genius and old modes of artistic production were to be restored, it was more than likely that old images of national identity would follow.) It is argued that these new national art movements use archaic representations so as to cut across history and culture: such, in any case, is the rhetoric of the "trans-avantgarde."[27] Yet what is this "culture" but a nostalgia for exhausted forms? And what is this "history" but a random tour? Provincialism so exploited is only compounded, and art becomes one more curiosity, souvenir, commodity among others. Pluralism is precisely this state of others among others, and it leads not to a sharpened awareness of difference (social, sexual, artistic, etc.) but to a stagnant condition of indiscrimination — not to resistance but to retrenchment.

If pluralism renders art merely relative, it also seems to de-define high and low art — but such is not the case. In most pluralist forms this line is obscured, and art that would be critical (of both high art and media culture) loses its edge. This is not part of any explicit agenda, but here, for example, the claim is clear: "There is no more hierarchy of heaven and earth, no difference between high and low: the perverse and limited bastions of ideology and of every other dogma have fallen."[28] Free of these "perverse bastions," the artist enters a (private?) state of grace. Yet what is this "grace" if not indifference? One is left with this dismal sense: that just as our pluralist state of affairs may reduce criticism to the homogeneity of local advocacy, so too may it reduce art to a homogeneity in which real differences are reclaimed as so many minor deviations and in which freedom is reduced to so many isolated gestures.

A polemic against pluralism is not a plea for old truths. Rather, it is a plea to invent new truths or, more precisely, to *re*invent old truths radically. If this is not done, these old truths simply return, debased or disguised (as the general conservatism of present culture makes clear). Many modernist premises are now eroded. The impulse toward autonomy, the desire for pure presence in art, the concept of negative commitment (i.e., of criticism by withdrawal) — these and other tenets must be rethought or rejected. But the need for critical art, the desire for radical change — are these prem-

ises invalid too? Are we quite sure that such avant-garde motives are obsolete? Granted, the logic of the avant garde often did seem foreclosed. But pluralism answers with a foreclosure — an indifference — of its own, one that absorbs radical art no less than it entertains regressive art. This, then, is the crucial issue that faces both art and criticism today: how to retain (or restore) a radicality to art without a new foreclosure or dogmatism. Such foreclosure, it is now clear, can come of a postmodern "return to history" no less than of a modern "reductionism."

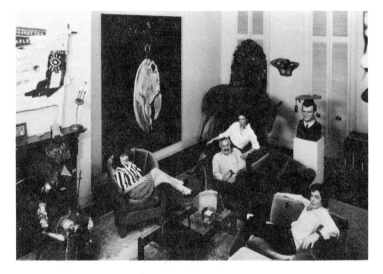

"The Rubells at Home," 1985. (Photo: © Theo Westenberger/SYGMA.)

Between Modernism and the Media

The contemporary western artist is faced with two new conditions: modernism has largely receded as a historical formation and the culture industry has advanced intensively. Indeed, two of the basic modernist positions on mass culture are now partly eroded: neither an austere refusal of the mass-cultural nor a dialectical involvement with its imagery and materiality is necessarily critical today; the first because æsthetic purity has become institutional; the second by default – few contemporary artists are able to engage both modernist and mass-cultural forms in a critically reflexive way. In response, some artists have simply embraced the mass-cultural (as if this constituted a definitive breakdown of cultural boundaries) and/or manipulated modernist forms as if they were media clichés. Below I discuss five forms of contemporary art that bear upon this problem of a remote modernism and an intrusive media – forms that must be grasped in relation to the expectations they engage and the contradictions they "resolve." They are: 1) an art, mostly American, that is ironic about the types of the modern artist but embraces them nonetheless; 2) an art, mostly Italian, that in its fetishism of past styles and modes denies the historicity of art and its imbrication in society; 3) an art, mostly German, that revives a modern style (expressionism) and a modern type (the artist as primitive) in a less than ironic way; 4) a form that until recently existed both outside modern art and against the media: graffiti; and 5) an art that claims to use both modern types and media forms against themselves.

Circus Pro Circum

For Clement Greenberg the early avant garde was opposed to the bourgeoisie "morally" but not necessarily politically. However critical of the middle class, it was still "attached [to it] by an umbilical cord of gold."[1] And though Greenberg does not say so explicitly, the avant garde served the bourgeoisie in an ideological capacity: it kept "culture *moving* in the midst of ideological confusion and violence."[2] On the one hand it resolved "relativities and contradictions" in the expression of artistic "absolutes," and on the other hand it depoliticized them in the form of cultural provocations. Like the "professional conspirators" that Marx numbered among the inhabitants of bohemia, the avant garde performed an ambiguous political function.

The term "provocation" suggests the ambivalent relation of the avant garde to both the bourgeoisie and the proletariat (as well as to the other subcultures that comprised bohemia). For even as "plebian" avant-gardists (like Courbet) politicized art, opened its aristocratic conventions such as history painting to new representations and classes, "bourgeois" avant-gardists (like Baudelaire) tended to abstract the political, to treat the adversarial as a gesture, for an effect — as in this famous statement:

> I say "*Long live the revolution!*" as I would say "*Long live destruction! Long live penance! Long live chastisement! Long live death!*"
> I would be happy not only as a victim; it would not displease me to play the hangman as well — so as to feel the revolution from both sides! All of us have the republican spirit in our blood as we have syphilis in our bones; we have a democratic and a syphilitic infection.[3]

For all its dandyish nihilism, this statement captures the contradictory position of the avant garde: both victim and hangman, suspended between classes. But it was precisely this intermediary position that enabled the avant garde to function as a "broker," to appropriate from subclasses and subcultures for the profit of the bourgeoisie — and thus to serve it in ways other than by its æstheticism. Like the ragpickers that so fascinated Baudelaire, the avant

34

garde helped to recycle the social discards of industrial capitalism back into its productive system, to mediate proletarian forms and subcultural styles (by the creation of new art, fashion, spectacles) in the interests not only of social control but also of commodity production.[4]

As Greenberg feared in 1939, the bourgeois elite has effectively abandoned its avant garde – both its critical factions and its factions concerned with artistic absolutes. Apparently its dual function as provocateur and as preserver is no longer required. Yet the avant garde which mediates subcultural forms and displaces proletarian ones is still useful; and it is in these terms that critics have disparaged the latest outpost of the art world, the East Village in New York (which, as Craig Owens has noted, is a *simulacrum* of bohemia).[5] This "avant garde," which consists of a heterogeneous group of media and graffiti-cum-cartoon artists, neoexpressionists and neosurrealists, etc., makes little pretense of critique (and still less of artistic absolutes). Its artists and dealers largely replicate the art world, expand its market; they have also served as reluctant accomplices in the gentrification of this neighborhood – in the displacement of its subcultural, racial and ethnic groups.

This important argument is now in place. What interests me here is how, in this simulated bohemia, the figures of the modern artist have returned as mass-cultural stereotypes; how modernism – its formations and styles – is engaged *as* an image *through* images (which is all the more ironical given the modernist insistence on the immediate, the contingent, the present, etc.). Just as the avant garde transformed subaltern types and subcultural expressions into poses and styles, so now this new avant garde has begun to recycle these very poses and styles for media consumption. Here, however, what seems a play at cultural provocation is more often a plea for public recognition. For in this simulation of bohemia – which is after all not restricted to the East Village – the sign of the artist is up for sale, and the bohemian values of physical detachment and political opposition are largely contravened.

Before the Enlightenment the figures of the child, madman and primitive were either subsumed or put out of mind. Thus when

they did emerge in art — in the poetry of the romantics, the postures of the avant garde, the primitivism of the moderns — they emerged with the force of the repressed. This is not the case today. The child and the madman have become the very ciphers of modern man: the child as the clue to his psychosexual order, the madman as the limit of his human experience, and both as sources of his art. Indeed, all these figures are no longer others so much as tokens of otherness, emblems of the marginality to which they were once consigned. As such, they have become the names by which the public calls the artist — and still these myths persist. In fact, they are given to us today in almost a parody of the return of the repressed (by such artists as Mike Bidlo, Mark Kostabi, Kenny Scharf, Rodney Alan Greenblat, to name but a few). But this only suggests that what is other, marginal or repressed now lies elsewhere, perhaps hidden by these very masks or rather displaced by them.

What are we to make of this embrace of the utterly conventional roles of the artist as bohemian, child, clown, madman, primitive...? Is it merely a cynical play to public mythology, a nostalgic retrieval of old fictions against present realities? Or can it be seen as an act of abandon in the face of a culture that offers nothing but myths and masks, in which all signs of the individual, the original, the transgressive seem coded? (Michael McClard has even made a banner for this melancholy troupe, a painting striped and smeared like a circus tent called *Circus Pro Circum*; it says, in effect, that though art is now more circus than ivory tower or authentic bohemia, it remains trapped in its own circular spectacle). In this case the embrace of conventional roles would be a rebuke, a strategy of hyperbole in which the old myths of the artist are taken up so excessively as to be exposed as our own bad fictions, our own repressive investments. But this case can only be made in a few instances (for example, when Sherrie Levine rephotographs the self-portraits of Egon Schiele, she effectively reframes the conventional image of the artist-as-expressionist). And in any case, abandon is not much of a strategy in art or in politics — especially at a time

when parodic excess is a characteristic expression of alienation. We need another reading here. In early modern art socially marginal figures made a symptomatic appearance as social alter egos (Courbet), seismographs of political change (Daumier), objects of ambivalent regard (Manet). Whether imaged politically as a potentially revolutionary force or romantically as another social world, these figures often "troubled" the propriety of the given discursive circuits of art.[6] (Consider Géricault's paintings of the insane or Manet's full-dress portraits of "philosopher" bums.) By the time of early Picasso, however, these figures no longer have this ambivalent charge: they are *coded* images for the artist of (his own) social marginality and historical alienation. Indeed, Benjamin Buchloh has proposed that the harlequins and such that appear in art of the '20s – in Picasso, Severini, Beckmann et al. – be read as "ciphers of an enforced regression." ("This new icon of the clown ...," he writes, "appears in the context of the carnival and the circus as the masquerades of alienation from present history.")[7] To Buchloh such regression is the fate of the artist who finds that his avant-gardist mission has failed. The analogy here is clear: in the '20s the early modernisms were regarded largely as culs-de-sac, and in the '80s so are minimalism and conceptualism. Indeed, the new international art of expressionistic, cartoonish figuration and "primitive," bohemian posturing is sold to us as a balm after years of "arid" abstraction and poststudio involvements. But what if this art signals an alienation from history and not a return to it – an acceptance of the cultural division of labor (of the marginal role of the artist as romantic, entertainer, purveyor of prestige goods) and a legitimation of social subjection and authoritarian tendencies in the present?[8]

Day Gleeson and Dennis Thomas.
PAD/D Project Against Displacement, 1984.

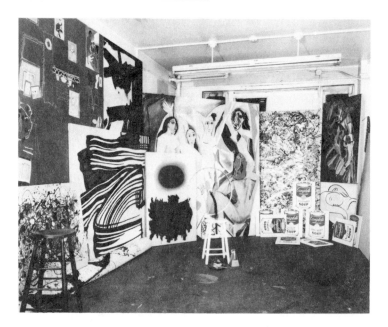

Mike Bidlo's studio, East Village, New York, 1985. (Photo: © Beth Phillips.)

The Culture-Effect

"Regression" is not only a metaphor here: it defines the very operation, psychological and (art)historical, of such work. For Freud regression is both "*temporal* insofar as the libido or erotic need falls back to a temporally earlier stage of development, and *formal* since the original and primitive psychic means of expression are applied to the expression of this need."[9] This dual return is manifested in the work of many contemporary artists, the Italians Francesco Clemente and Sandro Chia prominent among them. Infantile psychological stages and archaic artistic modes emerge symptomatically in the work of both painters: the artist as child or as hero; a narcissistic, autoerotic play; a fascination with anality; an exacerbated fetishism and castration anxiety – all these figures and formations are evident, exhibited in various figurative styles and anachronistic forms (fresco, tempera, even monumental bronze sculpture). This regression, which cannot be separated from its reception, conforms to two psychological tendencies in the bourgeois viewer: a certain narcissism (or suspension in an imaginary realm) and a certain fetishism (or refusal of loss, sexual or social). This art figures these forms of alienation in a way that can be subjectively consumed, not objectively grasped, and so effectively reconciles the viewer to them.

Now Clemente and Chia may well be aware of this process. After all, they regress "with style"; they even seem to flaunt or parody regression, just as they flaunt a fetishistic fixation on the anal (the work is full of coprophiliac references). Perhaps this is a spoof on the eroticism of art-making; it may even be a comment on our fetishism of art – of art treated as a substitute, as a compensation or sublimation. But the coprophilia is not just a motif here; it is embedded in the very æsthetic of this art – an æsthetic that regards history simply *as* style, as so much fecal stuff to mess with. This is a regression harder to enjoy: a recasting of the historical in infantile terms. Precisely because this art is "scandalous," *it satisfies the social expectations of its viewer.* Intended as a gesture of freedom from repression, as a parody even of the anal ("orderly, parsimoni-

ous and obstinate") character of its bourgeois audience, it is also a *performance*, an expression of "defiant mockery" (Freud) that is precisely mock-defiant, a convention or contract whereby the artist not only represents "freedom" and "fantasy" but also plays at "subversion." Here the artists poses as the Defiler of Civilization — never the critic of any specific social order or political regime. Like the feces that is the first gift of the infant, this "subversion" is intended to please rather more than upset.[10]

This vague gesture against civilization not only confirms the bourgeois cliché of the artist as by turns subversive and infantile; it also justifies the bourgeois denunciation of culture (as aristocratic, feminine) and dismissal of art (as irrelevant to a business society). Yet this is only part of the contract, for the bourgeois also *desires* the cultural, needs the imprimatur of artistic sophistication for the sake of social legitimation (or at least he did at one time). This is where the historicism, or use of old styles and modes in this art, comes into play. In general terms, its historicism is part of a revalidation of the academic, artisanal forms of bourgeois culture — its old division of labor and apolitical separation of the arts. As this cultural order was the very achievement of a triumphant bourgeoisie, such art allows the contemporary bourgeois to bathe in (nostalgic) glory. At the same time it offers the comfort of the cliché — of the anachronistic artist in the ivory tower or isolated bohemia — a cliché which in turn justifies the contemporary marginalization of art. Simultaneously, then, this art boasts a return to an elitist mode of art and a surrender to the mass-cultural cliché of the artist and thus confirms the old strict separation of social functions and cultural forms.

Sometimes the historical indexing seems calculated for social as well as art-historical legitimation. When Clemente uses fresco, he may evoke the (early) Renaissance, a time of cultural authority for artists and patrons alike — and the very prehistory of the bourgeoisie. Similarly, in its refusal of the historicity of artistic modes and materials, the bronze statuary of Chia (and others like Julian Schnabel and Bryan Hunt) may signal Eternal Art, which is to say that it plays to the "noble" pretensions of the *nouveaux*

riches and the "universal" presumptions of the bourgeoisie. In both instances the present is conflated with the past, and a "masterpiece" status or a simulation of transcendence is contrived.[11] The historicism need not be coherent; indeed, it rarely is in such work. Rather, the mix of dismissed styles and dysfunctional categories creates an *effect* of culture, insinuates a *sense* of sophistication. In a way just like kitsch, the operation of this art conforms exactly to the expectation of its audience — its simultaneous distrust and desire for the artistic.

Historical references can be disruptive: the use of different artistic techniques may open up our own mode of cultural production, reveal it to be an overlay of many modes; and the quotation of marginal expressions in the present (e.g., third world art) or dismissed figures in the past (e.g., woman artists) can challenge the official canon and value system of modern western art. But this is neither the intent nor the effect of such artists as Clemente and Chia. In the first instance, the use of different modes intends a culture-effect and is in any case made homogenous within one medium. In the second instance, the citation of artistic figures (e.g., Chagall, de Chirico, the Italian academicians of the '30s) is governed less by a desire to displace the institutional or to develop the peripheral (as the Russian formalist Victor Shklovsky advocated) than by the demand for the novel, the dictates of fashion — an arena controlled by the ruling class. Just as the culture-effect of old styles and modes helps to inflate the æsthetic-exchange value of this work, so this revisionism helps to redeem minor moments in art history for the art market.

The references in new Italian (and German) art are not only modish; as Buchloh has shown, they are also keyed to moments when regression in modern art has coincided with reaction in political life.[12] The use of such precedents or analogues is hardly propitious today: however ironic, it is not critical but again pseudo-scandalous. Thus when the Italians borrow elements from fascist art or when the Germans — especially Anselm Kiefer, Jorg Immendorff and Markus Lüpertz — cite Nazi emblems or enthusiasms (e.g., Wagner), the gesture is less antirepressive or culturally revo-

lutionary than risqué, repressively seductive, grisly chic. In this way, whether lugubrious or fey, such historicist art cannot but reveal a certain frustration with freedoms and fantasies that it knows are franchised, a certain desperation in its flight. (But what does it flee? What is repressed here and elsewhere? The "history" in this art offers a clue, for what is repressed is also a history — but one which cannot be reduced to funny figures or art-historical styles, to icons of alienation or reified signs: the history of social and political conflict. Traditionally, art has served to magically resolve this conflict. Some contemporary art seeks to articulate it; this art, however, ignores it, disavows it.)

Such art, then, is as ambivalent in relation to history as its artists are (at once scandalous and servile) to its bourgeois audience, and as this audience is generally to high culture (attracted to it, suspicious of it). In the absence of any other relevance or legitimacy, the historical references in this art serve as a form of sanction. Yet these forms and modes are precisely ahistorical, severed as they are from social practice. Stripped of historical context, they are emptied — with two or three related results. First, an archaism speaks — and speaks in a loosely "historical" rhetoric that is less than progressive. Second, this archaism is invested libidinally in such a way that a psychological regression supports the cultural-political one. Third, these modes, treated as mere signs, are reified all the more — a tendency which severs art from history. A pseudofine art that alludes to history only to dispense with it, to flaunt its freedom (read alienation) from it — what is potentially more amnesiac than this?

Sandro Chia. *Man and Vegetation*, 1980.
(Photo: Zindman/Fremont.)

Sandro Chia. *Genova*, 1980. (Photo: Bevan Davies.)

(Opposite) Francesco Clemente. *Three in One, Diego Cortez, Young Woman and Give, Wait*, 1983. (Photo: Zindman/Fremont.)

(Neo)Expressionism

The German neoexpressionists (Georg Baselitz, A. R. Penck, Immendorff, Lüpertz and Kiefer are the best known) are a different case: less ironic than the Americans as regards modern types of the artist and less insouciant than the Italians as regards historicism. By and large they sincerely, even doggedly return to expressionism. But in this search for legitimacy and authenticity, neoexpressionism fails to work through its own history: not only is much postwar art effectively excised (again, minimal and conceptual art, specifically the "deconstructive" work of such German artists as Gerhard Richter and Sigmar Polke), but the subjectivism and primitivism of the expressionists of 70 years ago is essentially rehearsed — as if the social conditions of the subject and the cultural valence of "the primitive" had not changed, as if what was a critically authentic art in Germany at the time of World War I could be so in the multinational art market of the present. Neoexpressionism presents expressionism not as a historically specific movement but as a natural, essential category — a style with a special purchase on the human condition and a natural (i.e., mythical) relation to German culture. If the position of the original expressionists was abstract and ahistorical, this position is doubly so.

For retrospective proponents like Ernst Bloch expressionism was a valid art of protest against both imperialist war and a culture in decay: it expressed the tensions, subjective and objective, of a morbid bourgeois order and an inchoate revolutionary one. Rather than "plaster over" this fragmented order as the neoclassical "return to order" in the '20s had done (Bloch does not spare the *Neue Sachlichkeit* of George Grosz, Otto Dix et al.), expressionism evoked it in full crisis; it also helped to undermine the schematic routines of bourgeois art and so to free desire of rationalized form — of mimetic representation and conventional imagery. For its detractors, this expression was a mystification: to Georg Lukács expressionism was an art not of demolition but of "collusion in the ideological decay of the imperialist bourgeoisie"[13] — its cultural vanguard rather than its artistic negation. "Frozen in its immediacy,"

44

expressionism could only misrepresent the social whole; concerned with isolated "essence," it could only mystify the objective state of capitalism (which was precisely *not* fragmentary). For Lukács expressionism was merely subjective and idealist – at best dedicated to the transformation of ideas, never of reality – and thus ultimately collusive with bourgeois decadence.[14]

It is important today, especially given neoexpressionism, to argue with both these readings: expressionism was neither critical nor collusive only. *Contra* Bloch, it did not express subjective freedom so much as it figured social and artistic alienation. Indeed, it is the claustrophobia of the monadic individual in a world remapped by monopoly capitalism and transnational ideologies and technologies that this art of sensuous distortion and subjective projection "expressed." And *contra* Lukács, this critical reflection renders it an objective expression of its moment. If this, roughly, was the historical position and cultural effectivity of expressionism, the question is: how does its appropriation in neoexpressionism function today?

The argument for this appropriation runs basically as follows: For the expressionists a subjectivist orientation had tactical value; it helped to displace a repressive, academic tradition. And so for the neoexpressionists subjectivism again has tactical value; it displaces a repressive, American tradition of postwar art. But two points contradict this case: the so-called academy of minimal and conceptual art is not critically displaced; it is abstractly dismissed, as is its neo-avant-garde critique of the given mediums and institutions of art. Moreover, such a return to expressionism (which is really a return to a return) shores up an *academic* model of meaning, one based on stylistic sources and biographical influences. Which is to say that the radicality of the original expressionists is rewritten, in terms of neoexpressionism, in the name of the academy, not its contestation. Such a redemption of expressionism is rather more its oblivion – and the repression of much else besides.

This is troublesome, for expressionism was an authentic art (or rather, its historical failure was authentic) precisely because it

expressed the conditions of a subject newly decentered by its unconscious, fragmented in its senses (especially in the industrial metropolis), diminished by the monolithic structures of monopoly capital and the state. To insist on this alienation now is to blind us to our own different forms of "alienation" — the libidinal investments engineered by consumer capital, the "passion for the code" of signs and commodities that delivers us up to its "abstract manipulation."[15] This manipulation has *recoded* the expressionist insistence on the (alienated) self for its own purposes; to insist on this expression today is to submit to the given regime of the individual. In short, the protopolitical protest of expressionism against subjection has become in neoexpressionism an ideological exhibition of "subjectivity."

Like many moderns, the expressionists sought the new man of modernity but conceived this figure in spiritual rather than political terms; it was thus no real threat to the social order. Indeed, Lukács argued, this expressionist project abetted the most reactionary forces within society: its romantic anticapitalism complied with antidemocratic reaction, and its abstract attack on "middleclassness" played into the hands of an authoritarian (facist) elite. As for its postwar recuperation by the upper-middle class, the subjective, romantic, "primitive" attitudes of expressionism "perfectly accorded with the desire for an art that would provide spiritual salvation from the daily alienation resulting from the dynamic reconstruction of postwar capitalism."[16] A similar neoexpressionist program, possessed of all the joys of the cliché, appeals to a similar audience for similar reasons today.

But what of the irrationality of expressionism, which *was* a threat, a refusal of the rational order not simply of academic art but of capitalist society (its exchange principle)? On one level, this irrational face was no sooner revealed than masked, rendered a social type — a function served in part by the modern figure of the artist as child, madman, primitive, expressionist. In this sense, expressionism was used against itself — to rationalize the irrational, to abstract not only protest within (cultural if rarely political) but also otherness without (in the form of tribal cultures met in the

A. R. Penck, *Ereignis in N.Y.*, 1983. (Photo: Zindman/Fremont.)

Anselm Kiefer. *Inneraum*, 1981.

imperialist march). On another level, even at the time of expressionism, the irrational could not be strictly opposed to the rational, and certainly today it is less the opposite of the rational than its effect. This is not simply a discovery of psychoanalysis (or of a genealogy of madness); it is the very logic of capitalist rationalization. As Régis Debray has suggested:

> The rise of the irrational parallels the rise of the threshold of applied scientificity; it is its compensatory effect. The more the 'objective' world is 'rationalized,' the more the irrational takes hold of the subjective.... At the end of modernity, we find God and the Devil again – and the priests.[17]

In short, a *demand* for the irrational is produced by capitalist order, a demand that expressionism first fully expressed in art and neoexpressionism now satisfies.

Neoexpressionism satisfies this demand in a coded, i.e., rational, manner. Like its subjectivism and primitivism, its "irrationality" is less an antagonist than an agent of the dominant order, which is simply to say that all these terms and values no longer exist in the same form or place, and that the "resolution" afforded them in expressionism cannot be adequate today. Current German painting which suggests that it is thus adequate enacts a play of false consciousness in which the very moment of the eclipse of the integral individual, of the conquest of "the primitive," of the production of the irrational is celebrated respectively as its liberation, its triumph, its expression.

Graffiti

Is there no "primitive" form that is not mediated, no raw that is not cooked? Or are all subcultural expressions recoded as mass-cultural styles, even graffiti? Graffiti is a symbolic activity of individuals who have no access to the media, who are represented (if at all) in the register of the stereotype (vandal, victim, unemployed youth) – a response of people denied response. In the midst of a cultural code alien to you, what to do but transgress the code? In

the midst of a city of signs that exclude you, what to do but inscribe signs of your own? This is part of the logic of graffiti on subway cars: how better to circulate your sign against the code, to mark a territory through alien property?

The graffitists have turned the walls of the city into spaces of response — for response outside the media of TV, magazines, etc. For response is precisely what these media replace with the given rituals of consumption and "participation" (call-ins, polls, letters to the editor).[18] So what do the media — into which the art world is tapped — do in response to this response of the graffitists? Mediate it, absorb it. The underground is pulled into a TV studio, the Bleecker Street Station is redrawn in a West Broadway gallery. There are other reasons why graffiti was ordained an art — its economic value could not be assured without such a taxonomic shift — but surely the subversion of the subversive is a principal motive. The official reclaims the unofficial, the galleries absorb the graffitists. Thus the street-artist Samo becomes Jean-Michel Basquiat, the new art-world primitive/prodigy; and the work of Keith Haring, a mediatory figure in graffiti-become-art, appears on the huge Spectacolor sign atop Times Square (January 1982). Graffiti, the act of antimedia response, becomes an art in the media of irresponsibility.

But graffiti's is not simply another tale of a subcultural expression mediated by the avant garde in the interests of mass culture. Only *some* graffiti is appropriated by the art world, and this valuation entailed a whole protocol of art-historical initiation: an ancient precedent (cave painting), a modern lineage (abstract expressionism and art brut; or as Rene Ricard gushes: "If Cy Twombly and Jean Dubuffet had a baby and gave it up for adoption, it would be Jean-Michel"), even a stylistic history (e.g., from abstract-expressionist graffiti, "the classic stage," to pop-psychedelic).[19] Moreover, graffiti escaped the total appropriation that rap music and break dancing have undergone — not because it could not be redeemed (its "criminality" makes appropriation all the more necessary) but because it could not be encoded: *it is itself* a *decoding*. Thus it was left to the art world — experts in appropriation, technicians in en-

Jean-Michel Basquiat. *In Italian*, 1983. (Photo: Zindman/Fremont.)

coding – to extract what sign exchange value it can from graffiti.

Generally, mass culture abstracts a specific content (or signified) into a general form (or signifier): a social expression is first reduced, then mediated as a "popular" style. Street graffiti resisted this abstraction because it already operated on the level of form or style; as a play of signifiers, it could not be readily reinscribed as such. Not only was graffiti "illegible," it was also "empty"; to invert the Barthes definition of photography, graffiti was a code without a message – without a content that could be easily abstracted into a form or style. This emptiness protected as well as charged graffiti: for a long time it was ignored, then appropriated only as this generic thing, this news item or urban problem "graffiti"; and even now its commodification is mostly restricted to the art world, where it can be broken down into signature-styles.

Graffiti erupted in a city of signs, at once homogenous and fragmented, not to be consumed like those signs but to attack this consumption in its own field.[20] Empty, illegible, graffiti defied the false plenitude of meaning in this code. Moreover, it ignored the given syntax, support, *space* of the city (i.e., it defied its structural boundaries – signs, maps, doors, walls – just as it defied its social ones). Thus graffitists "bombed" the subway, the streets, etc. – which is to say they covered the city and confused the code even as they circulated through and with them. (Jean Baudrillard suggests that subway maps are bombed precisely to deroute riders.) The stake then was not, as is often said, recognition. After all, graffiti "tags" were aliases more than signatures and certainly not "proper" names tied to "private" subjectivities. Indeed, Baudrillard argues that the tags were "totemic" – symbolic appellations of affiliation with a group. On this reading graffiti was at once a "riot of signs" and an alphabet of kinship that "territorialized the decoded urban space."[21]

This reading is romantic now: graffiti is largely mediated; even on the streets it has become its own reified ritual. Not only are these "empty" signs filled with media content, but a few are invested with art (economic) value, anonymous tags become celebrity signatures. Rather than circulate against the code, graffiti is

now mostly fixed by it: a form of access to it, not transgression of it. Like the cartoons and comics in much East Village art, graffiti art is concerned less to contest the lines between museum and margin, high and low, than to find a place within them.

Double Agents

Faced with such a media/art-world apparatus that recoups the most transgressive forms, how can "radical" artists respond? Many have opted to play the fool, often in a canny way. As noted, this confession of bad conscience might be an indictment of a social order which considers artists entertainers — if this docile role of whimsy and rue, scripted by the patron class, were not so embraced by these artists. If artful, the court jester is rewarded by the king; and if very artful, he may even conspire against him. Such, at least, is the proclaimed strategy of several painters, David Salle and Thomas Lawson prominent among them. Leery of the false freedoms of our culture (including much contemporary art), they would pose an art that rehearses how our own representations subject us. To this end they contrive an art that plays on our faith in art to cast doubt on the "truths" mediated by it, a "dead" painting that saps conviction in painting, that undermines its own claim to truth, authenticity, consent.

But how serious a conspiracy is this? A strategy of subversion in the most central of art forms? But this (it is said) is the necessary tactic: complicity. Heretofore, most critical art has intervened in the institutional positioning of the art object or has claimed a cultural space of its own, negative and marginal. But to artists like Lawson and Salle the first practice is now academic, the second romantic. So rather than oppose the dominant culture from without, they seek to conspire against it from within. In order to be subversive, they argue, they must be seen in a form that is culturally privileged: the painting in the galleries, of the museums.[22]

There are problems other than sophistry here. It is not at all certain that painting as an institution compels *general* conviction today (this is not to say that individual paintings do not) — a condi-

tion which might render its perverse use to provoke doubt in other forms not only misbegotten but moot. Critics such as Greenberg have claimed that since the Enlightenment painting has had no other source of legitimation than its own tradition; this is one reason why he (and others like Michael Fried) insist so strongly that contemporary painters aspire to the quality of the old masters; each painting has to compel conviction in Painting or die.[23] Apart from the fact that this cultural history is its own form of legitimation (of a certain formalist art and criticism), it ignores that modern painting is imbricated in, legitimated by, other institutions. (How else can a certain type of expressionist painting now be validated outside of any necessity of the tradition or logic of the medium?) To want to subvert this cultural history, this sovereignty of painting, one must first believe in it, even though it seems clear that the coherence of modern western culture — conviction in it, consent to it — hardly depends on painting, now much less than at any time in the past 200 years. (Whether this is "good" or "bad" is not the issue.)

Second, the strategy suggested by Lawson and Salle of sabotage in painting inverts rather than advances critical art. The strategy is based indirectly on the deconstructive criticism of Jacques Derrida and others: in particular, on the idea that any critique of a tradition must use the forms of that tradition — must commandeer them, in effect. But where deconstructionists like Derrida would reinscribe these discredited forms, "complicity artists" like Lawson and Salle submit to them. (In this sense, such complicity art is only a subtle form of an art like Chia's or Penck's that embraces clichés outright: acceptance of given types remains the fate of the artist.) More important, there is a basic inversion here of deconstructive practice: for rather than comply with a form (like painting) or an institution (like the gallery or museum) in order *to make visible* its conditions and operations (as artists like Daniel Buren, Dan Graham and Michael Asher are said to do), artists such as Lawson and Salle seek *to be made visible* through such complicity. They are, if you like, double agents whose "sabotage" becomes proof of their good standing.

Lawson almost admits as much: "Only now," he wrote in 1981,

"there seems to be a danger that the infiltration has become too complete; the seducer finds himself in love with his intended victim." Here, the "intended victim" is the class that controls cultural representations (as figured in the patron who buys contemporary art): Lawson fears that the artist-seducer — his type is Salle — is now in turn seduced. This implies that Salle *had* intended to disrupt the expectations of this oppressor, an implication which leaves for Lawson the other role: to speak for the oppressed or rather to disrupt how they are represented in official culture. It is not simply that the first "critical" role is now conventional — the artist as provocateur — and that the second is now revealed to be misbegotten, an instance of "the indignity of speaking [substituting] for others."[24] The positions of these two artists are more complicated than this.

To the Italian Marxist Antonio Gramsci, the political artist (or intellectual) must reject his or her class origins in solidarity with the oppressed. But the artist cannot simply pass from one class to another. Like it or not, he is usually either an ideological patron or an *arriviste* (to be lionized, disdained, etc.). In short, he is suspended between classes, lost in contradictions of belief and obligation — "an impossible place," as Walter Benjamin called it.[25] Now, in his art Lawson seeks to instill a "really troubling doubt" about our social roles, but this doubt is really a matter of his own "mixed feelings." And so with Salle: he projects *declassement/arrivisme* into his paintings, plays upon our confusions as to the psychosexual signals of social positions. (This may be why he has such an uneasy appeal for many intellectuals: he gives them pictures of their own alienated desires.)

But what precisely is this impossible place of the artist? For Lawson and Salle it is a place where victim and victimizer are conflated, where the artist (mis)represents both sides. Lawson, aware that this may be so, turns it to tactical use: he paints images of victims, derived from newswire photos, in a form, portrait painting, that is usually reserved for images of victimizers. But this representation is *mis*representation — in a way perhaps not intended by him. *Don't Hit Her Again* (1981) is a picture by Lawson of a

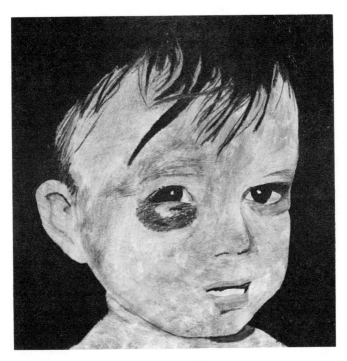

Thomas Lawson. *Don't Hit Her Again*, 1981.

battered child. This painting does indeed question our sense of what is "proper": why this social subject in this cultural form? The incongruity troubles us, but only at first, for in the end the old status quo is confirmed: we are made more concerned with this categorical mistake than we are with the psychological effect and social fact of child abuse (which has a certain shock value and so gains a certain art value). The child is all the more subjected and painting rendered all the more powerful in its abstraction. The passage is from the social subject to its cultural mediation, to the forces of subjection.

For artists like Lawson and Salle autonomous, abstract art is no longer critical. In its stead they offer a narrative art, one that would

engage and contest the narratives of our social world – our dreams of wish fulfillment, our fictions of the real. The idea is to scramble these narratives – to decode the repressive ideology encoded therein, to catch it in the act, as it were. But this is a misbegotten project: like any art, this work participates in ideology in a way that cannot be rewritten as subversive complicity. For the work of art is not simply a tool to be used for or against ideology: it is itself an ideological act – an imaginary resolution of a real contradiction.[26] It might be argued that with his tableaux of disconnected images Salle seeks to undo the reconciliatory function of the work of art. In *Seeing Sight* (1981), for example, the trite images (a crying kid, a prostitute, a 42nd Street scene blurred by graffiti spray) suggest a theme of sexual conflict and social disarray, but in such a way that its reality is seen to elude us. Salle, it seems, would expose these conventional images, would dissolve these imaginary resolutions – in order to show how they bind us. But the dissolved conventions are simply that – old conventions – and one is left with the idea (the ideology) that social processes are opaque or unreal. Our critical debility is thus compounded; indeed, a certain neurotic, even schizophrenic immobility is impressed upon us.

Though the collage aspect of a Salle painting is not finally disruptive (its heterogeneity – of illustration techniques, pornographic images, etc. – is folded back into the medium of painting), the images *are* disconnected, entropic. This depletion-effect is intended: for Salle the æsthetic is "really about loss and longing rather than completion";[27] and it works to withdraw the paintings from us, to frustrate our desire for order and resolution. But it also provokes *nostalgia* for these things (and so again plays on reactionary feelings). More important, his images are designed to work (only) subjectively, as "images that understand us" – i.e., that psychologize us. What Adorno wrote of surrealist tableaux holds true of Salle's: "Inasmuch as they arrange the archaic they create *nature morte*. These pictures are not so much those of an inner essence; rather they are object-fetishes on which the subjective, the libido, was once fixated."[28]

Lawson and Salle would have their images stand in contradic-

tion – both within the pictures and to the world – and in this way invite us to awaken. But awaken us how – who is the subject of these allegorical images? Such images can only stand without resolution in the unconscious, and so it is the psychological that is really privileged here. (Again, this is especially true of Salle. In his work we mostly see how we *subjectivize* social reality – unlike, say, in the work of Cindy Sherman where we mostly see how social reality *subjects* us.) And yet such art does suggest how tenuous our private resolutions are, and how strong our social contradictions. Unfortunately most art today offers us much less – old resolutions of even older contradictions.

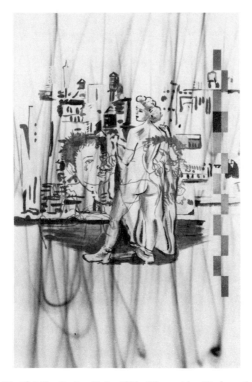

David Salle. *Seeing Sight*, 1981. (Photo: Alan Zindman.)

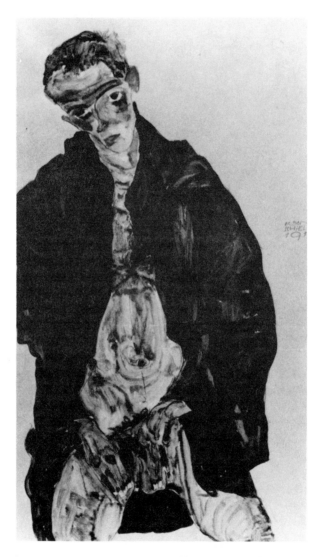

Sherrie Levine after Egon Schiele. *(Self Portrait Masturbating)*, 1982.

The Expressive Fallacy

We know that our entire social language is an intricate system of rhetorical devices designed to escape from the direct expression of desires that are, in the fullest sense of the term, unnameable – not because they are ethically shameful (for this would make the problem a simple one), but because unmediated expression is a philosophical impossibility. And we know that the individual who chose to ignore this fundamental convention would be slated either for crucifixion, if he were aware, or, if he were naïve, destined to the total ridicule accorded such heroes as Candide and all other fools in fiction or in life.

 – Paul de Man, "Criticism and Crisis"

Despite appearances, the art world is not a haven for Christs and Candides: few artists trade in "unmediated expression," though this is the issue over which many are said to contend. At one extreme are artists who suspect the very idea of expression; at the other are artists, mostly painters, whose passion seems earnest indeed. And somewhere in between come the neoexpressionists who, consciously or not, play at expression. Neoexpressionism: the very term signals that expressionism is a "gestuary" of largely self-aware acts.

As specific styles, German and abstract expressionism can now be *used* by artists chiefly in two ways – conceptually as second-degree image-repertoires, or ahistorically in a way that betrays false con-

sciousness. In "Between Modernism and the Media" I sketched German expressionism as a historical formation; here I want to discuss expressionism as a specific *language*. This is not easy to do, for expressionism denies its own status as a language – a denial that is necessary given its claim to immediacy and stress on the self as originary. For with a denial of its rhetorical nature goes a denial of the mediations that threaten the primacy of individual expression (e.g., class, language), mediations which are usually dismissed as mere conventions, as cultural not natural. Such a "transcendent attack on culture," Adorno wrote, "regularly speaks the language of false escape, that of 'nature boy.'"[1] And so with expressionism: it speaks a language, but a language so obvious we may forget its conventionality and must inquire again how it encodes the natural and simulates the immediate.

What is this language, what is its protocol? First and foremost, expressionism is a paradox: a type of representation that asserts *presence* – of the artist, of the real. This presence is by proxy only (the expressive marks of the artist, the indexical traces of the hand), and yet it is easy to fall into the fallacy: for example, we commonly say that an expressionist like Kandinsky "broke through" representation, when in fact he replaced (or superposed) one form with another – a representation oriented not to reality (the coded, realist outer world) but to expression (the coded, symbolist inner world). After all, formlessness does not dissolve convention or suspend mediation; as the expressionist trope for feeling, it is a rhetorical form too.

Here it is useful to compare expressionist representation with classical representation (of which Poussin may serve as an example). According to Louis Marin, the material elements in classical painting (especially, the traces of the artist) tend to be "concealed by what the painting represents, by its 'objective reality.'"[2] In expressionist painting another type of transparency is operative: the material elements tend to be subsumed by what the painting expresses, by its subjective reality.[3] Both types of representation are codes: the classical painter suppresses nonnaturalistic marks and colors so as to simulate (a staged) reality; the expressionist "frees"

such marks and colors of naturalism so as to simulate direct expression.[4] And as codes both types are based on substitution (and thus on *absence*): the classical painter "substitutes for things his representations of them" (Marin) in such a way that reality seems to speak; the expressionist substitutes for these representations the freed marks and colors that signal self-expression. Inasmuch as a stretched canvas "already exists as a picture,"[5] the expressionist is faced with a given (representational) paradigm which he must cancel or supersede with a paradigm of his own. Expressionist "immediacy," then, is an effect – of a twofold mediation.

Of course, this effect was conceived by the original expressionists quite differently; after all, they sought to tear asunder the linguistic veils that hung over reality and obscured the self, not to distance the one and defer the other all the more. For them expressionism was an art of "inner necessity" (Kandinsky) and "abstraction" (Worringer) that operated by a formula such as this: via abstraction the viewer is compelled by the inner necessity of the artist. Yet this notion of self-expression, which governs the common idea of modern art in general, derives, as Paul de Man noted, "from a binary polarity of classical banality in the history of metaphysics: the opposition of subject to object based on the spatial model of an 'inside' to an 'outside' world"[6] – with the inside privileged as prior. Expressionism not only conforms to this metaphysics of presence, it celebrates it (and this, in the case of German expressionism, at the moment when Picasso and Braque had begun to analyze the logic of *re*presentation and Duchamp to consider the conventionality of the expressive self). Indeed, the old metaphysical opposition of inside versus outside, soul versus body, is the very basis of expressionism – and of all its oppositions: nature versus culture (most emblematic in the animal paintings of Franz Marc); individual versus society (most apparent in the escapism of Emil Nolde); artist versus convention – all of which return, in an existentialist register, in abstract expressionism.

Nietzsche, who is often (mis)cast as the philosophic precursor of expressionism, effectively deconstructed it before the fact. To Nietzsche this "inner necessity" is based on a *linguistic* reversal:

"The whole notion of an 'inner experience' enters our consciousness only after it has found a language that the individual *understands* — i.e., a translation of a situation into a familiar situation...."[7] This "translation" precedes, indeed constitutes any formed expression so that between it and the self a rhetorical figure intervenes (in linguistic terms, the subject of the *énoncé* and the subject of enunciation are discontinuous). The adequation of self and expression is thus blocked — by the very sign of expression. Such is the pathos of the expressionist self: alienated, it would be made whole through expression, only to find there another sign of its alienation. For in this sign the subject confronts not its desire but its deferral, not its presence but the recognition that it can never be primary, transcendent, whole.

Contrary to expressionist belief, the unconscious is not at our transparent disposal; indeed, on the Lacanian reading not only is the unconscious structured as a language, it is also the discourse of the other.[8] The expressionist self, then, is decentered by its language *and* by its desire (which, as a lack, it can never fulfill): its utterance is less an expression of its being than an address, a plea, to an other. Expressionism bears this same contradictory, even self-deconstructive relation to the metaphysical order on which it rests: for even as expressionism insists on the primary, originary, interior self, it reveals that this self is never anterior to its traces, its gestures, its "body." Whether unconscious drives or social signs, these mediated expressions "precede" the artist: they speak him rather more than he expresses them. (Seen in this way, "the artist" is less the originator of his expression than its effect or its function — a condition that expressionism at once reveals and disavows.)[9]

The expressionist monologue, then, is a form of address, one that suppresses its rhetorical nature, it is true, but a form, a formula nonetheless. And to deconstruct expressionism is to show precisely how it is constructed rhetorically — that the expressionist self and sign belong to a preexistent image-repertoire. Thus in *Target with Plaster Casts* (1955) and other works, Jasper Johns revealed the vaunted gestures of abstract expressionism to be ambiguous

traces — not marks of presence so much as "casts" of absence. Simi-
larly in his depictions of brushstrokes, Roy Lichtenstein exposed
the expressionist equation of formlessness and feeling and re-
flected upon the gesture as a sign — a sign that does not present
the real *or* register the self so much as it refers to other signs, other
gestures. More recently, Gerhard Richter has analyzed in a series
of generic "Abstract Paintings" the manifold mediations of expres-
sionism: through mechanical enlargement of pictorial gestures
(which are then often repainted), he effectively deconstructs the
immediacy of expressionism and suggests that, far from the unique
and original, its program leads logically to the production of empty
signifiers and serial paintings.[10]

The expressionist quest for immediacy is taken up in the belief
that there exists a content beyond convention, a reality beyond
representation. Because this quest is spiritual not social, it tends
to project metaphysical oppositions (rather than articulate political
positions); it tends, that is, to stay within the antagonistic realm of
the Imaginary. This suggests in turn that the I of expressionism is
not the primary, transcendental individual but the alienated, with-
drawn subject. This same antagonism or ambivalence governs the
expressionist attitude to the natural and the primitive, which are
both embraced and feared as the site of the human *and* the nonhu-
man, the free self *and* the other. (Think of Picasso, the bourgeois
artist who romanticizes the primitive in himself.) At bottom, this
ambivalence arises from a social contradiction — of the natural and
the primitive privileged culturally precisely when endangered his-
torically. (At the climax of the great industrial-imperial period, ca.
1914, how could the natural and the primitive *not* be ambivalently
thought — and how much more so today when they are all the more
endangered?)[11] This is not to say that the value placed on the
natural and the primitive by expressionists is misconceived: it is a
"natural" response to social alienation. But to oppose nature and
culture so abstractly is to mythify both as absolute forces — almost
as fates before which one is supine. As social and historical connec-
tions are severed, political redress seems futile, and one is left with
a subjectivist response which quickly becomes its own form of

domination: "the more the I of expressionism is thrown back on itself, the more like the excluded world of things it becomes."[12]

Finally, the contradictions of expressionism are those of a language that would be immediate, a cultural form that would be natural. Perhaps in the end the denial of its historical and rhetorical nature is simply the repressed recognition of how thoroughly language invades the natural, mediates the real, decenters the self.

Jasper Johns. *Target with Four Faces*, 1955. (Collection: The Museum of Modern Art, New York. Gift of Mr. and Mrs. Robert C. Scull.)

Gerhard Richter. *Ohne Titel* (568-1), 1984.

Essentially, my own desires have very little to do with what comes out of myself, because what I put out (at least in part) has already been out....My way to make it mine is to make it again and making it again is enough for me and certainly, personally speaking, almost me.　　　　　　　　　　　　　— Richard Prince

In a way, my analysis is redundant: the work of several young artists reflects critically upon the language of expressionism. This critique, by no means the sole motive of such art, arises logically from its different premises: for this art, often of purloined and montaged images, is opposed to the expressionist model of the expressive self and the empathic viewer (it is less opposed, however, to the ironic *use* of this model by certain neoexpressionists). Moreover, the critique is limited neither to expressionism the historical style nor neoexpressionism the art-world phenomenon: for these artists expressionism is much more — it is the official rhetoric of both our old metaphysical tradition and our new consumerist society.

"Eating Friends" (1981) is an ensemble of short texts and crude images of body parts, printed and painted on large copper plates by Jenny Holzer and Peter Nadin. In the context of the time, this strategy of Johnsian literalism debunks expressionist "inner necessity," for here the only inside are internal organs, the only expression and empathy biochemical reactions (one text reads: "It's awful to see them deformed because they are rigid with fear."). Such literalism mocks the psychosexual rhetoric of expressionism; but more, it indirectly debunks a metaphysical order based on opposed terms, whereby one term — the "eternal life" of the spirit — suppresses the other — the "dead letter" of the body. This order promotes expression as the truth of art, the guarantee of its authenticity, and privileges expressionism precisely as an art of "inner life." In "Eating Friends," this order is reversed: inner life is reduced to body parts, and "ex-pression" is strictly seen to be a fallacy.

That the self is a construct is the subject of many young artists, Cindy Sherman prominent among them. Her photographs are portraits of the self as it emerges in the field of the other — in types presented by the media *as* women. In her work we see that to

Cindy Sherman. *Untitled.* 1982. Cindy Sherman. *Untitled.* 1984.

express a self is largely to replicate a model; indeed, that in our differential code of selves "no longer is there any imperative to submit to the model or to observation: 'You are the model.'"[13] Oppositions of original and copy, inside and outside, self and society all but collapse: in these "self" portraits identification is one with alienation; "the liquidated individual makes the complete superficiality of conventions passionately his own."[14] This is true too in her "Pink Robe" series, in which Sherman seems to expose her own self but in fact exposes the *type* of the exposed self in casual, confessional poses: even in private women are fixed by an internal gaze, a confessional speech. (Here the disciplinary nature of our society of confession and conscience — from talk shows to the "talking cure" — is also confirmed.) Though the subjection of woman is often charged to her projection as nature, Sherman has made clear, in a recent series of "fashion" photos, that it is also due

67

Richard Prince. *Untitled*, 1982.

to the manipulation of woman as sign, as fetish, as masquerade.
Even in the "Pink Robe" photographs it is less natural woman that
is deconstructed than expressive artifice – expression as artifice.
For Richard Prince this control-by-simulation is a given. Thus
he has rephotographed travel-and-leisure ads and nightclub and
movie displays in a way that distorts them extravagantly. He does
this not to expose the manipulations therein (that is didactic and,
besides, they are blatant enough) but to catch seduction in the act,
to savor his own fascination with such images – even as they manip-
ulate him via insinuated desire. His enterprise, then, is less a
critique of the "false" image than an exploration of simulation – of
a serial world in which the old order of representation (of "good"
and "bad" copies) is dissolved. In this spectacular society the self
is reflected everywhere and nowhere – but is nonetheless strictly
positioned by sexuality, class and race. And Prince shows us that
there is no spectacle "out there" that is *not* a subject-effect "in

James Casebere. *Arches*, 1985.

here"; that the projection of the one and the construction of the other are the same operation.

James Casebere reflects on this simulated world in a different way. His photographs of tableaux of his own making have no proper referents: neither objective copies nor subjective correlatives, they are akin to phantasms in which representations (of repressed events?) have usurped the real. They thus belie the epistemological definition of the photograph as a fragment of "spatial immediacy and temporal anteriority," and confound both its "effect of the real" (garnered through its representation of insignificant detail that we commonly accept as literal) and its conventional status as document, pure denotation, "message without a code."[15] (It is, of course, this putative absence of a code in photography that allows for its great power as a medium that renders things "obvious" and events "natural.") With oppositions between original and copy, nature and code blurred, the Platonic order of representation becomes unsta-

James Casebere. Installation, Staten Island Ferry Terminal, 1983.

ble in these photographs, and in this unfounding of the image is a subtle subverting of the subject. For not only is access to the real blocked, but the mastery usually afforded the subject by (photographic) representation — a certain subject position, an empowered point of view — is withdrawn. The viewer seems almost engulfed by these simulacra, which in turn appear distorted by his internalized perspective.[16] In this phantasmal, even uncanny disturbance of the field of vision,[17] the transparency of the real and of the self, as assumed by the expressive model of art, is rendered problematic.

If Holzer and Nadin suggest à la Foucault that the "soul" is the prisoner of the body (not vice versa),[18] and Sherman and Prince show that this subjectivity is constructed socially and consumed spectacularly, then Casebere displays the fundamental (philosophical) uncertainty of the relationship of this subject to representation and to the real. In this context the idea that the self is a fiction is liberative, even subversive; and yet there are signs that this too has become a conventional position, one that may encourage a passivity in the face of subjection — or conversely, a delusion that it can be "critiqued away" culturally. In this regard the work of an artist like Matt Mullican is salutary, for rather than passively consume fictions of the self or naïvely project self-expression, Mullican has fabricated, out of quasi-public signs and logos, a code of his own. Though this code borders on the hermetic (to the point of a parody of the modernist project of the Great Book, the encyclopediac text that is both private language and collective revelation), Mullican does not submit to given constructs of identity. A *bricoleur* in an age of corporate emblems and global esperantos, he is able to piece together a "supreme fiction" without recourse to ideological notions of interiority or transcendence. As Adorno wrote: "In the universally mediated world everything experienced in primary terms is culturally preformed. Whoever wants the other has to start with the immanence of culture, in order to break out through it."[19]

For these artists, "expressionism" is more than an artistic style: it is an ideological site where discourses of many sorts meet and

may be caught out. Here, then, we must open up the term to include the expressionist rhetoric of pop psychology and consumerist society in general. Express yourself, we are exhorted – but only via the type, only via the commodity. This expressionism thus has a social as well as an economic agenda, for expression is largely judged by *authenticity*, which in turn is largely judged by *typicality* – i.e., fidelity to sexual models, economic function, class position, ideological limits. (For example, in the traditional novel the villain is usually a transgressor of class lines – an imposter who climbs too high, a rake who falls too low.)[20] Now it is precisely this social use of typicality that Eric Bogosian exposes in performances like "Fun House." As he impersonates a lowly cast of urban characters (the M.C., the hood, the punker), Bogosian either inhabits the social type under such pressure that it explodes or reiterates the type – but in such a way that it is made defiant, and the label of marginality is turned into a sign of identity. Thus submission and transgression are rendered equivalent, and "that is the most serious crime, since it cancels out the difference upon which the Law is based."[21]

As to the "jargon of authenticity" in art, Sherrie Levine has reflected most critically on this rhetoric through different re-presentations of modern art works. A few years ago she turned her deconstructive gaze away from images of the other (women, the poor, nature) to images of the avant garde; but her primary interest remains the discursive (ab)use of these images in cultural politics. Significantly, Levine initiated her series on the avant garde with expressionist images (e.g., "Horse" paintings by Franz Marc, self-portraits by Egon Schiele), which she simply bought as posters or rephotographed from books. Thus reframed, the image may tell us two things: that far from univocal, it is riven with (conflicted) motives, and that our explanations, far from neutral, use these motives ideologically. Refocused then, the expressionist image may confess a cultural agenda – in the Marc paintings, the ideological use of nature as other; in the Schiele portraits, the mystifications of the psychobiographical – based on an economy of exclusion. Expressionism is thus seen to be a specific language, authen-

tic in its era (when subjective revolt was not yet absorbed) but ideological in our own. This is an important insight, for only insofar as it can deny its status as a historical language can expressionism claim a timeless transparency to reality and truth. Under the gaze of artists like Levine, this transparency opacifies and cracks.

Gretchen Bender returns us to expressionism as an ideology which renders desire particularly instrumental. In her series "The Pleasure is Back," she reproduces emblematic images (from both contemporary ads and art) on tin squares used for signs. A typical work may juxtapose a detail from a painting by A. R. Penck or Julian Schnabel or Sandro Chia, with an image of a Lichtenstein brushstroke and a photo (from a Dial soap ad) of an ecstatic woman in a shower. One image comments on another: the false freedom in the neoexpressionist detail is exposed by the Lichtenstein, in which spontaneous gesture has become reified sign, and both signs are revealed, in the false pleasure of the woman, to be complicit with the commodity. In her recent work Bender has extended this critique of authenticity. Because Levine seeks to deconstruct the discourse of originality (the privileged status of the unique art work, the artist genius), her inquiry must stay within the conceptual frame of this discourse; indeed, inasmuch as it is the *copy* that posits the original in the first place, her appropriations may confirm the position of her originals. Bender meanwhile has begun to use the computer to map images of all sorts onto one and the same field (photographic or video). Her images have none of the substantiality residual in the Levine re-presentations: they are simulacra, copies without originals, that collide and proliferate outside the orders of art and of representation as we commonly conceive them (though not outside structures of power).[22] In this realm no notion of expressivity or authenticity can control the play of signifiers.

(Left) Matt Mullican. *Untitled*, 1984. (Photo: Zindman/Fremont.)
(Right) Gretchen Bender. *Revenge of the Nerds*, 1984. (Photo: Pelka/Noble.)

Psychoanalysis, the Sartrean critique of bad faith, and the Marx-
ist critique of ideologies have made "confession" a futility: sincer-
ity is merely a second-degree Image-repertoire.
— Roland Barthes, "Deliberations"

Why, then, if the expressionist fiction seems so suspect, is it re-
newed today? The art market is only one factor: it depends on the
doxa of the time, which still holds to art as an individual retreat, a
last refuge of humanism. In this view, however decentered in rela-
tion to society (Marx), the unconscious (Freud), language (Saussure),
science and technology, the self remains sovereign in art. Strangely,
this popular position is now reinvented by critics, curators and
dealers alike — which is provocative momentarily as a reaction but
is precisely reactionary.

Meanwhile, the desperate attempt in neoexpressionism to rein-
vest art and artist with aura and authenticity, transparent in its
economic motives and political agenda, attests only to the historical
decay of these qualities. For however authentic expressionism
once was as a protest against rigid conventions, it is hardly so today
in our society of repressive desublimation. The crisis of the indi-
vidual versus society (bourgeois leitmotif that it is) is a cliché, as
is the crisis of high versus low culture. Indeed, both these "crises"
may act to obscure real ones (e. g., that the individual is now largely
an instrumental category: the entrepreneur of early capitalism
returned, in late capitalism, as a consumer of "individuality" — or
recycled by the right as a purely ideological figure).

So the return of expressionism is less than a turn in the zeitgeist
and more than a local reaction. It is a later response to the same
historical process that once educed German expressionism — the
progressive alienation or disintegration of the individual (to which
the expressionist bears witness precisely in his proclamation of self-
hood). The German expressionist could hope to reclaim a lost
reality through a new investment in subjectivity. But as the passage
from modern angst to contemporary "schizophrenic" culture sug-
gests, subjectivity is no more exempt from reification and fragmen-
tation than objective reality. Neoexpressionism, then, occurs as

one more belated attempt to deny this condition, to recenter the self in art.

But this is too easy a conclusion. A common plaint is that much neoexpressionism is *in*authentic, ironic, as mediated as any "media art." Institutional supporters may enwrap these artists in a rhetoric of authenticity and originality — but this too is ironic. For clearly these artists trade, if not in fraudulence and pastiche quite, then in *simulations* of authenticity and originality. (They often seem to confect masterpieces; in the paintings of Schnabel or Kiefer or Chia, say, pastiche may mime the grand synthesis of the masterwork and a disavowal of present conditions may simulate the timeless virtues of Great Art — a simulation that usually comes with masterpiece trappings: huge canvas, heavy frame, grand style, very heavy thematics.) Indeed, in this fraudulence, neoexpressionism is in some sense "authentic" as a *symptom* of our historical moment.

Far from a return to history (as is so ideologically posed), recent culture attests to an extraordinary *loss* of history — or rather a displacement of it by the pseudohistorical. Thus, today, artists and architects only *seem* to prise open history (a necessary disruption that frees it from mere continuity) to redeem specific moments; in fact, they only give us hallucinations of the historical, masks of these moments. In short, they return to us our historically most cherished forms — as kitsch. And strangely not only do we acquiesce in this liquidation of a tradition, we relish it. The irony is that this only seems to be old bourgeois self-hatred; in fact, it is a flaunted privilege — a kind of hubris. For now it seems we no longer need meaning, no longer need ideological control of "history" or "culture." (Or is it rather that our new ideological control is that we *seem* able to dispense with these things?)

Neoexpressionism appears as a problematic response to this loss — of the historical, the real, and of the subject. By and large, the neoexpressionists would reclaim these entities as substances; the work, however, reveals them to be signs — and expressionism to be a language. This finally is the pathos of such art: it denies what its practitioners would assert. For the very gestures that insist on the

76

presence of the historical, the real, and of the subject testify to nothing so much as desperation at their loss. There is an idealism here, to be sure, but it is an idealism "shown to be an idolatry, a fascination with a false image that mimics the presumed attributes of authenticity when it is in fact just the hollow mask with which a frustrated, defeated consciousness tries to cover up its own negativity."[23]

Jack Goldstein. *Untitled*, 1982.

Contemporary Art and Spectacle

The end of cultural history manifests itself on two opposite sides: the project of its supercession in total history, and the organization of its preservation as a dead object in spectacular contemplation. One of these movements has linked its fate to social critique, the other to the defense of class power.

— Guy Debord, *Society of the Spectacle*

It is no secret that our culture is fascinated by images of fascism (in film Rainer Fassbinder, Hans Jürgen Syberberg... and in art Robert Longo, Jack Goldstein, Troy Brauntuch, Anselm Kiefer, Gilbert & George...), and this fascination cannot be explained away either as a dandyish taste for the scandalous or as a return, not of the repressed, but of the desire for repression. For any such hypothesis there is no end of evidence (one sees a new authoritarianism as well as a new irrationalism everywhere). But I want to think about "fascinating fascism" in other terms — in terms of the *irreality* of contemporary capitalist culture.

Recently, Jean Baudrillard has suggested one reason why fascism is the site of such attraction. We suffer, he says, from a "loss of the real," and in order to compensate we have made a fetish of the period prior to this loss — the period of fascism (especially World War II).[1] For Freud the fetish is a substitute which blocks or displaces a traumatic discovery of loss (i.e., castration); it is often the last thing experienced before the event. Thus, if the trauma of

postwar consumer society is the loss of the real, fascism might well be our fetish period. Now on the face of it this idea seems absurd. Fascism as a period with a purchase on the real? It is infamous instead for its irrationality. But this paradox is precisely why it fascinates us, for it is in fascism that one sees a culture struggle with the loss of the real. How else to explain (on the cultural level at least) the fanatical resurrection in fascism of atavistic representations — myths of nature, race, empire, of blood and soil — except as a desperate means, in the face of the one-dimensionality of modern life, to rescue a sense of the real? Clearly, Nazi leadership exploited this cultural trauma, and just as clearly they exploited the modern mediums and effects which did so much to dissolve the real — mediums like film, effects like spectacle.[2] This is one reason why contemporary artists have explored representations of fascism: because in them one sees both an extraordinary investment in the real and an extraordinary manipulation of its loss (in spectacular pageants and films).

It is a commonplace to say that the primary public representation in the 20th century is now film or television, not architecture or sculpture (though the very term is suspect, if one grants the loss of the real). Of course, the Third Reich invested in old forms like architecture (the rigid classicist vocabulary of fascist monuments makes clear the pretensions of this "Empire of 1000 Years") even as it explored new forms, like film, of spectacular control. In fact, one can point to a specific instance in which the ideological stress passes from architecture to film — in the 1935 Leni Riefenstahl "documentary" of the Nazi rally at Nuremberg. There architecture becomes purely scenographic: Albert Speer designed the stadium essentially as a set for a cinematic event. (Note in general his obsession with the "ruin-effect" of architecture, a spectacle planned for posterity.) In this example we glimpse how the spectacle works as a simulated reality, a total illusion, a set of effects that consumes the primary event.

In the work of an artist like Robert Longo we are once again in a world of spectacle — but, more, we are in a "world of simulation, ...of the murder of every symbolic form and its hysterical, histor-

ical retrospection."[3] For Longo traces not only our loss of the real but also our morbid attempt to compensate for this loss via the resurrection of archaic images and forms. To think about Longo in these terms, one should turn to his performances, in particular *Empire*. Comprised of three pieces – "Sound Distance of a Good Man" (1977), "Surrender" (1979) and "Empire" (1981), with a fourth, "Iron Voices" (1982), added later – the performance deploys dance, music, sculpture, film and expressionistic theater to spectacular effect.[4] "Sound Distance" and "Surrender" are both sculptural/ cinematic triptychs. Each consists of three simultaneous tableaux, arrayed horizontally and spectrally before the audience, that simulate different art forms. "Sound Distance," for example, simulates sculpture, dance, film and voice but in such a way that each is stripped of its conventional supports (e.g., narrative) and known only in its effects (pose, lighting, etc.). Thus is enacted a simultaneous estrangement- and fascination-effect, which enables one to see how these "spectacular" arts operate.

"Sound Distance" corroborates this note of Guy Debord: "The spectacle in general, as the concrete inversion of life, is the autonomous movement of the nonliving."[5] Each art form is represented in terms of an opposition of "live" elements (present, active, etc.) versus "dead" ones (represented, prerecorded, etc.). In the tableau to the left, two spotlit wrestlers slowly revolve on a pedestal in a way which conflates dance and sculpture and opposes the live fact to the æsthetic form of two bodies. The center tableau is a screen on which is projected a *motion* picture of a *still* photograph. Again, an ambiguity of live versus dead, which in turn is echoed by the photograph – of a man, back arched as if just shot, in front of a massively immobile statue of a lion. Finally, in the tableau to the right, a soprano sings in an operatic forte at first with but then against a prerecorded tape of music and voices.

Here, as in the other tableaux, oppositions are posed, blurred, broken down: simulations are let loose, and the order of things – what is present, what is represented – is confused. "Sound Distance" does not reduce each form to a modernist essence; rather, it strips each to surfaces, to effects without origin or referent. (For

example, the film is of a photo of a man posing "as" a Longo relief that was in turn derived from a newspaper image of a fragment of a still from a Fassbinder film.... Sheer text: a production of images without truth content, an effect of immediacy through mediation.) These simulations seduce us in the manner of commodities. "Where the dream is at its most exalted," Adorno wrote of Wagner, "the commodity is closest to hand.... The object that [the subject] has forgotten he has made is dangled magically before his eyes, as if it were an absolutely objective manifestation."[6] In the commodity and spectacle all traces of productive labor and material support are erased; they fascinate us because they exclude us, place us in the passive position of the dreamer, spectator, *consumer*. In the Longo spectacle, we are made aware of this magical manipulation in the very act of consumption.

"Surrender" is also a triptych comprised of two long black runways on either side with three spotlights each and a movie screen in the center. A saxophonist plays and walks jerkily from the right, a film image of a Greek statue fades in and two dancers are revealed on the left. Very slowly – as images – the dancers and saxophonist move down the runways; as they do so, the music changes (from rhythmic to romantic to shrill) as do the styles of the dancers: in effect, they rehearse a short history of postwar popular dance. All this happens under the ægis of a motionless film of the Greek athlete, an image of conflicted investment (humanist nostalgia, authoritarian power). In "Surrender" we are again presented with seductive simulations, in this case, of pop forms of music and dance, dialectical counterparts to the high-art forms in "Sound Distance" and even more manipulative. The title "Surrender" catches this duality nicely: it speaks at once of romantic seduction and authoritarian subjection.

"Culture," we are warned at this point, "is not a burden, it is an opportunity. It begins with order, grows with liberty, and dies in chaos." This chaos, often a pretext for a return to order, is simulated in "Empire." A horizontal rank of spotlights appears amidst smoke and music for brass, strings and organ. The effect – the light colonnade and the fanfare music – evokes the spectacle at its most

explicit. As the rank of lights ascends, the music becomes martial, and male and female dancers in evening dress file in. Slowly the lights turn toward the audience, the music shifts to waltz and the couples dance. More dancers appear in waves as the music accelerates. Soon they are pressed against the audience in one rhythmic mass. Suddenly an air-raid siren sounds, and the performance ends in darkness with a clarion call of trumpets. Like Ravel's *La valse* (1920), "Empire" is a "frantic *danse macabre*"[7] that signals the violent death of a certain world; yet here Ravel's *fin-de-siècle* Vienna has become *fin-de-siècle* New York — and another empire altogether.[8]

In each piece of *Empire* elements of the arts, of popular culture, of spectacle are broken down, stilled, reframed so that we are paradoxically made aware of our own seduction. This in turn allows us to see how the spectacle functions: unlike a typical representation which works via our faith in its realism, spectacle operates via our fascination with the hyperreal, with "perfect" images that make us "whole" at the price of delusion, of submission. We become locked in its logic because spectacle both effects the loss of the real and provides us with the fetishistic images necessary to deny or assuage this loss. Our fascination with spectacle is thus even more total than it is with the commodity. If in the commodity-form "a definite social relation between men" assumes "the phantasmagoric form of a relation between things" (Marx), in spectacle it assumes a relation between *images*. (In spectacle even alienation is turned into an image for the alienated to consume; indeed, this may stand as a definition of spectacle.) This is why for Debord and others spectacle represents the very nadir of capitalist reification: with "capital accumulated to such a degree that it becomes an image" (Debord), social process becomes utterly opaque and ideological domination assured. In an earlier moment in bourgeois culture "the opacity and omnipotence of the social process [was] celebrated as a metaphysical mystery,"[9] transformed into myth (the best example is Wagner); in our own moment it is consumed as an image. Now as Longo represents this reification, recreates our fascination, he de-creates it in part; yet even in these early works there is an ambiva-

lence, and the seduction threatens to consume the skepticism.
Clearly, Longo is fascinated by the rhetoric of public representa-
tions (monuments, statues, reliefs...); again and again he has re-
framed archaic and/or authoritarian forms (though whether to draw
on or to draw *out* the power invested there is not always clear).
Why? Such forms bind a public via symbolic representation to a
leader, an event, a place — to a given history and reality. That such
representations vary in meaning is no surprise; they are "retooled"
in time and from state to state. What is a surprise is that so many
states — fascist, democratic, capitalist, communist — invest, at least
officially, in the same type of representation, the same model of
the historical and the real. (This investment is explored most
astutely in Eisenstein's film *October*.[10] Authority — of the old re-
gime of empire and of the old rhetoric of art — is figured there in
the statue of Czar Nicholas II. With a detailed shot Eisenstein
transforms this monument into an extraordinary symbol of power
— which is then toppled by the revolutionary masses. In one sym-
bolic blow the old imperial and cultural orders fall.)
 Now for Longo to use old forms like the statue and archaic me-
diums like the relief is troublesome, but it hardly means he is cel-
ebratory of state power or *only* nostalgic for its representations.
Rather, he is fascinated by the illusions at work in both discourses
— fascinated by the confidence both of the state in its power (rep-
resented in the statue) and of the opposition in its truth (repre-
sented by the statue toppled). For in this regard the two sides are
really of the same coin: they both invest in representation. And
such investment is naïve: in our world of diffuse subjection and
delirious simulation, how can one hold (whether in statist idolatry
or revolutionary iconoclasm) to such models of power and truth?
One answer seems evident: in the authority of these representa-
tions is concealed a fear — about a lack of authority, a loss of reality.
Faced with this loss, our culture resurrects — morbidly, hysterical-
ly — archaic forms (here the statue may stand for presidential
clichés about America, priestly adages about religion and family,
etc.) in order to recover at least the *image* of authority or a *sense*
of the real. For "it is no longer a question of a false representation

Sergei Eisenstein. *October* (still), 1927-28. (Photo courtesy Film Stills Archive, Museum of Modern Art, New York.)

Robert Longo. *Empire* (detail of "Sound Distance of a Good Man") performed at the Corcoran Gallery of Art, April 15, 1981. (Photo: Bob Epstein.)

of reality (ideology), it is a question of concealing that the real is no longer the real, and thus of saving the principal of reality."[11] It is this fetishism – of the real as well as of the commodity-image – that Longo explores in his simulations.

In 1983 Longo exhibited three large multipartite works of the sort with which he is now identified. *Corporate Wars: Walls of Influence* is a relief triptych with a battle royal of young business types cast in aluminum in the center and two skyscrapers in high wood relief as wings; *Love Police: Engines in Us (The Doors)* consists of two red busts set above a bronze relief of auto wreckage and flanked by two portrait panels of children on either side; and *Noweverybody (for R. W. Fassbinder)* is a four-panel drawing of a rubble-strewn street with a contorted bronze figure set out from the left panel. These three works, based like all Longo images on photographs, can be read singly or as an ensemble, a procession of public representations.

Like props for an expressive film, the two buildings in *Corporate Wars* mime the classic syndrome of modern city life: oppression and vertigo. But Longo's metropolis is not Kafka's or even Lang's: as is clear from the glossy relief surfaces, it trades in seduction and thrill, not estrangement and fear – which suggests a note of parody in *Corporate Wars*. This comes clear in the center relief: a mockery of corporate order, it is also a parody of history presented as an orderly procession of power, the ritual narrative of the state. Here the relief form is used perversely to expose what such history usually conceals – intraclass conflict. But to depict such struggle in mythic form is to render it absurd. Clearly, lived experience has eluded representation – which leads to two further thoughts: how difficult we find it today to image forth our present reality (of world banks, electronic information, etc., etc.) and how dangerous it is that we rely on archaic representations. (Can we really think of multinational affairs in terms of corporate "wars," or of nuclear superpowers in terms of 19th-century nation states?) Longo participates in this archaism deliberately – as if to rehearse the obsolescence of our thought, the inadequacy of our representations.

In any case his revival of old forms like relief and statuary is a

"bombasting" of our new-old artistic forms and public myths. Here we are very far from the modernist enterprise of "truth to materials" and "essence of the medium" – far too from the modern use of myth as order imposed on the chaos of contemporaneity (the famous T. S. Eliot dictum about *Ulysses*).

Longo's is not this serious modern reference as subtle allusion, nor is his the flagrant antimodern reference, found in much contemporary art and architecture, used to resurrect old values (if Longo quotes past art at all, it is only to collide it with a contemporary form – a movie or magazine image, say). In his quotations there is no truth-value: his is a mystification so outrageous as to demystify (corporate wars as a Roman frieze?), as to provoke us to think about the uses of public representations past and present. After all, "what liberates metaphor, symbol, emblem from poetic mania, what manifests its power of subversion, is the *preposterous*."[12]

Love Police: Engines in Us (The Doors), the next station in this passion of public forms, is also a triptych of sorts: a stack of wrecked cars in bronze relief guarded by male and female busts and at the sides by four portraits. Longo refers to the bronze relief as *The Doors*, perhaps with the Rodin *Gates of Hell* and its antecedents in mind. But again a rhetorical collision of representations, not an art-historical connection, is the operation here. *The Doors* portrays a junkyard, not a Last Judgement – in precious bronze an image of scrap metal, in the medium of history a representation of commodity debris.

Above this empire of surplus and waste preside the two red busts. Cast in quasi-social-realist style at its most bombastic, these "love police" evoke the "thought police" of Orwell's *1984*. ("He gazed up at the enormous face.... But it was all right, the struggle was finished. He loved Big Brother.") Yet even this thematic of complicity seems dated; even this representation of the future seems obsolete. Again we see how difficult it is to represent our social reality, how archaic our images (even of the future) have become. Meanwhile, the four portraits – on the left a white boy and an oriental girl and on the right a black boy and a white girl – comprise an image of the Family of Man, democratic perhaps but

potentially dystopian, for the Family of Man is really a benign version of the society of *1984*: both operate on the suppression of difference or its reduction to stereotype. Yet here these policed figures oppose such suppression: pressed up against the frame, each child defies representation, insists on difference, refuses to be seen either as "our child" or as our other.

Noweverybody (for R. W. Fassbinder)[13] explores most fully the contradictions of public representations today. The title suggests an apocalypse in which everyone is represented, but the image is of a public evacuated, if not destroyed; the only figure in the work is the bronze statue posed in violent contrapposto and set out into our space. Here again Longo plays with the hierarchy of representations: the historical scene (devastated Beirut) in a charcoal drawing, the anonymous man in fine bronze: with the result that we cannot quite specify what site or space this is — real, æsthetic, simulated or all three? Reality and representation, cause and effect slip and slide in a way that recalls the delirious reversals of *Gravity's Rainbow*. ("The last image was too immediate for any eye to register. It may have been a human figure, dreaming of an early evening in each great capital luminous enough to tell him he will never die, coming out to wish on the first star. But it was *not a star*, it was falling, a bright angel of death. And in the darkening and awful expanse of screen something has kept on, a film we have not learned to see.... Now everybody — ")

The public representation in *Noweverybody* is not the traditional statue or relief but a documentary image of Beirut. Yet such is the status of public representation today — a diffuse mass mediated by *Time* and TV images. This renders the absence in this street strangely appropriate: an historical scene "without a subject." (One recalls the Straub/Huillet film *History Lessons*, a search for the lost site of history, a circling around a vacated center.) But there is another absence at work here too. This "documentary" image of Beirut is not documentary at all (Longo based the drawing on four different photos). Reality here is a construct (which makes one wonder how images are processed in, say, *The New York Times*), a reality that on the one hand never existed and on the other was "already

written," constructed by the code of what documentary truth looks like.

These speculations lead to the economy of such images and events today: not only how such images function in a discourse of "crisis" to reinject a sense of the real into our lives (which is why images of war are so privileged) but also how such events often seem to be produced in advance as media spectacles (whose importance is judged in terms of "effect" or "impact"). One is confronted with the spectacle of events produced so as to be *re*produced as images and sold — of a history first scripted, then translated into pseudohistorical simulations to be consumed (a process in which Longo intervenes but also complies). This is why such images are so profuse and ephemeral: they must not slow down consumption and so relegate each new event to the used, the superficially known, the already familiar. Indeed, this often seems the function of spectacular representations: to use up events, to erase them in an oblivion of overexposure — or, as Debord writes, "to make his-

Robert Longo. *Noweverybody (for R. W. Fassbinder)*, 1982-83.

tory forgotten within culture." And this, finally, is the rhetorical intent of the Longo simulations: to reenact and so disclose the hyperreality of "a universe everywhere strangely similar to the original—where things are overtaken, duplicated by their own scenario."[14]

One persistent criticism of artists like Longo is that theirs is an art of sheer style concerned only with "look"—a criticism that suggests that we can somehow be free of our own culture, for ours is a culture of seduction, of thrill. Now to be seduced is to be at once lured and excluded by a false image of perfection: such is the mechanism of these Longo works. But this "cult of the glossy image" goes beyond seduction, as Fredric Jameson has noted: "The silence of affect in postmodernism is doubled with a new gratification in surfaces and accompanied by a whole new ground tone in which the pathos of high modernism has been inverted into a strange new exhilaration, the high, the *intensité*."[15] This *intensité*, he implies, is symptomatic of a cultural "schizophrenia," a state that we witness chiefly as a breakdown in our sense of time with the result that the present rises before us in the ultravivid mode of fascination. But this fascination, Jameson insists, is experienced as a loss, an unreality.[16]

Such notions corroborate others noted above: the inadequacy of our historical representations, our inability to image the "unreal" present, the angst-ridden modern city become the delirious surround of consumer capitalism. This simulated world of commodities and spectacles all but defies representation, for representation is based on a principle of equivalence between signs and the real, whereas in simulation signs precede, posit the real. In such a world of loss and irreality, it is almost to be expected that nostalgia would consume us—a nostalgia for realist art (in an age of schizo subjectivity), a nostalgia for monuments (in an age of information), a nostalgia even for spectacle (for the spectacle implies at least some scene, some place). Longo participates in nostalgia just as he participates in fascination, but he is also able to reframe it in order to suggest how it works. Now we must be ambivalent about this enterprise—the way his hyperreal images assume the character of

commodities on display and desiccate the "desert of the real" all the more, the way Longo too may be consumed by spectacle, convinced by the very signs of power that he simulates. But he also reflects for us in these seductive works two important cultural "truths": that "simulation is the master, and nostalgia, the phantasmal, parodic rehabilitation of all lost frames of reference, is our just desserts."[17]

The spectacle is the guardian of sleep. – Debord

In recent years Longo's practice and position have shifted: his collision of images and materials is now even more extreme. To treat these elements "as such" is to suggest that they are historically closed, and Longo does in fact use painting as if it were a ready-made, a given sign to manipulate, not a medium of self-expression or formal innovation. Like sculpture (or any other generic form or material) it enters his work as an emblem or relic – but an emblem of its past *or* of its power? a relic of its death *or* of its resurrection? Are these empty forms tropes of the anachronism of fine art or forms for its libidinal and economic reinvestment? Do they reflect a shoring up of old class representations or the bankruptcy of such cultural guarantees? These questions lead us again to the place of art in a spectacular society.

"For the first time in world history," Walter Benjamin wrote in 1936, "mechanical reproduction emancipates the work of art from its parasitical dependence on ritual."[18] To Benjamin this emancipation signaled not only the decay of the aura of art but also its potential passage from the "domain of tradition" to "another practice – politics." Fifty years later the practice which has reinscribed art is spectacle: of the two historical options posed by Benjamin, the æstheticization of politics (another connection with fascism) has overwhelmed the politicization of art. After all, what "shattered" tradition was a "sense of the universal equality of things" (i.e., the equivalence of capitalist exchange). This shattering thus represents not a "renewal of mankind" but its further alienation, of which

spectacle was and is a major manifestation. For in spectacle the "desire of contemporary masses to bring things 'closer' spatially and humanly" — to overcome estrangement — is falsely fulfilled precisely because what is offered is the very opposite of community, the very instrument of alienation: the commodity. (Again the double-bind of spectacle as both a symptomatic effect of reification and its supposed antidote.) In this way spectacle represents "the point at which æsthetic appearance becomes a function of the character of the commodity";[19] indeed, in spectacle the lost aura of art, of tradition, of community is replaced with the "aura" of the commodity. And it is this transformation, this passage of art through the condition of spectacle, that the work of artists like Longo manifests.

Above I related Longo to the spectacular loss of the real ("the puzzlement of a class over the society it has created to the point where the historically produced reality is perceived and represented mythically");[20] here he must be related to the "becoming-spectacle" of art. Benjamin wrote famously of its historical passage from cult value (art as ritual instrument) to exhibition value (art precisely as work or product). Perhaps now we will have to speak of its image value, of art as a pretext for the spectacular (re)production of effects, of images, of signs — of sign exchange value. Just as the cult artifact interiorized its ritual form (its magic, its aura), so too the work, once delivered up to the marketplace after the collapse of aristocratic patronage, interiorized the commodity form; its value, separated from any (ritual) use value, became based on exhibition and exchange. Could it be that in our society of the spectacle art has begun to interiorize *its* logic, to be based not simply on exchange value but on *sign* exchange value? The work of artists like Longo is permeated by this logic, by the primacy of the image as a form of capital. Not only is its form dominated by processes of image reproduction, but so is its content — these processes are often foregrounded as themes.[21] More important, the structures of identification typical of spectacle — scopic, voyeuristic, patriarchal — inform this art thoroughly.[22]

But these remarks do not answer the initial question: does Longo

collide and invert artistic forms and spectacular images in order to question the conviction-power of the former and to sap the fascination-effect of the latter or to restore the one and exploit the other? No one for whom "the artist is the guardian of culture"[23] can be entirely critical of the ideological character of such forms and images. Yet Longo does seek to dereify cultural representations,[24] only he does not decode or demystify them (in the accepted way of ideological critique) so much as he *remythifies* them. In the manner of Syberberg (the German director of such film-spectacles as *Ludwig, Requiem for a Virgin King*, 1972, *Karl May*, 1974, *Our Hitler*, 1977, and *Parsifal*, 1982) Longo rummages through kitsch images in order to reclaim them as art and "disremembers history in order to rescue it"[25] as hope. This process needs to be unfolded; but first note the relation here to both academic forms and media images. Contemporary artists like Longo do not automatically disdain these things as did the moderns; they embrace them but not solely in the interests of camp or the culture industry. Often they use academic forms and media images in part because this is how history comes to us today — in the form of such myth. As Barthes wrote: "I am only the imaginary contemporary of my own present: contemporary of its languages, its utopias, its systems (i.e., of its fictions)... but not of its history, of which I inhabit only the shimmering reflection: the *phantasmagoria*."[26]

This then is the first step: to see in the phantasmagoria of archaic art forms and contemporary media images the figure of history, however kitsched up. The second step follows: to hold up these forms and images for our contemplation, which is at once fascinated and melancholy. The third step is to invert this "dream-kitsch" (as if literally to indicate the inverted truth that it ideologically expresses), to collide it and so to dereify it. Thus in his tableaux Longo juxtaposes incongruous things (e.g., the black couple in the water and the astronaut on a spacewalk in *Rock for Light*, the baby and the soldiers in *We Want God*) not in order to blow them apart or to disprove one image with the other or even to disenchant us: "the point is not to allow one of the poles of the image to settle into the truth of the other which it unmasks..., but

Robert Longo. *Rock for Light*, 1983.

Robert Longo. *We Want God*, 1983-84.

rather to hold them apart as equal and autonomous so that energies can pass back and forth between them."[27] But why fragment the (false) totality of spectacle only to assemble another? Why not simply deconstruct or destroy these media myths? One reason may be that such images possess a utopian (or at least collective) force and that this force can be "rescued," rewritten in another form. Too many myth-critical artists neglect this utopian aspect of the dialectic; here it is useful to recall how Marx understood religion. It is, he wrote, the "halo" of our "vale of tears" — an illusion but one that, as "an expression of protest against real wretchedness,"[28] reveals a truth. One must see *through* such haloes but also *see* the truth (or at least the desire, the hope) at work in them. But one can also attempt to do more: to rid them of ideological import but retain the utopian charge.

"Utopia" is one of the most corrupted of modern ideologemes, "exposed" by the likes of Orwell and Huxley to be one with dystopia, i.e., with totalitarianism. Yet this celebrated critique (now used ideologically by neoconservatives and others) often has another target: not only Marxism (which is reduced to Stalinism) but *any* social change, *any* alternative future. Recently, Marxist critics have sought to recover the utopian as a subversive concept: they argue that any cultural text, to function ideologically, must first arouse utopian desires, which only then can be defused, controlled, "managed"; indeed, that even the most ideological of these texts (fascist spectacles, Hollywood films, corporate ads) contains some collective drive or fantasy — a utopian moment that can be potentially prised open, revalued, used.[29] Thus it is possible that when Longo draws on his ideological sources, he does not (merely) legitimate them, nor is he (simply) seduced by them. Rather, he fragments and collides them as ideological images in order to reinscribe them as utopian ones. In the soldiers of *We Want God*, for example, there is a figure of collectivity, however perverted, and in the face of the baby in the same work there is a figure of the future, however sentimental. In short, in the most destructive forces of present society — in spectacle (*Empire*), in war (*Noweverybody*), let alone in the most regressive forms of bourgeois culture

— there is a collective, utopian dynamic that can be appropriated. Indeed, to Longo as to Ernst Bloch, the great philosopher of hope, "all passions, nihilistic as well as constructive, embody a fundamental drive towards a transfigured future."[30] Now this future is at once submerged in old social and artistic forms and emergent in new ones. And this may be why Longo collides old modes, mediums, styles, images and materials — in order to reveal, perhaps even recover, the *hope* latent in them.

There are many risks and profound problems with this practice. How can a collision of ideological representations be said to dereify them? After Godard, isn't this collision a cliché — a collage device that, far from critical or utopian, actually replicates our experience of the commodity-filled landscape? More important, a utopian principle of hope may be evoked here but no actual community is engaged. This work has no social basis (other than the dominant class whose representations are collided). Its mix of archaic and futuristic forms attests to this absence — as does its apocalypticism, which is symptomatic of the failure of the dominant culture (and its "artist guardian") to conceive social change in terms other than catastrophe. In the absence of such a social basis utopian desire may well become a will to power — or an identification with the powers that be.

Robert Morris. *Untitled*, 1983-84.

Louise Lawler. *Sappho and Patriarch* ("Is it the work, the location or the stereotype that is the institution?"), 1984.

Subversive Signs

A writer — by which I mean not the possessor of a function or the servant of an art, but the subject of a praxis — must have the persistence of the watcher who stands at the crossroads of all other discourses (trivilias is the etymological attribute of the prostitute who waits at the intersection of three roads).

— Roland Barthes, "Leçon"

The most provocative American art of the present is situated at such a crossing — of institutions of art and political economy, of representations of sexual identity and social life. More, it assumes its purpose to be so sited, to lay in wait for these discourses so as to riddle and expose them or to seduce and lead them astray. Its primary concern is not with the traditional or modernist proprieties of art — with refinement of style or innovation of form, æsthetic sublimity or ontological reflection on art as such. And though it is aligned with the critique of the institution of art based on the presentational strategies of the Duchampian readymade, it is not involved, as its minimalist antecedents were, with an epistemological investigation of the object or a phenomenological inquiry into subjective response. In short, this work does not bracket art for formal or perceptual experiment but rather seeks out its affiliations with other practices (in the culture industry and elsewhere); it also tends to conceive of its subject differently.

The artists active in this work (Martha Rosler, Sherrie Levine, Dara Birnbaum, Barbara Kruger, Louise Lawler, Allan McCollum,

Jenny Holzer, Krzysztof Wodcizko . . .) use many different forms of production and modes of address (photo-text collage, constructed or projected photographs, videotapes, critical texts, appropriated, arranged or surrogate art works, etc.), and yet they are alike in this: each treats the public space, social representation or artistic language in which he or she intervenes as both a target and a weapon. This shift in practice entails a shift in position: the artist becomes a manipulator of signs more than a producer of art objects, and the viewer an active reader of messages rather than a passive contemplator of the æsthetic or consumer of the spectacular. This shift is not new – indeed, the recapitulation in this work of the "allegorial procedures"[1] of the readymade, (dadaist) photomontage and (pop) appropriation is significant – yet it remains strategic if only because even today few are able to accept the status of art as a social sign entangled with other signs in systems productive of value, power and prestige.

The situational æsthetics of this art – its special attention to site, address and audience – is prepared by the varied institutional critique of such artists as Daniel Buren, Michael Asher, Dan Graham, Hans Haacke, Marcel Broodthaers, Lawrence Weiner, John Baldessari and Joseph Kosuth. Yet if Kruger, Holzer et al. inherit the conceptual critique of the given parameters of art production and reception, they do so not uncritically. For just as the conceptual artists extended the minimalist analysis of the art object, so too these later artists have opened up the conceptual critique of the art institution in order to intervene in ideological representations and languages of everyday life. It is important to trace this genealogy (which is *not* intended as a conscription of these mostly feminist artists into a paternal tradition), especially in the face of the contemporary rejection of *all* institutional critique, indeed *all* avant-garde practice, under the cynical pretense that it is now "exhausted" or "academic" – a pretense that abets the forced resurrection of a traditionalist art largely given over to the manipulated demands of the market and the myths of the museum.

As is well known (in part because of a countermemory afforded

by later artists and critics), the investigation of Buren, Asher, Haacke and Broodthaers focuses primarily on the institutional frame, and secondarily on the economic logic, of the modern art object. In critical writings and works in situ, these four artists (among others) have sought to reveal the ways in which the production and reception of art are institutionally predetermined, recuprated, used. Thus since 1965 Buren, with his banners and flags of alternately colored and white (or transparent) stripes set in specific art and nonart spaces for specific periods of time, has stressed the *spatiotemporal* predisposition of the work of art by its institutional frame. And since 1969 Asher, with his (dis)placements of different gallery/museum objects, services and spaces, has foregrounded the *functional* delimitation of all artistic activity sited there. Before his death in 1976, Broodthaers, with his fictitious museums (in which the roles of artist and curator are reversed), allegorically doubled the ways in which the museum *acculturates* heterogeneous objects and activities as art. And finally, since 1970 Haacke, with his detailed exposés of different museums, corporate benefactors and art collectors, has probed the *material* bases of the fine-art apparatus which, repressed, allows for its pretenses of social neutrality and cultural autonomy.

It was the need to expose this false idealism of art that initially led these artists to its "mystical body," the modern museum, for it became clear that its supposedly supplemental role of "preservation, enclosure and refuge" (Buren) actually preconditioned art production, predisposed it to an ideology of transcendence and self-sufficiency.[2] As opposed to the argument that avant-garde practice had attempted to *destroy* the institution of art,[3] these practitioners held that modern artists had not *comprehended* it — its conditions of production, exhibition and exchange; thus Buren in 1970: "20th-century art is still so dependent on 19th-century art since it has accepted, without a break, its system, its mechanism and its function (including Cézanne and Duchamp) without revealing one of its main alibis, and furthermore accepting the exhibition framework as self-evident."[4] To these artists transformation of this apparatus is contingent upon an exposing of its "alibis," to which

101

Marcel Broodthaers. *Départment des Aigles...*, 1968.

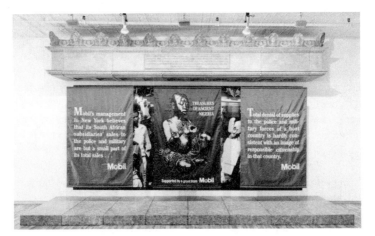

Hans Haacke. *MetroMobiltan*, 1985. (Photo: Fred Scruton.)

the work of Broodthaers and Haacke in particular is committed, and upon a foregrounding of its "framework," in which Asher and Buren are engaged. Clearly this is an important intervention, but it is a necessarily (de)limited one. It is limited, first of all, by its very attention to the institutional frame, which determines its production no less for being exposed in doing so; by its deconstructive posture, this work diminishes its own transformative potential. Secondly, posed within the gallery/museum, it is often referenced to the given forms of art (thus Buren's banners tend to be read in relation to easel painting and Asher's (dis)placements in relation to sculpture);[5] however residual, these categories are sustained even as they are demonstrated to be logically arbitrary, ideologically laden and/or historically obsolete. On a different score, the "scientificity" of this practice tends to present the exhibitional limits of art as socially indiscriminate and sexually indifferent (this is perhaps the most obvious point of critical revision by feminist artists); it also cannot fully account for the systems of circulation in which the art work is involved *after* exhibition — the processes by which it becomes a discriminatory sign. (Of the four only Haacke *thematizes* the intertextuality of art and power, which allows him actually to use the limits of the gallery/museum as a screen for his political attacks.) Finally and familiarly, this practice runs the risk of reduction in the gallery/museum from an act of subversion to a form of exposition, with the work less an attack on the separation of cultural and social practice than another example of it and the artist less a deconstructive delineator of the institution than its "expert."

Such criticisms come after the fact, however, and are less failings of this practice than insights developed from it by later artists. Such legatees of conceptual art as Louise Lawler and Allan McCollum work to literalize more than to abolish the rules of art.[6] Though this may seem its own negation of institutional critique, it is instead its adaption to a code of art that now extends beyond conditions of production and exhibition. (As the "title" of a recent work by Lawler — a photograph of a statue of Sappho and a bust of a patriarch — asks: "Is it the work, the location or the stereotype

that is the institution?") These later artists stress the economic manipulation of the art object — its circulation and consumption as a commodity-sign — more than its physical determination by its frame. And yet no less than the conceptual artists they too seek to reveal the definitional character of the supplements of art, only they tend to foreground the institutionally insignificant (the overlooked) rather than the transparent (the unseen) — functions like the arrangement of pictures in galleries, museums, offices, homes, and forms like press releases and exhibition invitations which, thought to be trivial to the matter of art, in fact do much to position it, to determine its place, reception, meaning.

For Walter Benjamin the "artistic function" as we still know it today — the isolated maker of art objects for the market — is "incidental" to the determination of art by its exhibition (or exchange) value."[7] It is this function, this determination that artists like Buren and Asher, Lawler and McCollum explore. But there is another "function" that emerges when art passes from courtly patronage to the marketplace: the collector; and Lawler and McCollum are no less interested in this beast. In her "Arrangements of Pictures" Lawler reframes in photographs the various ways in which different collectors — museums, corporations, the old and new rich — invest art with value by "sumptuary expenditure," guarantee this value by reference to an institutional code of proper names and affiliations (a lineage of artists and works, a pedigree of owners and experts) and display it as a marker of taste, hierarchy, prestige or simply investment.[8] For his part McCollum is obsessed by the contractually adversarial rapport between artist and collector; this convention has "inspired" him to produce thousands of surrogate paintings — objects which consist solely of a frame, mat and, for an image, a blank, with but minor differences in size and proportion.[9] With these decoys McCollum feeds the hunger for pictures felt by a social group dedicated to the mastery of both accumulation and signification but in such a way as to famish it. For he beckons the desire to spectate and buy — the desire for spectacle, for control through consumption — only to re-present the very emptiness which the picture-fetish is supposed to fill, only to turn the ritual

of mutual confirmation into a charade of (mis)recognition:

> You see yourself insofar as you see me see myself, yet I see myself
> only as I see that I am seen. Our reciprocal surveillance is sustained
> through my artwork, which thrives. Our misplaced assignations of
> authority and our fraudulent identifications are thus mediated into
> a dislocated ritual of self-congratulation, strange looks, and the
> exchange of money for false tokens.[10]

This is not to suggest that these artists neglect the exhibition framework. In a 1978 show at Artists Space in New York, Lawler installed an 1824 painting of a racehorse (borrowed from the New York Racing Association) with two stagelights, one set above the picture and aimed at the viewer, the other directed outside through a gallery window. Here Lawler did indeed make "the element of an exhibition the subject of her production,"[11] but she also posed a funny, provocative conflation of exhibited painting and displayed thoroughbred that exposed them both as tokens in the sumptuary production of value and prestige. (Are not art world and racetrack alike based on a closed system of training and grooming, of handicapping and betting, of investment, competition and auction? After all we do call galleries "stables.") More recently, Lawler and McCollum collaborated on an installation that foregrounded in a different way the status of art as display: 100 hydrocal sculpture pedestals set on bases and bathed in spectacular light, titled *For Presentation and Display: Ideal Settings* (1984). Here the abstraction of modern sculpture, its passage from sited, figurative monument to siteless, autonomous sign,[12] was decoded as its "abstraction" by the commodity-form — as if sculpture had not absorbed its base in the pursuit of æsthetic purity so much as spectacle had swallowed art in the pure display of the commodity. Exhibition value, once productive of an autonomous "artistic function," here consumed it entirely.

This displacement of art by its own support, by its own spectacle, is both a characteristic strategy and a historical demonstration of Lawler and McCollum. The functional indifference of art objects produced in the studio/gallery/museum nexus, remarked by Bur-

en, is shown by McCollum to be no less determined by the market. His "empty" surrogates make explicit the reduction of content to form in the exchange of like for like as well as the general equivalence of objects in a serial mode of production. For her part Lawler makes clear the division of labor that produces the hierarchical functions and generic forms of art (i.e., who creates what for whom in what order of privilege and value). This institutional order of names, services and forms is then confused by the (relative) anonymity of her interventions, by her assumption of different guises (arranger, publicist, etc.), by her production as art of such giveaways as gallery matchbooks (supplements which again seem superfluous but are crucial to the spectacle of art). Yet just as it may be unclear whether the McCollum surrogates "dislocate" the ritual of exchange or replicate the status of the object become sign (delivered up in all its minor difference for our consumption), so too it may be unclear whether the Lawler gambits subvert the mechanisms of art exhibition, circulation and consumption or play them to the hilt. (Do her giveaways update the Duchamp readymade, substitute use value for exchange value, or æstheticize use one more time?) Like a dye in the bloodstream, the work of these artists does delineate the circulation system of art, but it also operates within its terms. If artists like Buren and Asher may become guardians of the demystified myths of the art museum, then artists like Lawler and McCollum may indeed serve as "ironic collaborators"[13] of its market apparatus.

Other artists, no less influenced by conceptual work, have sought to reflect critically on representations outside the art apparatus — and from there to turn back to address discourses within it. For these artists ideology cannot be reduced to one language, then critiqued, or the institution of art to one space, then charted. Such signs and sites are not simply given, open to manipulation only:[14] other meanings can be constructed, other publics sought out. Specifically, the position of the subject must be taken into account, and it is at the point of production of the subject rather than of the art object that this work intervenes. Barbara Kruger takes a feminist tack: through different collisions of images and

Allan McCollum. *Surrogates*, 1979-82. (Photo: Mary Ellen Latella.)

texts she seeks to dispel the specular nature of representations that subject women to the gaze of a univocal male subject, "to welcome a female spectator in the audience of men." Jenny Holzer's is a "situationist" strategy: in a variety of signs she presents opinions, credos, anecdotes in a way which both manifests the domination active in everyday discourse and confounds it by sheer anarchic display. In this way the work of such artists seeks to disorient the law, to call language into crisis. This is what ideology cannot afford, for it tends to operate in language that denies its status as such: stereotypical language. Yet, by the same token, this art cannot afford to take the demonstrations of institutional critique for granted. For without specific attention to its own institution this critical practice, even now well received in the gallery/museum nexus, will be recuperated as yet another avant-gardist exercise, a mere manipulation rather than an active transformation of social signs.

A strong sense of duty imprisons you.
Abuse of power comes as no surprise.
Alienation produces eccentrics or revolutionaries.
Ambivalence can ruin your life.

Both Kruger and Holzer are concerned with the power at work in social representations; Holzer's site of intervention is language. As Barthes wrote:

Language is legislation, speech is its code.... To utter a discourse is not, as is too often repeated, to communicate; it is to subjugate. ... Language – the performance of a language system – is neither reactionary nor progressive; it is quite simply fascist.[15]

In her texts Holzer seeks to undo this "fascism," to display the censurious circularity of our idiolects. Her work suggests not only how language subjects us but how we may disarm it; and here again the tactic is subversive complicity: "it is within speech that speech must be fought, led astray – not by the message of which it is the instrument, but by the play of words of which it is the theater."[16] With Holzer this "theater" becomes a bedlam of voices which mocks the certainty of personal credos and the neutrality of public discourse (e.g., of the mass media). Her texts often function as a dictionary of received ideas to deplete our ideologemes, to rob them of the "fascist" power to compel.

This bedlam-effect is strongest in her *Truisms* (1977), an alphabetical list of statements which together confound all order and logic. First presented as public-information posters on New York City walls (and since as T-shirts, electronic signs, plaques, works of art), the *Truisms* not only "place in contradiction certain ideological structures that are usually kept apart"[17] but set them into open conflict. This contestation-by-contradiction is also contextual, for the *Truisms* expose the false homogeneity of the signs on the street among which they are often placed. An encounter with them, then, is like an encounter with the Sphinx: though one is given answers, not asked questions, initiation into our Theban society is much the same: entanglement in discourse.

This entanglement is a continual displacement – to the point where the reader begins to see, first, that (s)he is not an autonomous individual of free beliefs so much as a subject inserted into language and, second, that this insertion can be changed. The experience of truistic entrapment cedes to a feeling of anarchic release, for the *Truisms* expose the coercion that is usually hidden in language, and once exposed it appears ridiculous. Essentially, this release comes of the recognition that meaning is a rhetorical construction of will more than a Platonic apprehension of an idea – that, however directed toward truth, it is finally based on power. This is not a nihilistic insight: it allows for resistance based on truth constructed through contradiction. And this indeed is the one genuine truth that the *Truisms* express: that only through contradiction can one construct a self that is not entirely subjected. (This truth, that of dialectics, denies its own closure as a truth: this is what makes it true.)

Entanglement in discourse is most extreme in the *Inflammatory Essays* (1979–82), which also appeared first as street posters and then as signs, books, art works. Here again the voices are provocative: imperative commands and subjunctive inducements mix with the impersonal mode of truth. Yet the *Essays* are more arguments than statements, and they do not taxonomize ideologies so much as hyperbolize political rhetoric (in these tracts poles of left and right threaten to implode).[18] Thus even more than the *Truisms*, the *Essays* are concerned with the *force* of language: they exhibit how different ideologies position and pervert us as subjects of discourse. Some voices insinuate, others demand. A few almost convince, but finally each voice is convinced, conquered by its own speech. This closure is of the kind noted by Barthes in political language where reality is prejudged, and naming and judging are one: "A history of political modes of writing would therefore be the best of social phenomenologies."[19] Together the *Truisms* and the *Essays* evoke such a phenomenology.

In 1981 through 1983 Holzer worked (in part with Peter Nadin) on the *Living* series. With these signs and plaques Holzer functioned more in given art spaces; at the same time she drew

more on everyday talk. Indeed, the language of the *Living* series is omnivorous; as one set of texts, "Eating Through Living,"[20] suggests, living *is* eating — consuming and being consumed by speech. In the *Living* texts especially, Holzer meets the subtle subjections active in social discourse with wit and play. That is, she leads language astray. Thus, for example, she may turn our official tongue of efficacy and etiquette into its own parody:

Once you know how to do something you're prone to try it again. An unhappy example is compulsive murder. This is not to be confused with useful skills acquired through years of hard work.

Or she may beguile officialdom with metal signs and bronze plaques that publicize the private ("The mouth is interesting because it is one of those places where the dry outside moves toward the slippery inside") or pronounce the socially repressed ("It takes a while before you can step over inert bodies and go ahead with what you were wanting to do"). A sign is a social directive; a plaque is a marker of official truth which exalts a place or proper name as the very presence of history. The Holzer signs and plaques foil this marking, traduce this official language and proper speech which, like an old chauvinist in the hands of a supple feminist, undoes itself.

Her recent *Survival* series is again more desperate: these short texts about class domination, racial oppression, sexual subjection and nuclear annihilation rebut the Panglossian feel-goodism of the Reagan era. Yet here, as is implicit elsewhere in her work, it is uncertain whether Holzer re-presents the rhetoric of "crisis" — an ideology which can mystify the secure positions of power or alternately "justify" its open authoritarian acts, which can erode activism into fatalism or alternately force it into terroristic acts of its own — or whether she succumbs to it. The same question may be asked regarding the fragmentation of communication into private, often paranoid codes: does Holzer foreground this fragmentation or confirm it? Do her texts resist "the government of individualization"[21] or present us with so many linguistic objects to consume? Like all her work, the *Survival* series is involved in a delegitima-

tion of power, in a rhetorical exposure of its discursive guises and ploys. (Yet today it is as if capitalist power, the very agent of our linguistic fragmentation, feels no great need of legitimation... as long as it supplies the goods.) In this critique, it is said, Holzer is not specific: her work is too anarchic, too atopic. This is not the case with her most recent interventions such as "Sign on a Truck" (nor is it with most of her other work, which is often as "site-specifically" critical of the ideologies of everyday life as conceptual work is of the institution of art). For this project Holzer presented video-tapes by 22 artists concerning the 1984 presidential election on a large sign truck parked at two Manhattan locations on two days just before the November 6th vote. Through the provocation of art and the reaction of passers-by on the street, different political positions were articulated publicly through contradiction. By this direct presentation of political response outside the irresponsibility of the popular media, the work assured both its radicality and its visibility. For it operated within everyday representations and spaces but not at the positions which power establishes through them. It is at such a shifting crossroads that effective resistance can be (pro)posed. Holzer knows this; so does Barbara Kruger.

We are obliged to steal language.

In her panels, posters and books Kruger appropriates photographs (mostly of women) from media sources, blows them up and crops them severely, then combines them with short texts. She has alternated image and text in a way reminiscent of photo-stories, montaged them in a parody of display ads, and combined them in the declarative address of signs in the street. In her first series of photo-texts Kruger re-presented various images (e.g., of a woman slumped among fashion magazines or with her hands clasped in prayer) stamped with single words (e.g., "deluded" or "perfect") that rendered them invalid, took them out of circulation. This "interception" of the stereotype is her principal device, yet in

these early works it was only blasted and its maimed reality not redeemed. Such foreclosure implied not only that such cultural fictions and subject positions are more absolute than they are but also that the artist is in a transcendent relation to them. Aware of these problems, Kruger has suggested that image appropriation, rather than question "the 'original' use and exchange value" of representations, contradict "the surety of our initial readings" and strain "the appearance of naturalism," may in fact confirm them.[22] Her later work evades this closure, for in its oscillation "from implicit to explicit, from inference to declaration"[23] neither photograph nor text, neither connotation nor denotation is privileged as a stable site or mode of truth; in fact, the usual coordination of the two (as employed in the media to fix unstable meanings) is undone. More important, her photo-texts shift address and block identification in a way that allows for no certain or essential subject position. This is not to say that they are arbitrary. Her reminting of the image is as motivated as her target is specific: the transparent naturalism of masculine readings which position women as objects of scopophilic pleasure ("We are being made spectacles of"); as figures of nature or otherness which support the patriarchal order of things ("We won't play nature to your culture"); as fetishistic images which serve to allay the anxiety ("I am your immaculate conception") about the castration that woman otherwise suggests to man ("I am your almost nothing"). It is this phallocentric surety that Kruger literally contradicts. First, she sets up "suave entrapments" with the very representations which position "woman as image and man as bearer of the look,"[24] then manipulates that pose, catches out that gaze. Though as seductive as any mass-media ad, her photo-texts work to reflect the masculine look that subjects women via a false feminine ideal and to block the feminine identification that submits to this construct.

The women in the images used by Kruger are most often posed or pursued but in either case passive, there to be gazed upon, saved, found out, used. These positions of capture presuppose a male subject who seeks to fix his image of desire and/or who identifies with the assumed protagonist of the situation. This ac-

cords with the ways in which Hollywood cinema plays upon the scopophilic drives and ego identifications of the masculine viewer, as analyzed by Laura Mulvey in her celebrated essay "Visual Pleasure and Narrative Cinema" (1975). Yet just as these processes are often at odds, so too the figure of woman is often conflicted. Mulvey: "The woman as icon, displayed for the gaze and enjoyment of men, the active controllers of the look, always threatens to evoke the [castration] anxiety it originally signified."[25] There are, she argues, two conventional "avenues of escape": a narrative exposing of the woman as flawed, incomplete (as in Hitchcock's *Vertigo*) or a spectacular fetishizing of her as a "whole," an erotic image (as in von Sternberg's Marlene Dietrich films). No doubt because they are culturally general, these two scenarios recur in the Kruger photo-texts, where they are restaged precisely so that sadistic sleuthing ("You destroy what you think is difference") and fetishistic fascination ("You are seduced by the sex appeal of the inorganic"), voyeuristic control ("You molest from afar") and spectacular pleasure ("We have received orders not to move") may be apprehended, refused. This disruption is effected through a shattering of the image (the fetish-fragment fragmented again) and/or through an indictment of the masculine voyeur/fetishist as well as an injunction to the feminine spectator not to be taken in. In effect, what "culinary theater" was to Brecht, "spectacle" is to Kruger: a subject-effect to estrange.

Such disruption might also be grasped by general reference to the Lacanian orders of the Imaginary and the Symbolic. Lacan spoke of the Imaginary in terms of a dialectic of self and image, of an "immediate opposition between consciousness and its other in which each term becomes its opposite and is lost in the play of reflections,"[26] and of the Symbolic in terms of the mediation of language (the intercession of the Name-of-the-Father) whereby one emerges from the immediacy of the Imaginary to be inserted as a subject into social structures. (It is at this point that primary repression occurs, with its effect: the unconscious.) As the phallus is the privileged signifier in this order, the presence around which its structures are diacritically arrayed, the female obviously has a

particularly problematic relation to the Symbolic. I make this simplistic summary to suggest that Kruger attempts both visually to upset the Imaginary captures of the ego and textually to contest the phallic privileges of the Symbolic. Ideally, her usurpations not only jolt the Imaginary projections and Symbolic prerogatives of the masculine viewer but also foreground for the feminine viewer that her subjected position is not an essential one. Potentially, then, with the Imaginary investments of both viewers thus blocked, the different relation of each to the Symbolic – to insertion as subjects in patriarchal society – may be recognized and reassessed.

For Lacan, as soon as the subject is represented in language, (s)he is excluded or absented from it, and so is literally divided by it. [27] With her excessive use of pronouns, Kruger makes this linguistic division all but physical, and so again disturbs the pretense of a certain, centered subjecthood. This decentering is not indifferent: though her address constantly shifts (from I to You to We), its inclusions and exclusions are consistent (the You that stands accused is masculine, the We that is welcomed is feminine). Nevertheless, the subject *positions* in her work are not fixed. Indeed, in her recent pieces, in which with a lenticular screen two opposite photo-texts are disclosed from two different positions, the linguistic decentering of the subject becomes an actual displacing of the viewer. The stake of her art is here made explicit: the positioning of the body in ideology. Thus the imperative in her work to contest the stereotype, for, as Craig Owens has noted, it is in the stereotype that "the body is apprehended by language, taken into joint custody by politics and ideology."[28] Thus too the insistence in her address on the here and now, on the spatial and temporal relations of the lived, for it is precisely this bodiliness which traditional western art conspires with stereotypical mass culture to efface. (Norman Bryson: "Western painting is predicated on *the disavowal of deictic reference*, on the disappearance of the body as site of the image, and this twice over, for the painter, and for the viewing subject.")[29] In her work Kruger resists this disavowal of the body, for with it goes a disavowal of the productive, of the transforma-

tive – in short, of the individual in process and of history subject to change. At the same time, she rejects the manipulation of the female body as an image for masculine delectation.

Her critique, then, is not a single or simple sabotage: it seeks to catch our various desires and disciplines that position the body and invest representation. Thus, for example, Kruger may stamp a text like "Charisma is the perfume of your gods" over a photo of a coin with two noble profiles, and so convoke ideologemes that are usually separated – the patriarchal rhetoric of the republic and the authoritarian cult of personality, or the historical experience of artistic aura and the contemporary manufacture of stars, politicians, artist geniuses. Celebrated as her work has become, it has had to be reflexive in this way; indeed, her recent pieces are concerned as much with the economic manipulation of (her own) art as with sexist subjection. This finally is the interest of her work: the reflexivity with which it considers the discourses – of high art and mass culture, of sexual politics and cultural power – with which it is engaged. Though it may often seem insufficiently specific, it is this reflexivity which allows her work to circulate, and not be totally recuperated: "I will not become what I mean to you."

Barbara Kruger. 1980.

(Left) Jenny Holzer. Plaque from the *Living* series, 1981-83.
(Right) Jenny Holzer. *Inflammatory Essay*, 1979-82.

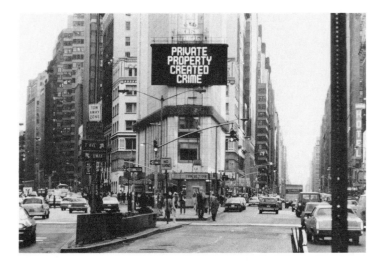

Jenny Holzer. Selection from *Truisms* on Spectacolor Board, Times Square, 1982.

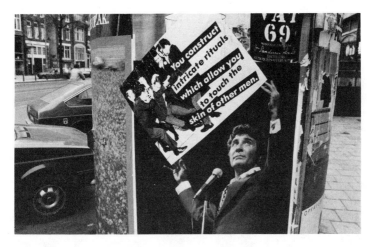

(Top) Barbara Kruger. 1984. *(Bottom)* Barbara Kruger. 1980.

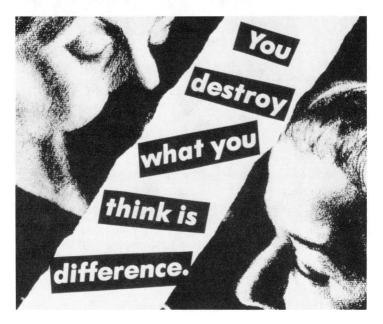

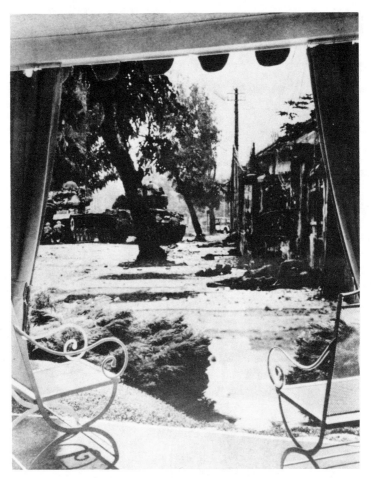

Martha Rosler. *Bringing the War Home: Patio View,* ca. 1968. (Photograph from original black and white and color-photo montage, from *Scenes from Modern Life.*)

II. (POST)MODERN POLEMICS

109. Arch of Constantine, Rome

110. Tanya billboard, Las Vegas

Photo pairing from Robert Venturi, Denise Scott and Steven Izenor, *Learning from Las Vegas* (Cambridge, Massachusetts: MIT Press, 1977), pp. 124 and 125.

(Post)Modern Polemics

In American cultural politics today there are at least two positions on postmodernism now in place: one aligned with neoconservative politics, the other related to poststructuralist theory. Neoconservative postmodernism is the more familiar of the two: defined mostly in terms of style, it depends on modernism, which, reduced to its worst formalist image, is countered with a return to narrative, ornament and the figure. This position is often one of reaction, but in more ways than the stylistic – for also proclaimed is the return to history (the humanist tradition) and the return of the subject (the artist/architect as *auteur*). Poststructuralist postmodernism, on the other hand, assumes "the death of man" not only as original creator of unique artifacts but also as the centered subject of representation and history. This postmodernism, as opposed to the neoconservative, is profoundly antihumanist: rather than a return to representation, it launches a critique in which representation is shown to be more constitutive of reality than transparent to it. And yet, however opposed in style and politics, it is my contention that these two concepts of postmodernism disclose a historical identity.

I

In art and architecture neoconservative postmodernism is marked by an eclectic historicism, in which old and new modes and styles (used goods, as it were) are retooled and recycled. In architecture this practice tends to the use of campy pop-classical order to deco-

rate the usual shed (e.g., Charles Moore, Robert Stern) and in art to the use of kitschy historicist references to commodify the usual painting (Julian Schnabel is the inflated signifier here); indeed, the classical often returns as pop, the art-historical as kitsch. In what way is such work *post*modernist? It does not argue with modernism in any serious way: to a great degree its postmodernism seems a front for a rapprochement with the market and the public – an embrace that, far from populist (as is so commonly claimed), is alternately elitist in its allusions and manipulative in its clichés. Or as Robert Venturi once remarked, "Americans don't need piazzas – they should be home watching TV." Now this notorious phrase reveals a truth: there is scarcely any place of public appearance in the megapolis or metroplex today. And still we are given art and architecture that pretends to speak to such a realm, and the public is mystified all the more. (In what way does the historicism of Philip Johnson's AT&T Building represent the present reality of this multinational telecommunications corporation?)

The postmodernist status of such art and architecture is unsure on other grounds too, for reactions against the modern were common enough within its own period: think, for example, of the *rappel à l'ordre*, the traditionalist turn of art in the late 1910s and '20s (Picasso, Braque, Picabia; Severini and Carrà – both of whom, not untypically, embraced fascism; Malevich and Rodchenko . . .). As with such antimodern returns, so with this postmodern one: however parodic or ambivalent, it comes in the guise of humanism, in the name of authority. This return to history, then, must be questioned. What, first of all, is this "history" but a reduction of historical periods to ruling-class styles that are then pastiched? A history of victors; a history, moreover, which denies the historicity of forms and materials – an *a*history, in fact. And what, secondly, does this "return" imply if not a flight from the present? Clearly, this was the thrust of eclectic historicism in 19th-century art and architecture (especially British): a flight from the modern – in its romantic form, from the industrial present into a preindustrial past; in its neoclassical (academic) form, from lived class conflict to the ideal realm of myth. But then this flight expressed a social

protest, however dreamy; now it seems symptomatic of sheer *post-histoire* escapism.

Of course, this postmodern return to tradition is conceived otherwise — as a redemption of history. Yet, I would argue, it is only in certain works of modernism, so commonly seen as a- or antihistorical, that such redemption is glimpsed — and through critique, not pastiche. What I have in mind are works that recall a repressed source or marginal sign-system in such a way as to disturb or displace the given institutional history of an art or discipline. This critical strategy is various and strong in art from David through Manet to Frank Stella and Jeremy Gilbert-Rolfe, and in criticism from T. S. Eliot to Harold Bloom. Such displacement — an illumination of a demoted past — has a political, even utopian edge (as is clear from the writings of Walter Benjamin and Ernst Bloch). Yet, in Anglo-American culture, this critical enterprise is often reduced to an abstract, ahistorical opposition between "tradition and the individual talent." (In architecture this redemptive operation meets its historical closure in a work like Philip Johnson's Glass House (1949), in which the reinscription of historical forms becomes a matter of dandyish, narcissistic connoisseurship.)[1]

If in this postmodernism history is not returned, let alone redeemed, how is it treated? Theodor Adorno once remarked that modernism does not negate earlier art forms; it negates tradition *per se*. Almost the opposite is the case with such postmodernism. For one thing, the use of pastiche in postmodern art and architecture deprives styles not only of specific context but also of historical sense: husked down to so many emblems, they are reproduced in the form of partial simulacra. In this sense, "history" appears reified, fragmented, fabricated — both imploded and depleted (not only a history of victors, but a history in which modernism is bowdlerized). The result is a history-surrogate, at once standard and schizoid. Finally, such postmodernism is less a dialectical supercession of modernism than its old ideological opponent, which then and now assumes the form of a popular front of pre- and antimodernist elements.

This popular front, it is important to see, is more than a stylistic

program; it is a cultural politics, the strategy of which is to reduce modernism to an abstraction (e. g., in architecture the International Style and in art formalist painting) and then to condemn it as a historical mistake. In this way, the adversarial, even negational aspects of modernism are suppressed: apparently, in the neoconservative scheme of things, culture after modernism is to be affirmative — which means, if postmodern architecture is any indication, a more or less gratuitous veil drawn over the face of social instrumentality.[2] Such a reading seems shrill, but consider the implications of a program which elides pre- and postmodern elements. Not only are the signs of modernism excised, but lost traditions are imposed on a present which, in its own contradictions, is far beyond such humanist pieties. Thus we have the manufacture of "master" artists and works in which the denial of historicity is mistaken for transcendence, and in which the corrosive effects of time are disavowed by allusion to canonical sources.[3] Such a program of reference to quasi-cultic traditions, moreover, is not a historical novelty: it is often used to beautify reactionary politics (most extremely with the fascists).

It is in regard to this return to tradition (in art, family, religion, etc.) that the connection to neoconservatism proper must be made. For in our time it has emerged as a new political form of antimodernism: neoconservatives like Daniel Bell charge modern (or adversary) culture with the ills of society and seek redress in a return to the verities. In this sense, they oddly overrate the effectivity of culture; for, according to them, it is largely modernism — its transgressions, scandals, intensities — that has eroded our traditional social bonds. Now such erosion cannot be denied (nor should it be, at least on the left, for it is as liberative as it is destructive), but what is its real, salient cause? The "shock" of a Duchamp urinal, long since gone soft (say, with Oldenburg), or the decoded "flows" of capital? Certainly, it is capital that destructures social forms — the avant garde only fenced with a few old artistic conventions.

Yet here the neoconservatives confound matters to advantage. First, cultural modernism is severed from its base in economic

modernization and then blamed for its negative social effects (such as privativism). With the structural causality of cultural and economic modernity confused, adversarial modernism is denounced and a new, affirmative postmodernism proposed.[4] This is, if you like, the classic neoconservative position: there are variants. For example, though Hilton Kramer also views avant-gardism as more or less infantile, he is not so sanguine about postmodern production, most of which he sees as kitsch. This leaves him to uphold modernism as the new/old "criterion" — but a modernism long ago purged of its subversive elements and set up as official culture in the museums, the music halls, the magazines. Meanwhile, the politics of this program remain much the same — mainstream neoconservative.

If culture from the neoconservative position is a cause of social anomie, it can also be a cure. Thus, in the old American tradition of therapy over analysis, tendentious diagnoses are offered and proscriptive prognoses proposed. (Robert Stern has called for a new "cultural synthesis" — a recipe of such conservatives as John Gardner in fiction, Daniel Bell in social criticism, and Stern in architecture.)[5] In short, symptoms are taken for diseases and treated cosmetically. These cosmetics, however, finally reveal more contradictions than they resolve. For example, urban contextualism is to postmodern architecture what traditionalism is to postmodern painting and sculpture — a program that seeks to recoup the ruptures of modernism and restore continuity with historical forms. (Leon Krier is perhaps the most extreme contextualist at work today: basically, his paradigm is the urban fabric of 19th-century Paris — the street, the square, the quarter.) Such contextualism derives from a reactive reading of modernism: its ruptures were posed against historicism, not history — in order to transform the past in the present, not to foreclose it. But the disruptions of the modern age are real enough, and the rhetorical urgency of contextualism owes much to the "catastrophe" of modern architectural utopias.

Surely no one can deny that, when executed, the great modern utopian projects were changed utterly. Manfredo Tafuri has argued

Leon Krier. Ærial perspective and plan for the completion of Washington, D.C., 1985.

that these utopias actually served the ends of both "social planning" and capitalist development (in this sense, utopia equals *tabula rasa*).[6] And Robert Venturi has stressed how such projects were reduced to autonomous monuments — to fragments that rent rather than transformed the social fabric. Strangely, then, these two very different critics — the Marxist Tafuri, the pop architect Venturi — agree, and indeed, as Fredric Jameson has noted, the Tafuri and Venturi positions are dialectically one: both read architectural modernism as a failure, from which "Tafuri deduces the impossibility of revolutionary architecture, whereas Venturi...decides to embrace the other side of the opposition, the fallen city fabric of junk buildings and decorated sheds of the Las Vegas strip."[7]

But then we must ask what contextualism, posed against such utopianism, intends. Is it not, in part, a policy that would reconcile us to our Las Vegases – to the chaos of contemporary urban development? Here the preservationist aspect of contextualism appears in a new light, as both a symptomatic reaction to this chaos and a sympathetic policy that acts as its public (relations) cover or compensation. Thus, as landmarks play the part of "history," postmodern façades assume the role of "art." And the city, as Tafuri writes, is "considered in terms of a superstructure," with its contradictions resolved – that is to say, dissimulated – "in multivalent images."[8] In this way such architectural postmodernism exploits the fragmentary nature of late-capitalist urban life; we are conditioned to its delirium, even as its causes are concealed from us.

So: on one side, a delight in the contemporary cityscape of capital (e.g., Las Vegas Venturi); on another, a nostalgia for the imageability – even the typology – of the historical city (e.g., Paris Leon Krier); and mixed in with both, the fabrication of more or less false (i.e., inorganic, commercial) regionalisms. Here, the contradictions of neoconservative postmodernism begin to cry out, and in relation to history they fully erupt. We have noted that this postmodernism privileges *style* – in the sense both of the signature style of the artist/architect and of the "spirit" of an age. This style, articulated against "less is a bore" modernism, further proclaims a return to *history*. Thus the postmodern zeitgeist. Yet nearly every postmodern artist and architect has resorted, in the name of style and history, to pastiche; indeed, it is fair to say that pastiche is the official style of this postmodernist camp. But does not the eclecticism of pastiche (its mix of codes) threaten the very concept of style, at least as the singular expression of an individual or period? And does not the relativism of pastiche (its implosion of period signs) erode the very ability to place historical references – to think historically at all? To put it simply, this Postmodern Style of History may in fact signal the disintegration of style and the collapse of history.[9]

My point is a basic one: dialectically – which is to say, necessarily and in spite of itself – neoconservative postmodernism is revealed

by the very cultural moment it would otherwise flee. And it in turn reveals this moment as marked not by a renascence of style but by its implosion in pastiche; not by a return of a sense of history but by its erosion; and not by a rebirth of the artist/architect as *auteur* but by the death of the author — as origin and center of meaning. Such is the postmodern present of hysterical, historical retrospection in which history is fragmented and the subject dispersed in its own representations.

II

Lest this criticism seem too tilted, I would argue much the same about poststructuralist postmodernism, with this proviso: that it assumes this fragmentation of history, this dispersal of the subject as given — again, not without its own ideological reasons. But this is to anticipate: we must first see how the two postmodernisms are different.

They differ, first of all, in opposition to modernism. From the neoconservative position, modernism must be displaced because it is catastrophic; from the poststucturalist position, because it is recuperated. The two also differ in strategy: the neoconservative opposition to modernism is a matter chiefly of style, of a return to representation, whereas the poststructuralist opposition is of a more epistemological sort, concerned with the discursive paradigms of the modern (e.g., the ideology of purely formal innovations).[10] But more important here is the mutual opposition of these two postmodernisms. From the poststructuralist position the neoconservative style of history is doubly misconceived: style is not created of free expression but is spoken through cultural codes; and history (like reality) is not a given "out there" to capture by allusion, but a narrative to construct or (better) a concept to produce. In short, from the poststructuralist position, history is an epistemological problem, not an ontological datum.

It is on the question of representation, then, that the two postmodernisms differ most clearly. Neoconservative postmodernism

advocates a return to representation: it takes the referential status of its images and meaning for granted. Poststructuralist postmodernism, on the other hand, rests on a critique of representation: it questions the truth content of visual representation, whether realist, symbolic or abstract, and explores the regimes of meaning and order that these different codes support. It is this critique of representation that aligns this postmodernism with poststructuralism. Indeed, it is difficult to conceive the one without the other. As Jameson writes:

> The contemporary poststructuralist æsthetic signals the dissolution of the modernist paradigm – with its valorization of myth and symbol, temporality, organic form and the concrete universal, the identity of the subject and the continuity of linguistic expression – and foretells the emergence of some new postmodernist or schizophrenic conception of the artifact – now strategically reformulated as "text" or "écriture," and stressing discontinuity, allegory, the mechanical, the gap between the signifier and signified, the lapse in meaning, the syncope in the experience of the subject.[11]

This theoretical redefinition of the artifact can also be seen as a passage from modernist "work" to postmodernist "text." I use these terms heuristically: "work" to suggest an æsthetic, symbolic whole sealed by an origin (i.e., the author) and an end (i.e., a represented reality or transcendent meaning); and "text" to suggest an a-æsthetic, "multidimensional space in which a variety of writings, none of them original, blend and clash."[12] The difference between the two rests finally on this: for the work the sign is a stable unit of signifier and signified (with the referent assured or, in abstraction, bracketed), whereas the text reflects on the contemporary dissolution of the sign and the released play of signifiers. For our purposes, however, only two questions are important here: how does the postmodernist text differ from the modernist work as a model of discourse? And how does (poststructuralist) textuality differ from (neoconservative) pastiche as a form of representation?

After the failure of utopian, protopolitical modernism (e.g., constructivism, the Bauhaus) on the one hand, and the recuperation of the transgressive avant garde (e.g., dada, surrealism) on the

other, a new model of modernism was needed. (There were, of course, more critical pressures: the diaspora of the moderns under fascism, the suppression of productivist art under Stalin, the rise of an instrumental mass culture far beyond the blandishments of kitsch, etc.) The principal response (at least in the United States) was an apolitical, adamantly high-cultural paradigm of art, which shifted the discursive "essence" of modernism from utopianism and transgression to æsthetic purity. "The essence of Modernism, as I see it," Clement Greenberg wrote retrospectively in 1965, "lies in the use of the characteristic methods of a discipline itself not in order to subvert it, but to entrench it more firmly in its area of competence."[13]

Here, in brief, is the model that came to dominate American art and criticism at mid-century – a self-critical program (Greenberg refers specifically to the Enlightenment) pledged to maintain the high quality of past art in current production; to stem the reduction of art in general to entertainment; to ensure the æsthetic as a value in its own right; and to ground art – the medium, the discipline – ontologically and epistemologically. On the Greenbergian account, modern art turned within "to keep culture *moving*," to resist, on the one hand, the Alexandrianism of the academy and, on the other, the debasement of kitsch.[14] But as its criticality declined into rhetorical exercise without repercussive effect, this turn within atrophied into withdrawal pure and simple. And postmodernist art is posed, at least initially, against a modernism become monolithic in its self-referentiality and official in its autonomy.

But postmodernism also derives from this modernism, and nowhere is this more apparent than in its discursive orientation: for what self-criticism is to modernist practice, deconstruction is to postmodernist practice. If the "essence" of modernism is to use the methods of a discipline in order "to entrench it more firmly in its area of competence," the "essence" of postmodernism is to do the same but in order, precisely, to subvert the discipline. Postmodernist art "disentrenches" its given medium, not only as an autonomous activity but also as a mode of representation with assured referential value and/or ontological status. In general, post-

modernist art is concerned not with the formal purity of traditional artistic mediums but with textual "impurity" – the interconnections of power and knowledge in social representations. It is in these terms that the art object – indeed, the art field – has changed, as the old Enlightenment decorum of distinct forms of expression (visual versus literary, temporal versus spatial), grounded in separate areas of competence, is no longer obeyed. And with this destructuring of the object and its field has come a decentering of the subject, both artist and audience.

As paradigms, then, the postmodernist text and the modernist work are distinct, but what of (poststructuralist) textuality and (neoconservative) pastiche? Stylistically and politically, the deconstruction of an art or discipline is quite other than its instrumental pastiche, and a critique of representation is wholly different from a recycling of pop- or pseudohistorical images – but epistemologically, how distinct are they?

Take as examples of opposed postmodernist practices the "decomposed" architecture of Peter Eisenman and the cubistic-classical architecture of Michael Graves, or the multimedia image-spectacles of Laurie Anderson and the macho painterly confections of Julian Schnabel. Both Graves and Schnabel pastiche art-historical and pop-cultural references; but though they collide different signs, they do so not to question them as representations or clichés. (For example, Graves seems to invest as much meaning in his typical keystone motif as Schnabel does in his thoroughly reified expressionism.) Indeed, in the work of both, modernist practices of critical collage have become mere devices, instrumental tricks: the sign, fragmented, fetishized and exhibited as such, is resolved in a signature look, enclosed within a frame. The traditional unity of architecture or painting as a discipline is reaffirmed, not challenged – and the same goes for the old sovereignty of the architect and artist as expressive origin of unique meaning.

The practices of Eisenman and Anderson are articulated quite differently. Unlike Graves, Eisenman reflects on architecture not as a repository of stylistic attributes to be collaged, but as a discipline to be deconstructed precisely with its own methods. In ef-

fect, he uses the very modes of architectural representation (primarily the axonometric drawing and model) to generate the actual structure – which is thus both object *and* representation. And unlike Schnabel, Anderson uses the art-historical or pop-cultural cliché against itself, in order to decenter the masculine subject of such representation, to pluralize the social self, to render cultural meanings ambiguous, indeterminate.

This said, do these opposed practices of textuality and pastiche differ in any deep *epistemic* way? Whatever else is claimed for them, is not the subject decentered, representation disentrenched, and the sense of history, of the referent, eroded in both? Granted, one may explore the traditional language of art or architecture critically, the other exploit it instrumentally; but both practices reflect its breakdown. If this is the case, then the neoconservative "return" to the subject, to representation, to history may be revealed – historically, dialectically – to be one with the poststructuralist "critique" of the same. In short, pastiche and textuality may be symptoms of the same "schizophrenic" collapse of the subject and of historical narrativity – as signs of the same process of reification and fragmentation under late capitalism.[15] And if these two models of postmodernism, so opposed in style and politics, are indeed historically one, then we need to consider more deeply what (post)modernism might be – how to periodize it, how to conceive it as a problematic. That is beyond the scope of this essay, but the questions that arise in the (post)modern condition are clear: the status of the subject and its language, of history and its representation.

III

To end here, however, is too neat, for this formulation is flawed. To speak of a fragmented subject is to presuppose a prior moment or model in which the subject is whole and complete, not split in relation to desire or decentered in relation to language; such a concept, whether heuristic or historical, is problematic. On the

Michael Graves. *Whitney Museum of American Art*, 1985.
(Photo: Pascall/Taylor.)

Peter Eisenman. *Project Romeo and Juliet Castles*, 1985.
(Photo: © Mark C. Darley.)

right, it leads to the charge of cultural decay and the call for the old pragmatic, patriarchal self. On the left, reactions are only somewhat less troublesome. Denunciations of our culture as regressive or schizophrenic may preserve this bourgeois subject, if only in opposition, if only by default. (Even for Adorno, the most dialectical of the Frankfurt School, this subject often seems the counterterm of the decay of the ego in the culture industry, of the psyche penetrated by capital.) Meanwhile, celebrations of this dispersal, the radical position of various French critics, may only collude with its agents; indeed, the result may be a position-paper on such cultural fragmentation, not its counterdiscourse. Then there is always ambivalence: on the American left, artists and theorists are so split on this issue as to exhibit the very schizophrenia that is in question here – an inability to mediate subject and other, to resolve them either dialectically or symbolically.

For some, however, this double-bind does not exist, and so we must ask: what *is* this subject that is supposedly dispersed? By way of an answer I want to refer to a few symptomatic works of art. *Brother Animal* (1983) is a typical painting by David Salle, a formulaic display of dead, dispersed images with charge enough only to damp out any connection or criticality. Like many others, Salle parades this schizo dispersal of the subject as a theme, exhibits it as a form of fetishistic fascination – but from a position so alienated as to be beyond despair. This is fragmentation at its most entropic, most cool, its zero degree, and indeed the title narrates a regression to a presymbolic or schizophrenic state. In our culture this state is usually the preserve of woman – as nature, as other, as object – and the opacity of representations of woman by Salle suggests this is the case here as well.

In *The Exile* (1980), a representative work by Schnabel, regression is disguised in its usual form, the romantic convention of artist-as-outsider. Schnabel often paints martyr-figures – ones that testify, hysterically so, to heroism even as they narrate its loss. (The last irony, however, may be his: so instrumental is the myth of the artist-as-exile to both the mass-cultural and art-market apparatuses that the bacchic artist has returned, as indeed the hero is pictured

David Salle. *Brother Animal*, 1983. (Photo: Dorothy Zeidman).

Julian Schnabel. *The Exile*. 1980.

here, with the horn of plenty.) Such art revives the clichés of the masterwork, the seminal artist; it requires such rhetoric as its supplement and support. Yet this mythology is exposed here and elsewhere; it is self-deconstructive. Reification and fragmentation are revealed even as they are disavowed. This disavowal comes today in many forms: in the unity of traditional medium or titular theme, the device of the frame, the persona of the artist, etc. Here it has to do with the fetishistic nature of the painting, the antlers in particular. (Schnabel also paints on velvet and furs, fetishistic materials par excellence.) What is a (Freudian) fetish? Simply put, it is an object that serves as a substitute for the apparently castrated penis. In other words, a substitute that covers up a perceived lack — a lack, if you like, of mastery. But more, it is a substitute that denies sexual difference.

Here, then, we begin to see what is at stake in this so-called dispersal of the subject. For what is this subject that, threatened by loss, is so bemoaned? Bourgeois perhaps, but patriarchal and phallocentric certainly. For some, for many, this may indeed be a great loss, a loss which leads to narcissistic laments and hysterical disavowals of the end of art, of culture, of the west. But for others, precisely for Others, it is no great loss at all.

A sleek and whole identity

Marie Yates. *The Missing Woman* (detail), 1984.

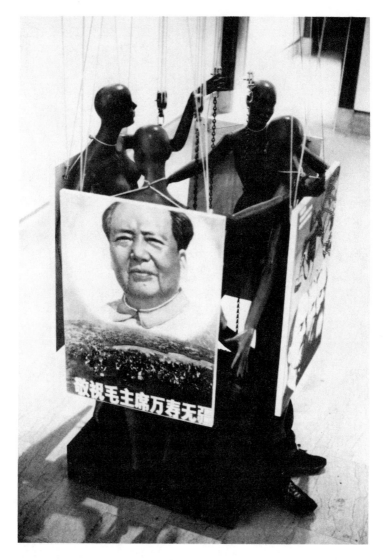

Vito Acconci. *Raising the Dead (And Getting Laid Again)*, 1980.

For a Concept of the Political
in Contemporary Art

Consider these two emblematic dates: 1983, the centenary of
Marx's death, and 1984, the dread year of Orwell's dystopia. In
what way do they locate the cultural politics of the present? For
many, the first date marks the failure of Marxism as an historical
science; and so we are offered, on right and left alike, various
post-Marxisms that proclaim the end of ideology or of the economic
as determinant. "1984" slips along a very different chain of signifi-
ers (totalitarianism, communism...) that signals, to conservatives
and liberals alike, "the present danger" of Marxism as a social sys-
tem – a reactionary reading that tends to reduce socialism to
Stalinism.

So construed, "1983" and "1984" hardly locate the present – ex-
cept perhaps as a moment of ideological polarity and historical
dislocation. But even this dislocation offers insights, for it suggests
the febrility of our historical grasp, symptoms of which are every-
where (the consumption of history in media images by an en-
chanted public, the profusion of pastiche in art, architecture,
fiction, film).[1] And yet a diagnosis is tricky: Is this fragmentation
an illusion, an ideology of its own (of political "crisis," say, versus
historical "contradiction")? Is it a symptom of a cultural "schizo-
phrenia" to be deplored? Or is it, finally, the sign of a society in
which difference and discontinuity rightly challenge ideas of total-
ity and continuity?

For the moment we need only retain a sense of this dislocation,

for it is this that has compelled a contemporary rethinking of the ratios between the cultural and the political, the social and the economic. This rethinking often takes the form of a critique of Marxian concepts of class and of the means of production, prompted in part by a perceived significance of the cultural in society. Below I want to consider these issues in terms of recent western political art. How does the critique of the concept of class relate to the social-realist representation of a given subject of history? How does the critique of the productive apparatus bear on modernist programs like productivism that urge its cultural transformation? And how, if the cultural does pervade social exchange, does this invasion affect the strategic position of political art? That is, if it can no longer be conceived as representative of a class, materially productive *or* culturally vanguard, how and where is political art to be posed?

Marxist concepts, however self-critical or scientific, are subject to historical limits; this may be particularly the case with the Marxist stress on (the proletarian) class as subject of history and on the means of production as object of revolutionary struggle. These two questions — of class agency and of productivist bias — are central to the current critique of Marxism; they are no less important to a consideration of political art today.

For Marx it is the worker who produces the world and he who must seize the means of production from capital in the name of a new collectivity. For myriad reasons (radical divisions within the international division of labor, seriality of mass culture, recuperation by corporatist policy...) this has occurred only in a fragmentary way, and Marxists have had to question whether the worker in the place of production remains the fulcrum of social change. (Indeed, to André Gorz, the revolutionary agent today is the "non-class of nonworkers"[2] who, free of productivist ideology, are able to deny capitalist rationality and seek individual autonomy.) Despite signs of recent proletarianization, new social forces — women, blacks, other "minorities," gay movements, ecological groups, students... — have made clear the unique importance of gender and sexual difference, race and the third world, the "revolt of nature" and the relation of power and knowledge, in such a way that the

140

concept of class, if it is to be retained as such, must be articulated in relation to these terms. In response, theoretical focus has shifted from class as subject of history to the cultural constitution of subjectivity, from economic identity to social difference. In short, political struggle is now seen largely as a process of "differential articulation."[3]

In a similar way, political art is now conceived less in terms of the representation of a class subject (à la social realism) than of a critique of social representations (gender positioning, ethnic stereotyping, etc.). Such a change entails a shift in the position and function of the political artist. In part or whole, modernist programs of art as an instrument of revolutionary change (from the productivists through Brecht and Benjamin to Barthes and *Tel Quel*) all subscribed to a Marxian model of structural contradiction. According to this model, any mode of production (e.g., market capitalism) defines a specific set of productive forces and social relations (e.g., worker and capitalist, proletariat and bourgeoisie). As the productive forces develop, these social relations tend to be rent, or as Marx writes (in *A Contribution to the Critique of Political Economy*, 1853): "From forms of development of the forces of production these relations turn into their fetters. Then begins the epoch of social revolution."

Now if this productivist model is rewritten as a political program, the task of the artist is clear. As Benjamin writes in "Author as Producer" (Gramsci says related things about the intellectual), the artist must "reflect on his position in the process of production," resist the appropriative culture of the bourgeoisie, migrate to the (proletarian) class of revolution and there work to change the means of production. Yet more than speak *for* this new social force, he must align his practice *with* its production. In this way the artist is transformed "from a supplier of the productive apparatus into an engineer who sees it as his task to adapt this apparatus to the purposes of the proletarian revolution."[4] The historical importance of this program cannot be denied. In varied forms (in Russian productivism, the Bauhaus...) it did much practically to redress the division of cultural labor: to turn workers into producers of art and

to free the artist and intellectual from the "impossible place" of "benefactor and ideological patron."[5] This program of productive art also did much socially to reground forms that had become generic (e.g., academic sculpture) or merely reflexive (e.g., cubistic painting). And, finally, it did much theoretically both to discredit banal ideas of art as representational or abstract and to prompt a new model of meaning as actively produced, not passively (i.e., institutionally) received.

But so posed, without due recognition of the complex mediations involved, this productivist conception of art may tend to a technocratic or instrumental view of culture. Insufficiently dialectical, it has prompted several fallacies: the "Brechtian" notion that the denial of bourgeois conventions (e.g., illusionism in painting) is ipso facto a political critique or the "Barthesian" fallacy that productivist art is free of ideology because as an activity it engages the real. (Barthes: "The oppressed *makes* the world, he has only an active, transitive [political] language; the oppressor conserves it, his language is plenary, intransitive, gestural, theatrical: it is Myth.")[6] Finally, this model of art as productive activity may be compromised by productivism per se, in which "all revolutionary hope is bound up in a Promethean myth of productive forces," the "liberation" of which "is confused with the liberation of man."[7] For any theory centered on the means of production may not be able to account culturally for the significance of consumption[8] (or the consumption of significance) or historically for the importance of social and sexual difference (in regard to other cultures or within our own).

Today progressive social forces in the west cannot be defined strictly in terms of "productive man" – for two reasons. Historically, women, blacks, students... were long subordinate in production or consigned to a realm outside it – to consumption or culture; and socially, the site of struggle for these political forces is as much the cultural code of representation as the means of production, as much *homo significans* as *homo œconomicus*. For example, patriarchy and racism, though almost structural to any given workplace, are first learned in cultural institutions like the school or through

the media. Such institutions subject us unequally to a social structure whose center remains the patriarchial white male: thus it is there, in such institutions, that patriarchal and racist practices must first be resisted. Now these institutions are governed by capital and serve its interests — in the construction of "adjusted" social types.[9] But if for any mode of production, capitalist or otherwise, "the ultimate condition of production" is still "the reproduction of the conditions of production,"[10] then cultural subjection via such institutions as the school and the media remains paramount: "as we 'consume' the code, in effect, we 'reproduce' the system."[11]

Marxism, then, is faced with two displacements — from a concept of an (a priori) class subject *of* history to a concern with the production of the social subject *in* history (of subjectivity *as* subjection); and from a focus on the means of production (on use and exchange value) to an interest in the processes of circulation and the codes of consumption (sign exchange value).[12] And it is only in light of these displacements that the related repositioning of political art within the social totality can be grasped. If political art in the late-capitalist west can no longer be conceived simply as a representation of a class subject (in terms of a "message" via the given mediums of art) or an instrument of revolutionary change (in terms of "work" done on the productive apparatus), this is due not to the stylistic failure of these two programs but to new conditions that neither position can address with specificity. To put it simply: class is a construct of specific social praxis, not a historical datum always "there" to be represented (as it appears in social realism). And the productive apparatus, even if it can be culturally transformed, may no longer be the sole crux of political power.

This is not to say that the political artist cannot speak for the oppressed or align his production with the worker's. Clearly, the politics of representation is a strictly contextual affair: what seems radical in SoHo may be counterrevolutionary in Nicaragua. To rethink the political, then, is not to rule out any representational mode but rather to question specific uses and material effects — to question the assumption of truth in the protest poster, of realism in the documentary photograph, of collectivity in the street mural.

Nor is this rethinking to deny the need to transform the productive apparatus — only to specify it as a historical program (even by 1937, when Benjamin published "Author as Producer," political reaction against the productivist program in the Soviet Union was all but complete, and Benjamin was soon to turn from revolutionary prognosis to a melancholy messianism) or, conversely, as a project to be continually written in terms of the present conjuncture. For clearly under multinational capitalism the productive apparatus has changed, and intervention in the consumption of mediated images may now be more critical than the creation of private ones.

To reconceive the project of political art it is necessary not only to grasp the connection between these two displacements in class and production, but also to relate them to a third (contested) displacement: from a theory that power is based on social *consent*, guaranteed by class or state ideology, to a theory that power operates via technical *control* that "disciplines" our behavior (and indeed our bodies) directly. As conceived by Michel Foucault, this control is a matter less of ideological representations that mystify us as to our true selves or real conditions than of social regimens (at work in schools, the corporation, etc.) that structure our lives materially. Though both these theories of power address the ways in which the individual is inserted into society, this displacement (if conceived as such) helps to clarify why issues of representation and sexuality, of symbolic versus economic determination, and of "total systems" are so debated in cultural politics today. For it is only in relation to these issues that we can decide the present place and import of political art.

The Place of Culture

In bourgeois society culture is generally considered autonomous, separate from material production. Marxism inherits this polar model of the cultural and the economic but stresses the structural interaction of the two. Its model of base and superstructure has led to many vulgarisms: for example, the notion that the cultural

passively reflects the economic (e.g., that the subjective, abstract nature of modern art is a direct expression of capitalist reification). But this model has also prompted important revisions, such as the Althusserian argument that the economic is determinant only "in the last instance"; that, though any given historical juncture is overdetermined, it remains governed by a "structure in dominance"; and that the causality between the economic and the cultural is not direct or expressive but "structural" (whereby the levels of any social formation are related by difference and contradiction, not by identity).[13]

Historians and anthropologists have also argued that the base/superstructure model is historically limited—that other periods and cultures cannot be adequately measured by it.[14] (For example, Jean Baudrillard has suggested that our society, based as it is on the equivalence of commodities and of signs, is haunted by the "ambivalence" that governs symbolic exchange in primitive societies.) So too, social critics, Marxian and otherwise, have explored aspects of existence obscured by this model: domestic work (stressed by feminists like Christine Delphy); the spaces and practices of everyday life (Henri Lefebvre); the "mythologies" of human nature and common sense active in fashion and the media (Barthes); and so forth.

However incisive, all these critics still see the cultural and the economic as (semi)autonomous realms related by ideology. They are concerned with the demystification of this separation, with the silences created by it; they do not reflect on the potential reintegration of one realm into the other. And yet such is the reality we seem to face now: a breakdown in the old structural opposition of the cultural and the economic in the simultaneous "commodification" of the former and "symbolization" of the latter. "Today," Baudrillard argues, "consumption defines the stage where the commodity is immediately produced as sign, as sign value, and where signs (culture) are produced as commodities."

> Nothing produced or exchanged today (objects, services, bodies, sex, culture, knowledge, etc.) can be decoded exclusively as a sign,

nor solely measured as a commodity; everything appears in the context of a general political economy in which the determining instance is…indissolubly both [commodity and sign], and *both only in the sense that they are abolished as specific determinations, but not as form.*[15]

Now if there is indeed such a commutation of the cultural and the economic, it must be grasped politically as part of a new problematic, not ethically as per the usual condemnation or celebration of the "collapse" of art into commerce or the "merger" of high and low culture. And basically there are two adversarial positions to take on this problematic, one more radical than the other.

According to the first position, the cultural is not strictly an effect of economic determination or of ideological reflection (i.e., of the encoded values of one class): it is a *site* of contestation, in and for cultural institutions, in which all social groups have a stake. Now this hegemony of representations and disciplines cannot be effectively contested by conventional class struggle alone, for hegemony operates as much through cultural subjection as it does through economic exploitation – which is one reason why Lacanian psychoanalysis and Foucauldean critiques of disciplinary social apparatuses now appear so crucial to political theory. With culture thus seen as a site of struggle, the strategy that follows is one of neo-Gramscian resistance or interference – here and now – to the hegemonic code of cultural representations and social regimens (whether or not this code is to be read strictly by the Marxist book of capital).

The second position on this commutation of the cultural and the economic, though more radical, is also more debilitated. On this position (which might be called Baudrillard's Endgame), we confront a total system in the face of which resistance is all but futile, for not only is the cultural commodified (an "industry" as in the Frankfurt School diagnosis) but the economic is now "the main site of symbolic production."[16] According to this position, the bourgeoisie no longer needs a traditional culture to impress its ideology or retain its rule; the commodity no longer requires the guise of a personal or social value for us to submit to it: it is its own excuse,

its own ideology. Here capital has penetrated even the sign, with the result that resistance to the code via the code is almost structurally impossible. Worse, this resistance may be collusive with the very action of capital.

This last point will be clearer if we take as an example the "critique of representation" so central to (post)modernist art and criticism. In such practice the epistemological value of representations may be questioned (e.g., in art the documentary truth of a photograph) and ideological forms of meaning may be deconstructed. But to the benefit of whom or what *finally* is this truth-value banished, this meaning destructured? In practical terms such critique is likely not only to exacerbate our "schizo" inability to think our present but also to serve capital in its erosion of traditional forms (family and community or even, in multinational capitalism, the city and the nation-state).[17]

One can only be ambivalent about the effects of capital, for even as capital liberates us from repressively centered structures like the old community, it delivers us into new or recoded ones (such as the serial city). So too, one can only be ambivalent about a diagnosis of capital that oscillates between radical celebration of its intensities and reactionary nostalgia for structures eroded by it. With this much, though, one can agree: the real radicality is always capital's, for it not only effects the new symbolic forms by which we live but also destroys the old. More than any avant garde, capital is the agent of transgression and shock — which is one reason why such strategies in art now seem as redundant as resistance seems futile. What is needed, then, is a practice that somehow exceeds the claims of capital — its omnivorous ability to recoup and recode — and yet accedes neither to nostalgia for mandarin culture on the one hand or to romantic strategies of marginality or nihilism on the other.

The relation of modern art and capital is more complexly ambiguous than this (capitalogic) position allows. T. J. Clark has recently framed it in terms of an ambivalence: whereas the transgressive avant garde (dadaists, surrealists...) saw "an *advantage* for art in the particular conditions of 'ideological confusion and violence'

under capital" ("it has wished to take part in the general untidy work of negation"), formal Greenbergian modernists held that art must "substitute *itself* for the values capitalism has made valueless."[18] Such difficult formal art, posed by Greenberg against both the Alexandrianism of the academy and the debasement of kitsch, could not forestall commodification, nor could its distillation of æsthetic value serve as a substitute for lost social meanings. And as for the strategy of the avant garde, it may be that its æsthetic negations occasionally prompted social praxis – in art such as Brecht's where "ideological confusion" is turned into political contestation – but these exceptions largely prove the rule: the avant garde was, if not an agent of capital, then at least in its ambivalent service.

This complicity with capital is not due to avant-garde advocacy of bourgeois notions of historical progress. In general, the program of the modernist avant garde was one of total transformation or anarchic change (thus its zeal for the new object-world of modernity), not of social betterment. No, the collusion with capital of the avant garde involves its twin ideologies of utopia and transgression, both of which clearly abetted the modernization of western urban life. For what has rent the fabric of the city more completely than the "utopias" of modern architecture, virtual *tabulas rasas* for capitalist development?[19] And what has reconciled us more subtly to the chaos of the late-capitalist world than the shock of the now-not-so-new in modern art? Again, the service rendered capital by the avant garde was ambivalent – and, at moments, subversive to its interests. But now apparently it is superfluous, for by all signs bourgeois culture has sacrificed the very avant garde that it once retained as its provocateur: "this independent, critical, and progressive intelligentsia was put to death by its own class."[20]

The "radical" conception of capital does not offer us much in the way of critical strategy today. One can do little more than bear with the logic of capital or somehow go through it to its other side – which leaves us, on the one hand, with an indefinite delay (e.g., socialism can only come after capital has penetrated all psychological and geopolitical space) and, on the other, with a critique of

capital that enthuses over its disruptions and intensities. (An example of this celebratory critique may well be art that seeks to out-media the media, to "capitalize" on its spectacles.) This program leads to nihilism, as announced by Jean-François Lyotard when he remarks that the capitalist liquidation of social forms must be made "still more liquid."[21]

As for the program of avant-garde transgression, it is culturally specific and historically bound – to a productivist model (as in "change the apparatus"), to a simplistic notion of ideology as encoded class beliefs (as in "transgress the conventions"), to a now tenuous idea of art as instrument of revolutionary change – all this apart from its complicity with capital. In short, both capitalogic and transgressive programs must generally be put to one side in favor of the first position (counterhegemonic and resistant) sketched above: to see in the social formation not a "total system" but a conjuncture of practices, many adversarial, where the cultural is an arena in which active contestation is possible. For if this analysis is correct, it is only in such terms – as a practice of resistance or interference – that the political in western art can now be grasped.

From Transgression to Resistance

There are no fixed or generic subjects in political art: historical specificity, cultural positioning is all. So to reconsider the status of the avant garde is not to challenge its criticality in the past, but on the contrary to see how it may be reinscribed as resistant, as critical in the present. The import of this repositioning is suggested by the (military) metaphorics of both terms: *avant garde* connotes revolutionary transgression of social and cultural lines; *resistance* suggests immanent struggle within or behind them.[22]

To conceive resistance in this way is not to proclaim the "death" of the avant garde (that is usually a proclamation of the right) but rather to question the present validity of two of its principles: the structural concept of a cultural "limit," to be broached with reper-

cussive effect, and the politics of social "liberation," conceived as a program that vanguard art might somehow parallel or even prompt. Modernist transgression does indeed posit a limit to cultural experience (this may well be its purpose) beyond which lie "the scandalous, the ugly, the impossible"[23] (in a sense, the sacred). In a highly structured society like that of monopoly capitalism, there was such a limit — a "natural" outside, a "dark" continent that a Mr. Kurtz penetrated at great risk to self-consciousness (to say nothing of detriment to the other). In such a society transgression did have strategic force: think of the provocation, at the turn of the century, of modern primitivism alone — of the very repressed of European imperialism returned home to challenge the superiority and autonomy of western cultural traditions. Such transgression has much less effectivity in a formation like our own where old structures — of self, family, class, religion, nation — are largely eroded (however much they reactively return in the guise of antimodernism, fervent nationalism, religious fundamentalism, etc.).

In a similar way, the social liberation espoused by the avant garde has lost its historical object. Foucault has even argued that "liberation," conceived as the opposite of repression, is not liberative at all — that it may abet cultural subjection as part of a private discourse of the self and sexuality. (Thus, for example, Foucault reads psychoanalysis as a disciplinary apparatus whereby the subject is known by means of "confession," and social control is made internal through "conscience.")[24] Resistance, on the other hand, implies no such limit or liberated position — only a deconstructive strategy based on our positioning here and now as subjects within cultural significations and social disciplines. Such a practice is thus skeptical of any transcendental truth or natural origin outside ideology (such as posed by the avant garde) as well as of any representation that claims to be "liberated," i.e., not invested or troubled by desire (such as often posed by '60s countercultural politics).

This passage from a model of avant-garde transgression to one of critical resistance is not merely theoretical; it must be seen historically in relation to the different conditions that have shaped the production and reception of art over the past 100 years. This con-

junctural view is likely to go against our conventional conceptions. For example, the avant garde is seen as originally opposed to the academy, as transgressive of the lines and limits of salon culture and polite society. So too, critical or resistant art is conceived as opposed to official modern culture in the form both of the mass media and of a recuperated modernism (the modern art in the museums). Yet these oppositions remain partial, abstract, moralistic more than analytic (i.e., one term is good, one bad), formal more than historical (e.g., the avant garde is cast as simply negational, formalist art as simply autonomous). In short, such cultural terms must be grasped dialectically, (re)grounded in context, and read through to a periodizing of culture in relation to economic mode and social formation.

Fredric Jameson has posed a model (drawn in part from Ernest Mandel) in which the modern history of capital is grasped in three uneven moments: a market economy which, in its erosion of traditional forms through the equivalence of commodity exchange, allowed for early (negational) modernism; a monopoly capitalism whose monolithic structures prompted the private and ironic languages of high modernism; and multinational capitalism, in whose mediated space, at once homogeneous and discontinuous, the "schizo" productions of postmodernism surface.[25] Though skeletal, this conjunctural model makes clear that no cultural moment is total or definitive (as the terms "modernism" and "postmodernism" otherwise imply), reflective of an economic mode or separate from it. The model for modernism can be extended in the form of a field triangulated by three principal elements: the academy, understood as a repressive code of bourgeois and aristocratic conventions; the second industrial revolution, with its technologies of reproducibility and mobility; and socialist revolution (most obviously, the Russian) as a paradigm of cultural transformation.[26] Given different contextual emphases (e.g., that the academy was partly articulated in relation to a nascent mass culture), this model does much to suggest the bases for the radical, apocalyptic imagination of avant-garde modernism – its simultaneous transgressive strategy and utopian desire – in the first quarter of the century.

It also does much to mark our difference, for clearly this conjuncture is not our own. Many artists and critics see the present as morassed in an endgame of modernist irony to which the only response is passive parody or puritanical refusal, but I would argue that we inhabit a new conjuncture – not (it is important to note, given the alarm about postmodernism) a clear epistemic break, but a new social order of heterogeneous elements that demands a new positionality for political art. Here we can retain the schema of a triangulated field, but in the present conjuncture the dominant terms are less the academy than mass culture; less the second industrial revolution than a third (which, apart from nuclear energy and electronic information, does not herald a "postindustrial" age so much as a completely industrial one);[27] and finally, less the example of revolution in the first or second world than revolt in the third – a revolt in the face of (neo)colonialism that can be related, albeit abstractly, to the revolt of women in the face of persistent patriarchy, of minorities in the face of pervasive racism, of nature in the face of ruthless domination. . . .[28]

Now this new field suggests a later, greater moment of capital, which in turn suggests that the structural codes which the modern avant garde sought to transgress no longer exist as such or are no longer defended as such by the hegemonic culture. In this new, all-but-global reach of capital, there may be no natural limit to transgress (which is not at all to say that there is no structural outside or cultural others). And in this case, the modernist strategy of transgression must pass, bound to its moment, and a new critical strategy of resistance from within come to the fore. Such a model also allows us to begin to periodize strategies of transgression and resistance in terms of modernism and postmodernism. (For example, both resistant and postmodernist practices stress cultural representations rather than utopian abstractions, and explore the social affiliations of texts rather than pose anarchic negations of art.) Again, these are uneven developments, tendencies only, which it is nonetheless the task of the political artist to articulate. And here perhaps there is an analogy to the program of the artist "as producer": just as he was urged not to feed the productive apparatus

but to change it, so the political artist today might be urged not to represent given representations and generic forms but to investigate the processes and apparatuses which control them.

Aspects of this practice are evident in the work of many artists today: two that come to mind are Hans Haacke and Martha Rosler whose respective critiques of the "museum industry" and of domination in the media are now partly in place. To see such practices as passive is not only to fall into a false opposition (active/passive, practical/theoretical) but also to mistake the positionality of critical art in our cultural formation, for clearly this is not a "confrontational" moment in the classic political sense. However much right and left ideologues dress each other down in public, the material operations of real political power remain obscure or are so spectacular as to blind critical review. Indeed, it may be the task of political art not only to resist these operations but to call or lure them out by means of "terroristic" provocation – literally to make such operations as surveillance or information control vividly *public* – or, conversely, to deny the power of intimidation its due.

Hans Haacke. *U.S. Isolation Box, Grenada, 1983*, 1983-84.

What then of the place and function of "political art" today? In the past, this generic term has connoted a nonmodernist mode of art that, however hortative, works with received codes in a passive, presentational relation between artist and audience. (Social realism in its various forms can serve as an example here.) This presentational art contrasts with both transgressive and resistant modes of political art, the first of which seeks to transform, the second to contest the given systems of production and circulation. Such presentational political art rarely questions its own rhetoricity or challenges the positivity of its representations. In its social-realist forms and often in its agit-prop montage forms, it conceives of class in an almost ontological way. This is so because as an art of protest it sets up an opposition – between two interests or classes (e.g., worker and bourgeois) – whose forms of address respect the institutional boundaries of society, the given "spaces." Both transgressive and resistant art forms, on the other hand, seek to intervene in just those spaces, cultural and otherwise. (Think, in the case of transgressive art, of the productivist programs of the '20s and, in the case of resistant art, of the "situationist" æsthetics of the '60s or the textual strategies of the '80s.)[29]

The presentational mode of political art, however, *is* suited to the organic expression of specific social groups – when there is an authentic political collectivity to be represented. Of course, this mode is also used in the polemics of the art world. But displaced, even groundless there, it is often treated fetishistically as if in longing for a lost power of the image, or ironically as if this mode of representation had become but a generic figure of political naïveté or historical futility. Thus made to parade its own hapless reduction to gesture, convention, cliché, this political mode of art becomes parodistic, submissive. Theoretically at least, this ironic use of presentational political art may be pushed to a deconstructive point where the truth-value or binding power of *any* given political representation, collided with others, is undone. Though the films of Godard are canonical in this regard, works by artists like Vito Acconci and Barbara Kruger are also important examples. And yet even this (Godardian) strategy, posed as an alternative to

generic political art, may now be a convention in need of critique –
a disruption outstripped by the world of simulation spun out by
capital. Presentational political art, then, remains problematic. And this
is so, above all, because such art tends to represent social practices
as a matter of iconic idea(l)s.[30] However general the social practices
of the industrial worker are, as soon as they are represented as
universal or even uniform, such representations become ahistorical
and thus ideological. It is here that the rhetoricity of presentational
political art is exposed: for when such art seeks most directly to
engage the real, it most clearly entertains rhetorical figures for it.
In the west today there can be no simple representation of reality,
history, politics, society: they can only be constituted textually;
otherwise one merely reiterates ideological representations of
them. Generic political art often falls into this fallacy of a true or
positive image, and from there it is but a short step to an axiological
mode of political art in which naming and judging become one.[31]
Politics is thus reduced to ethics – to idolatry or iconoclasm – and
art to ideology pure and simple, not its critique.

This lapse in art comes of ideology conceived in an idealist
way – as a fixed corpus of class beliefs (a fiction that renders them
more real, stable than they otherwise are). Ideology must instead
be grasped as Marx in fact saw it: as a matter less "of 'false con-
sciousness' or of class origins [than of] the structural limits or
ideological closure imposed on thought by its class positioning
within the social totality."[32] Here, then, one might distinguish be-
tween a "political art" which, locked in a rhetorical code, repro-
duces ideological representations, and an "art with a politic"
which, concerned with the structural positioning of thought and
the material effectivity of practice within the social totality, seeks
to produce a concept of the political relevant to our present. A
purchase on this concept is no doubt difficult, provisional – but
that may well be the test of its specificity and the measure of its
value.

Ray Barrie. *Masterpieces*, 1982.

Readings in Cultural Resistance

One often hears today that the west has lost its cultural and ideological coherence: that the traditional bonds of bourgeois culture are dissolved, that state power is faced with a legitimation crisis, that the great narratives of modernity have stuttered to a stop. This assertion seems perverse at a time of deep political retrenchment, but this retrenchment may be in part a reaction to such an erosion in modern forms of belief. The question arises then: how is order contrived and consent compelled in contemporary western society?[1]

Traditionally it is ideology that guarantees consent: in Marxism it is said to promote false consciousness or (better) to limit thought in such a way that social conflicts and historical contradictions are magically resolved. Art or the æsthetic is also traditionally defined as a realm of resolution situated midway between the practical and the theoretical: in Kantian (Enlightenment) philosophy æsthetic judgment is said to reconcile sense and reason, nature and freedom, judgments of fact with judgments of value. Now it is easy, perhaps too easy, to decode the æsthetic in terms of the ideological — as a sphere, projected beyond social divisions and instrumental economic logic, that falsely resolves the first and compensates for the second. ("We must be at liberty," Schiller wrote, "to restore by means of a higher Art this wholeness in our nature which Art [i.e., technique, science] has destroyed.")[2] Yet obviously the æsthetic and ideological are related — not (only) because the work of art may

"reflect" this or that ideology but because it too is an ideological act, it too magically resolves. Moreover, the very definition of the æsthetic as an autonomous, reconciliatory sphere answers the needs of capital. As Franco Moretti has remarked, "Kant's research reveals all its historical 'necessity' if one reflects that while capitalist society is unthinkable without the scientific and technical progress reflected in the separation of intellect and morality, it is equally unthinkable without the incessant attempt to annul that separation and remedy it, an attempt to which the extraordinary and apparently inexplicable proliferation of æsthetic activities that distinguishes capitalism bears witness."[3]

Yet to conflate the æsthetic with the ideological, as this statement threatens to do, is troublesome because it tends to evacuate the critical potential of the work of art (as well as its semi-autonomous status): it is almost as if the æsthetic is regarded, at least in its first modern formulations, as not much more than a realm where consent to bourgeois class rule is guaranteed.[4] However revised historically in terms of compromise (i.e., that later, in the 19th century, the cultural does not simply guarantee one system of values but reconciles different adversarial codes), this model still disavows the criticality of art, especially as regards its own ideological or reconciliatory function.

This criticality may indeed be in doubt in the production of contemporary culture, but clearly it is a mistake to rule it out too quickly in the case of all modern art. For as we know, practices within modernism variously confirm and contest these Enlightenment notions of the æsthetic. At the risk of too stark an opposition, one can point to a formalist practice that obeys the Kantian injunction of autonomy — of criticism *within* the institution — and to an avant-gardist practice that challenges this autonomy — criticism *of* the institution.[5] For a formalist the goal of art is the refinement of the æsthetic in its autonomy and purity; this goal clearly involves a consensual function (the final criterion of painting, one formalist critic has written, is that it "compel conviction"). Now it is precisely this ideological operation of the æsthetic — its expression of an absolute that renders all relativities and contradictions "beside

the point"[6] — that much advanced art, politically committed or not, has disobeyed since the 19th century. This art — Manet's is no less an example than Duchamp's — has sought "neither to affirm nor refuse its concrete position in the social order, but to represent that position in its contradiction and so act out the possibility of critical consciousness."[7]

However, the more anti-æsthetic aspects of this practice have also become problematic. It was possible not so long ago to believe that art, once freed of "its parasitical dependence on ritual," would be based on political practice, indeed that a "tremendous shattering of tradition" might assist in a revolutionary "renewal of mankind." (I echo here Walter Benjamin in his famous essay, "The Work of Art in the Age of Mechanical Reproduction.") In the west, however, this "shattering" — which capital, not art, executed — has opened the way not to an active transformation of cultural institutions and social relations but to a passive consumption of the spectacles of mass culture. In *this* transformation the consensual guarantee of traditional culture is no longer so crucial to social order, for today we are socialized less through an indoctrination into tradition than through a *consumption* of the cultural.[8] Culture is no longer simply a realm of value set apart from the instrumental world of capitalist logic, no longer entirely a compensation for our renunciation of certain instinctual drives or a reprieve from our otherwise commodified existence — it too is commodified.

If this is the case with the cultural sphere, then we might expect the function of ideology to be likewise changed. Jean Baudrillard has argued that "ideology can no longer be understood as an infrasuperstructural relation between a material production (system and relation of production) and a production of signs (culture, etc.), which expresses and masks the contradictions at the 'base'"[9] — precisely because the two realms are no longer structurally divided. The logic of the commodity and the logic of the sign are part of the same process of abstraction, one that traverses all fields of social production, and it is *this* process that constitutes ideology in advanced capitalist society today. Given this state of affairs, in which the cultural may no longer be an autonomous sphere (to ne-

gate) or serve a consensual function (to expose) and in which the ideological may no longer simply be a mystification (that can then be demystified), the definition and deployment of cultural resistance becomes difficult to pose. It is this problem that I want to take up below.

The Bourgeois "Divestiture"

Here the questions relevant to cultural resistance become: What is the system of objects, practices and institutions that is commonly called bourgeois ideology? How is it dominant, and what is specifically bourgeois about it? Was the culture of the bourgeoisie ever other than a text woven of aristocratic terms on the one hand and proletarian or popular forms on the other? And is its practice now any other than the appropriation of the significations of other social groups? Can one describe these related operations – the first one of contestation, the second one of appropriation – as two phases of bourgeois cultural formation?

When emergent as a political force in the 18th century, the bourgeoisie was "a culturally coherent class."[10] It forged specific meanings, possessed distinctive values, as was necessary to its struggle for hegemony. The issue here is not the class character of this culture of the salon painting, the romantic symphony, the realist novel, etc., but its formation. Take as the broadest example of bourgeois ideology the program of the Enlightenment – of the natural rights of man, the sovereignty of the people and of the republic, of a public sphere "open" to all interests and a state "above" all conflicts. This project of *universal* representation was conceived in resistance to the *special* interests of the aristocracy, monarchy and church. In this sense it was contestatory or "dialogical"; it was also dialectical: it freed man from superstitious "immaturity" (Kant) but only to fetter him as labor and deliver him into the hands of capital. Indeed, its very liberatory program – to naturalize, rationalize, universalize – has come to be seen as the ideological operation par excellence. In its "dialectic," Adorno and

Horkheimer argued, the Enlightenment has become its own dark other, its own grotesque myth; the rule of reason encompasses the capitalist domination of nature, the imperialist eradication of the other, the fascist regression into the irrational (and now the potential extinction of us all).

The dialogical, duplicitous nature of this bourgeois ideology is most evident in the fate of its "public sphere," also conceived in opposition to the arcane policies of the *ancien regime* as a realm of free speech and open debate. This sphere of free association was largely an ideological cover for "free enterprise": behind the general interests there expressed lay the quite specific interests of capital. (In a related way, the bourgeois definition of æsthetic judgment as subjective but universally valid was also posed against the elitist address of culture, based on objective rules and norms in the *ancien regime*. And behind this "universality," too, lay particular mystifications: the suggestion that art, like democracy, was for all, that it was not socially conditioned or effective, etc.) The class-specific nature of the public sphere was made clear as soon as non-capital (i.e., proletarian) interests sought representation there. Once within the reach of others, forms of representation rule originally deemed liberative became dangerous, and the bourgeoisie began its own "counterrevolution" — to forego its the public sphere — a reform that can be traced from the early manifestations of the spectacle down to our own mediated network of "information" and "entertainment."[11] Nevertheless, this first alien adaption of its public prerogatives was traumatic enough that the bourgeoisie began its own "counterrevolution" — to forego its own distinctive practices and inherited aristocratic beliefs, its own status as a culturally coherent class, in order to give capital full rei(g)n. In *The Eighteenth Brumaire of Louis Bonaparte* (1852) Marx details how the bourgeoisie adopted the despot Louis Bonaparte so that it "might be able to pursue its private affairs with full confidence in the protection of a strong and unrestricted government,"[12] might, that is, secure its control of the means of production quite apart from any contestation of its cultural representations.

This sacrifice was hardly material, nor was it political. Indeed,

this divestiture was a strategic redeployment, a new form of hegemony. For one thing, it confirmed the separation of the cultural from the economic, which preserved the former in institutional impotence even as it freed the latter to erode social forms. For another, it signaled a shift away from dialogical struggle with aristocratic culture toward direct appropriation of other social practices — away from ideology as a contest of coded beliefs, values, etc., to ideology as a cultural *combinatoire* of signs of other social groups. (It was at this point that control of symbolic production, of the process of signification, became as crucial as control of material production, of the means of production.)[13]

This appropriative operation is efficacious, to be sure, but it nonetheless compensates for a lack — the lack of a coherent social base for cultural production. This lack is in fact the site of a contradiction, one that becomes overdetermined in the course of the 19th century. For its part, the bourgeoisie was faced with a conflicted need: 1) to dissolve a politically compromised cultural order; 2) to retain a quasi-aristocratic claim to cultural supremacy; and 3) to control the industrial masses "democratically," i.e., to reconstitute them as serial (separated) consumers rather than collective producers.[14] But this problem was also an opportunity, one which allowed the bourgeoisie to shore up the cultural spoils of its class struggle with the aristocracy and to deflect the class struggle of the proletariat — ideally, to pass into a *post*dialogical position of power. We have described via Marx the cultural divestiture of the bourgeoisie, its shift from a distinctive cultural practice to a practice of appropriation. The "solutions" to the other two problems may now be named, provisionally, avant-garde and kitsch or (in a later, more complex form) modernism and mass culture.

The formulation of this problematic is the subject of much debate, today no less than 50 years ago. (This is not to suggest that it has not changed: the great difference between kitsch — defined by Clement Greenberg in 1939 as the reproduction of high art for the easy consumption of the new urban industrial masses[15] — and mass-mediated culture is only an indication.) To grasp this problematic, one must return to the separation of the cultural and the

economic realms. Programmatic in the Enlightenment, the autonomy of art was proclaimed in order to "save" art from such instrumental uses as instruction or entertainment. Yet it was only with the bourgeois cultural divestiture that such autonomy was practiced, for only then did art for art's sake become possible. "In point of fact," Benjamin wrote in his Baudelaire manuscript, "the theory of *l'art pour l'art* assumed decisive importance around 1852, at a time when the bourgeoisie sought to take its 'cause' from the hands of the writers and poets.... At the end of this development may be found Mallarmé and the theory of *poésie pure.*"[16] If the bourgeoisie no longer needed art as an ideological instrument, by the same token the artist was no longer required to represent its interests — and in the default of other class interests could take as the subject of art its own internal processes.

This reading overlooks certain practices of the original avant garde: the representation of nonbourgeois social practices as in Courbet or the staging of conflictual social representations as in Manet. That is, it distinguishes but one *æstheticist* aspect of the avant garde, which even as it withdrew its active representation or ideological support from the bourgeoisie nonetheless confirmed the bourgeois principle of the autonomy of art. Another aspect of the avant garde, its *anarchic* faction, emerged later in dialectical response to this state of affairs. This anarchic avant garde disputed the æstheticist faction, but more importantly it challenged the very principle of art as an institution. Here, the figure to appose to Mallarmé and his Great Book — or, better (given the avowed anarchism of the poet), to Cézanne and his pure visuality — is Duchamp, who renounced "retinal painting" and who exhibited readymade urinals and bottle racks in such a way as to debunk the transcendental pretensions of the art object and decode its "autonomy" as the lack of any real use value. To this avant garde it is *this* "autonomy" of art — i.e., its subsumption by the exchange principle — that has rendered it instrumental and ideological.

The fact that the anarchic faction contested only the cultural order of the bourgeoisie, not its political status, is seen by some as its failure. (Thus Jürgen Habermas: "Nothing remains from a

desublimated meaning or a destructured form; an emancipatory effect does not follow.")[17] But this is to mistake an anarchic project for an actual program; it is also to misread as a target what is also a precondition. For this avant garde depended historically on the bourgeois order (as a source of financial support as well as a cultural system to negate), just as this order used the avant garde (to mediate social unrest and, later, subcultural styles); the two are bound together in a necessary contradictory knot. Moreover, it is this anarchic avant garde, often dismissed as "arbitrary" or "trivial," that sets up the properly political avant garde (e.g., Russian productivism) in its attempt not to destroy but to *transform* the institution of art, indeed the entire apparatus of cultural production, dissemination and reception.

In sum, the æstheticist avant garde responded to the bourgeois need to preserve the principles of "value" and "quality" in a system economically stripped of the same and culturally enervated by academicism and debased by kitsch. This æstheticist faction was in turn exposed by the anarchic faction as part of the problem, not the solution. Though this avant garde did not destroy art as an institution, it did effectively ruin "the possibility of positing æsthetic norms as valid ones."[18] Thus, at one and the same time, avant-garde modernism was the "last best hope" of the bourgeoisie (which had disowned for political reasons its old cultural order) *and* the first best challenge to its new order of academic rarefication on one side and mass-cultural appropriation on the other.

The full complexity of these relations — avant garde and kitsch, modernism and mass culture — is not usually granted. Most often the terms are abstracted, then opposed, when instead they must be seen as dialectical. If we consider a constellation of a kitschy art reproduction, a Cézanne painting of Mont Ste. Victoire and, articulated in relation to both, a Duchamp readymade, we see that each variously reflects, resists or addresses two conditions: commodification and the lack of a culturally coherent public (bourgeois or otherwise). The reproduction *is* a commodity image that circulates freely. The Cézanne, in all its compulsive repetition and "doubt" about seeing, formally resists such reification as a sign system

(even as its stress on the purely visual and painterly attests to the specialization of the senses and the division of labor) but in the name of no social group other than the avant garde. And the readymade polemically underscores both artistic commodification and social alienation. In this way modernism and mass culture, "torn halves of a freedom to which however they do not add up,"[19] perform dialectically different functions: the one preserves a semblance of value (perhaps even its avant-gardist negation does this), the other culturally controls the masses; the one "purifies" the language of the tribe (or, again, disrupts or opacifies it), the other "debases" it. (Here, perhaps, the dialogical nature of the two can still be seen: the avant garde as the "aristocratic" sign of high culture, kitsch as the "plebian" sign of "an art and culture of instant assimilation, of... equality before the image of capital.")[20] So, too, the two practices treat the lack of a coherent social base in dialectically different ways: modernism, as T. J. Clark suggests, tends to "make over" this absence into form, mass culture to regard it as a void to fill with substitute signs — a condition of desire, if you like, that demands the appropriation of specific social practices into general cultural commodity-images. As Henri Lefebvre remarks, "We are surrounded by emptiness, but it is an emptiness filled with signs."[21]

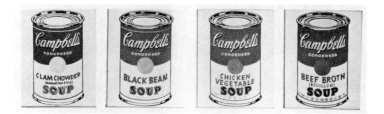

Andy Warhol. *Campbell Soupcans* (detail), 1961-62.

(Counter)Appropriation

Bourgeois culture, then, consists of a dialectical modernism and mass culture. More elastic than any rigid "ideology," this text poses great difficulty for any resistant practice: How to counter or even confont a culture with no integrity or fixed form, one which rarefies with one hand and appropriates with the other?

In "Myth Today" (1957) Roland Barthes defined the (petit) bourgeois as a "man unable to imagine the Other... the Other is a scandal which threatens his existence."[22] Yet it is precisely as a "scandal" that the other is structurally necessary, for it defines the limits of the bourgeois social text – what is (a)social, (ab)normal, (sub)cultural. In short, order is produced around the positioning of the other by which (on the social level) it is made marginal and (on the historical level) suspended as exotic or "primitive." Exclusionary stereotypes, which effectively turn the other into "a pure object, a spectacle, a clown" (Barthes), have long comprised a principal mode of this control. But such stereotypy can allow for resistance whereby the image of subjection is made over into a sign of collective identity. The operations of our own social regime are more sophisticated: though still dependent on subjection, they no longer rely entirely on exclusion. (As Foucault has argued, exclusion, whether of the mad, the criminal or the deviant, is simply not productive enough of knowledge and thus of power.) Today the other is also recouped, processed in its very difference through the order of recognition, or simply reduced to the same.

Barthes noted two characteristic forms of this recuperation: *innoculation*, whereby the other is absorbed only to the degree that it may be rendered innocuous; and *incorporation*, whereby the other is rendered incorporeal by means of its representation (here representation acts as a substitute for active presence, naming is disavowing). Such recuperation is effected partly in art (e.g., in the documentary photographs of Walker Evans that "domesticate" social others like the poor, or in the pseudovernacular architecture of Robert Venturi that appropriates indigenous forms of collectivity for its own pop purposes), but its primary field of operation is mass

culture. Take, for example, the recuperation of subcultures. Dick Hebdige has detailed two ways in which these particular others are captured: "1) the conversion of subcultural signs (dress, music, etc.) into mass-produced objects (i.e., the commodity form); 2) the 'labelling' and re-definition of deviant behavior by dominant groups – the police, the media, the judiciary (i.e., the ideological form)."[23] Yet these two forms – the commercial and the ideological – are in fact one; they converge in the commodity-sign form, by which the other is socially subjected as a sign and made commercially productive as a commodity. In this way the (subcultural) other is at once controlled in its recognition and dispersed in its commodification. And in the circulation of this commodity-image power and knowledge penetrate the very cracks and margins of the social field. Difference is thus used productively; indeed, in a social order which seems to know no outside (and which must contrive its own transgressions to redefine its limits), difference is often fabricated in the interests of social control as well as of commodity innovation.

Sherrie Levine after Walker Evans, 1981.

All of these techniques of recuperation depend on one master operation: *appropriation*, which on the cultural level is what expropriation is on the economic level. Appropriation is so efficacious because it proceeds by abstraction whereby the specific content or meaning of one social group is made over into a general cultural form or style of another. Barthes called this process "myth": "[Myth] is constructed from a semiological chain which existed before it: it is *a second-order semiological system*. That which is a sign... in the first system becomes a mere signifier in the second."[24] In the mass media such appropriations are so ubiquitous as to seem agentless; they also appear traceless: the marks of social origin, of use value, are usually effaced. In effect, the media transforms the specific signs of contradictory social discourses into one normal, neutral narrative which *speaks us*. Collective expressions are thus not only appropriated but also "dismantled and reassembled,"[25] remotivated and retransmitted. (Myth, Barthes writes, is "speech stolen and restored," "not put exactly in its place.") In this way social groups are silenced; worse, they are transformed into serial consumers – *of simulacra of their own expressions*. They hear what they say in a false (distorted, mediated) echo to which they cannot respond and which structurally blocks further expression.

Here then is the disciplinary as well as the economic function of mass-cultural myths: they serve as substitutes for active social expression and as alibis for consumerist management. Appropriate collective signifieds and retransmit them as "popular" signifiers; divide and conquer, commodify and circulate. In this way mass culture, *our* public sphere, "turns [us] into speaking corpses."[26] And we may see that, far from a cultural "divestiture," mass culture represents an extraordinary expansion of the bourgeois – only it is "exnominated," not named as such. No more culturally coherent for this, the bourgeoisie is also far less targetable. (Barthes: "Any student can and does denounce the bourgeois or petit-bourgeois character of such and such a form." Foucault: "I believe that anything can be deduced from the general phenomena of the domination of the bourgeois class.")[27]

168

Against this operation of appropriation, what resistant practice is possible? On the countercultural front the old left-liberal call is "seize the media," but this strategy neglects the domination inscribed in media forms (i.e., the fact that structurally we cannot respond to them).[28] On the cultural front critical modernism, with its will to opacify the medium and open up the sign, may be regarded as countermythical, at least in its first moment. But either as a formal totality that reflects critically on the putatively total system of capital (the Adorno model of modern music and art) or as a negation that seeks to lay bare the world constructed as crisis (the Brecht model), critical modernism is also prey to myth, as the first, recalcitrant modernism (especially in its American reception) is reduced to formalism, and the second, adversarial modernism is abstracted as an empty signifier of "political art." What does this leave us with? Barthes, in 1957, offered this:

> Truth to tell, the best weapon against myth is perhaps to mythify it in its turn, and to produce an *artificial myth*: and this reconstituted myth will in fact be a mythology.... All that is needed is to use it as the departure point for a third semiological chain, to take its signification as the first term of a second myth.[29]

"Since myth robs myth, why not rob myth?": this secondary mythification is the political motive of much image appropriation in recent art (at least when it pretends to critique); polemical points about the dissolution of aura and the commodification of art, about the privileged myths of originality and intentionality, are all related concerns. To rob myth in this way is not merely to rehearse the mythical process by which signs are appropriated by the mass media so much as it is to counter *or* compound it. Basically, in art, "myth-robbery" seeks to restore the original sign for its social context *or* to break apart the abstracted, mythical sign and to reinscribe *it* in a countermythical system. In the first instance, the sign is reclaimed for its social group; in the second, the appropriated sign is traced, revalued, rerouted.[30] Ideally, such myth-critical art circulates with mass-media signs so as to be socially current, but remains tactical, neither complicit with media functions nor anar-

169

chic only, neither a stylistic ruse nor a "true" representation of its own. I have written elsewhere about the first practice and its relation to counterhegemonic (feminist, third world, gay...) social forces; to be discursively effective, it must connect with these other resistant practices.[31] Here, I want briefly to explore the second, countermythical practice but in terms of subcultural as well as artistic activity.

Subcultural practice differs from the countercultural (e.g., '60s student movements) in that it recodes cultural signs rather than poses a revolutionary program of its own. Far from an inert sociological category, the subcultural must be grasped as a textual activity. Plural and symbolic, its resistance is *performed* through a "spectacular transformation of a whole range of commodities, values, common-sense attitudes, etc.,"[32] through a parodic collage of the privileged signs of gender, class and race that are contested, confirmed, "customized." In this *bricolage* the false nature of these stereotypes is exposed as is the arbitrary character of the social/sexual lines that they define. At the same time these signs (which, as noted above, often function as substitutes for active social presence) are made over into a "genuinely expressive artifice," one that resists, at least in its first moment, the given discursive and economic circuits. Media myths, commodity signs, fashion symbols — these "speak to all in order to better return each one to his place."[33] The subcultural plays with this encoded discrimination — to contest it perhaps, to confuse it certainly. Neither in nor out of the social text (its underside, as it were), the subcultural symptomatically expresses its limits and aporias. A slightly scandalous presence, it "spoils" the consistency of this text precisely because it enacts a specific experience of social contradictions that is at once collective and ruptural.

Different but not quite other, the subcultural nevertheless attracts the sociological gaze. Indeed, it is often dismissed as a spectacle of subjection, but this is precisely its tactic: to provoke the major culture to name it and in so doing *to name itself.* No doubt subcultural contestation is finally partial (it rarely rises to the political and signs of social and sexual subjection are often assumed);

yet even when reduced to a gesture or abstracted as another major style, the subcultural lingers as a disturbance, as a doubt. In Baudrillardian terms it reinvests signs and commodities with a symbolic ambivalence that threatens the principle of equivalence on which our social and economic exchange is based.[34] It knows it cannot transform this code, but it can fetishize it to the point that it becomes apparent as such. And it can perhaps pose (as) a difference (or at least a "symbolic disaffection") within the code.

Paradoxically, however, it is precisely this which attracts recuperation, for our socioeconomic system requires "difference," a difference to encode, to consume, to eradicate. Jacques Attali poses the contradiction (or is it a *dynamic?*) in this way:

> No organized society can exist without structuring a place within itself for differences. No exchange economy develops without reducing such differences to the form of mass production or the serial. The self-destruction of capitalism lies in this very contradiction . . . : an anxious search for lost difference, within a logic from which difference itself has been excluded.[35]

This anxious search not only may compromise the recovery of repressed or lost difference (sexual, social, etc.); it may also promote the fabrication of false differences, differences coded for consumption. And if difference can be fabricated, so too can resistance. Here emerges the possibility that critical marginality is a myth, an ideological space of domination where, under the guise of liberal romanticism, real difference is eradicated and artificial difference created to be consumed.

In our system of commodities, fashions, styles, art works . . . , it is difference that we consume. Baudrillard: "The sign object is neither given nor exchanged: it is appropriated, withheld and manipulated by individual subjects as a sign, that is, as coded difference. Here lies the object of consumption."[36] Here too lies the object of fascination: for it is the arbitrary, artificial nature of this code — its fetishistic facticity, *not* its mythical naturalness — that compels us, controls us. To expose its false nature, to manipulate its differences hardly constitutes resistance, as is commonly believed: it simply means that you are a good player, a good consumer.

171

The Code and the Minor

> In the economic order it is the mastery of *accumulation*, of the appropriation of surplus value, which is essential. In the order of signs (of culture), it is mastery of *expenditure* that is decisive, that is, a mastery of the transubstantiation of economic exchange value into sign exchange value based on a monopoly of the code. Dominant classes have always either assured their domination over sign values from the outset (archaic and traditional societies) or endeavored (in the capitalist bourgeois order) to surpass, to transcend and to consecrate their economic privilege in a semiotic privilege because this later stage represents the ultimate stage of domination. This logic, which comes to relay class logic and which is no longer defined by ownership of the means of production but by the mastery of the process of signification... activates a mode of production radically different from that of material production....[37]

Traditionally the rule of the bourgeoisie is referred to its direct control of the means of production and to its effective management of social relations through cultural institutions and state apparatuses. Yet, as suggested above, this rule came to depend no less directly on "mastery of the process of signification." This change, a shift in the nature of bourgeois hegemony, was a response to resistance on the part of the producers, i.e., of the proletariat. Yet its consequences extend to this day, for this change was also a shift in the nature of social production: the economic and the cultural realms, once separated in the bourgeois order, have come to subsume one another (in Baudrillardian terms the commodity form and the sign form unite in a single code of sign exchange value).[38] We have noted how the bourgeoisie, confronted by the proletariat, began to relinquish its own cultural forms (indeed its own cultural coherence) and how this "surrender" allowed it to free up its economic enterprises and to devise new modes of domination. Here we need to investigate its "monopoly of the code," for it is this that is now the decisive form of social control and this, as much as any patriarchal order, that a political cultural practice must resist.

To Baudrillard, the Marxist critique of the commodity form and

exchange value pertains to the "productivist" phase of capital only. For the "consummativist" phase, in which we literally consume the coded differences of commodity-signs, this critique must be extended to the sign form and sign exchange value. The two logics are similar because they both abstract. Commodities are produced and exchanged in reference to the market (where they acquire an equivalence), not in relation to the individual or to the world – not to use value. And so with signs: they make meaning and produce value in differential relation to other signs, not as human expression or representation of things in the world – not in relation to the referent (or, finally, to the signified).[39] This process by which symbolic material is abstracted and reduced was to Barthes the very operation of myth; it is to Baudrillard the very logic of the commodity-sign – a logic of domination that is thus inscribed not only in our systems of production and consumption but also in our systems of communication:

> All the repressive and reductive strategies of power systems are already present in the internal logic of the sign, as well as those of exchange value and political economy. Only total revolution, theoretical and practical, can restore the symbolic in the demise of the sign and of value. Even signs must burn.[40]

But what inflammatory strategies can be taken up? In this regard appropriation becomes problematic not only because it implies a truth beyond ideology and a subject (e.g., a critic or artist) free of it, but because it is predicated on the logic of the sign, not a critique of it. In fact, the two practices of myth-critique "are generated in the spirit of one of the two terms that comprise [the sign]: that is, either in the name of the signified (or referent: same thing), which it is then necessary to liberate from the stranglehold of the code (of the signifier) – or in the name of the signifier, which must be liberated from that of the signified."[41] Which is to say that the first practice, the move to *reclaim* the appropriated sign for its social group, may succumb to an idealism of the referent, of truth, meaning, use value (as if these things, once abstracted, can be readily restored); and the second practice, the move to *remythify*

Sherrie Levine. *Untitled*, 1978.

or reinscribe the mass-cultural sign, may be compromised by a "fetishism of the signifier." That such a practice often reflects a *passion* for the code (even in the guise of a critique of it) is apparent in the work of many artist appropriators and subcultural *bricoleurs*: virtuosos of the code, these connoisseurs are its best producers/consumers, seduced by its abstract manipulations, "trapped in the factitious, differential, encoded, systematized aspect of the object."[42] As they shake the sign, contest the code, they may only manipulate signifiers within it and so replicate rather than dismantle its logic. This is not to make the facile charge that myth-critical art is now another museum category or that subcultural *bricolage* is continually recouped as fashion, but to question whether such appropriation is indeed a *counter*appropriation, a deconstructive doubling, or simply a reproduction of the code, a further fragmentation of the sign. For, again, the code is defined as the "free play and concatenation of signifiers," and what is the agency of this circulation of shattered signs if not capital?[43]

What strategy, then, short of an impossible(?) disinvestment in this code, can disrupt or *de*code it? To Baudrillard it is the purity and uniformity of our system of object-signs that fascinate us. This clue, together with the fact that what we consume in the code is the *difference* of object-signs, suggests that fetishism is involved:

> Something like a desire, a perverse desire, the desire of the code is brought to light here: it is a desire that is related to the systematic nature of signs, drawn towards it precisely through what this systemlike nature negates and bars by exorcising the contradictions spawned by the process of real labor — just as the perverse psychological structure of the fetishist is organized in the fetish object around a mark, around the abstraction of a mark that negates, bars and exorcises the difference of sexes.[44]

Like the narcissism of the child, the perfection of the code excludes us, *seduces* us — precisely because it seems to offer "another side or 'beyond'" to castration and to labor. The first point of resistance, then, is to insist on the reality of sexual difference and on the fact that commodity-signs are products of labor. So, too, though both sexuality and representation answer to a specific social regime and

Silvia Kolbowski. *Model Pleasure, Part 5*, 1983. (Photo: Mary Bachmann).

"monopoly of the code," it must be insisted that this regime, never uniform, is a text of conflictual relations of production, and that this "monopoly," never total, is constantly tested by contrary modes of signification. For it is the denial of these uneven conditions that lends the code of commodity-signs its fetishistic quality as a system; and it is in turn this systematic character that allows it to encode social practices in the present and to efface them in the past. Finally, then, it is this ceaseless semiotic encoding – by which all political and symbolic activity, new and old, is reduced to another form, language or style in the code – that must be resisted, exceeded or otherwise disrupted.

Briefly, I want to suggest two perhaps contradictory models that seem useful in this regard: the concept of *the minor* developed by Deleuze and Guattari, and the concept of *cultural revolution* elaborated by Fredric Jameson. In my use here, "the minor" represents a cultural practice that exceeds the (differential) logic

176

of the code as well as the conventional categories of sociology,[45] and "cultural revolution" stands for a critical activity that reactivates the conflictual history of sign-systems so as to break through the (ahistorical) logic of the code as well as the formalist discourse of academic disciplines.[46]

For Deleuze and Guattari the minor (which is precisely *not* a value judgment) is an intensive, often vernacular use of a language or form which disrupts its official or institutional functions. As an example they cite the writing of Kafka — i.e., of an other (a Jew) in a master language (German) in an alien place (Prague). Unlike other discourses or styles in major (bourgeois) culture, the minor has no desire "to fill a major language function, to offer [its] services as the language of the state, the official tongue."[47] Yet, by the same token, it has no romance of the marginal (on the contrary, the minor is apposed to the marginal, to its delusory critique positioned as it is in relation to the center); and it has no romance for the individual (it refuses the Œdipal arrangement of individual artist versus paternal tradition). Indeed, in the minor "there is no subject: *there are only collective arrangements of utterance.*"[48] (Examples of the minor might include Black gospel, reggae, surrealist Latin American fiction.) This is a "death of the author" that is perhaps new to us: a postindividual experience based less on the dispersal of subjectivity than on the articulation of a collectivity, one that does not heed the normative categories of major culture. (As Lyotard says, minorities are "not critics; they are much 'worse'; they do not *believe*.")[49] In this refusal of the major culture is the possibility that traditions and languages repressed by it might return. It is this "mishmash" that Deleuze and Guattari urge us to express:

> Even if a tongue is unique, it is still a mishmash, a schizophrenic mélange, a Harlequin suit in which different functions of language and distinct power centers act — airing what can and cannot be said. Play one function against the other, bring the coefficients of territoriality and relative deterritorialization into play. Even if it is major, a tongue is capable of intensive use which spins it out along creative lines of escape.... Set the oppressed character of this

177

tongue against its oppressive character, find its points of nonculture and undevelopment, the zones of linguistic third-worlds through which a tongue escapes, an animal is grafted, an arrangement is connected...know to create a becoming-minor.[50]

The minor comes into play here precisely because it is innocent of any passion for the code. Resistant to semiotic appropriations, it is able to expose the very "mishmash" that the code seeks to exorcise. But the minor must do more than ruin or exceed the code as a system; it must also disrupt it in time — which is to say it must connect with minor practices in the past. Only when linked with such "nonsynchronous" forces ("the objectively nonsynchronous is that which is far from and alien to the present; it includes both declining remnants and, above all, uncompleted pasts, which have not yet been 'sublated' by capitalism")[51] can the minor become truly untimely, critically effective, in the present. To this end the notion of cultural revolution comes into play — as a way to restore the conflictual complexity of productive modes and sign-systems that is written out of the causal history of major culture (the history of the victors, as Benjamin would say) and as a way to decode how our own mode of domination exploits all old and new productive modes and sign-systems for its own purposes.[52] The two operations may go hand in hand. For the illumination of nonsynchronous elements (i.e., incomplete elements in past social formations, residual ones in our own) may well provoke the irruption of minor elements (contrary, revolutionary, emergent forces) in the present and vice versa. Theoretically at least, such an irruption would not play into the hands of the code, would escape recuperation, precisely because these new and old signs would contest the code as an absolute sign-system. (It would also not be a matter of the revalidation of this or that archaic mode: on the contrary, the contradictory coexistence of modes in any one cultural present would be underscored.) In this critical rewriting, this cultural revolution, any model of history as a series of discrete, necessary "stages" or any theory of one social moment as a total system (as a "code" or a "culture industry") is revealed for what it is: a fallacy, an *ideology* whereby, in the example of the code, one mode (i.e., advanced

capitalism) is mistaken as final and its dominant feature (i.e., commodity reification) as absolute.

Here important tasks for criticism and art alike emerge: for criticism to (re)apprehend in the (historical) work of art the revolutionary conflicts (between sign-systems and ultimately perhaps between classes) that the work of art resolves or otherwise engages;[53] and for art to expose rather than reconcile these contradictions in the present, indeed to intensify them. What I propose is not entirely new: it is basically what Nietzsche termed a "genealogy" and what Foucault called the "insurrection of subjugated knowledges."[54] But what must be stressed is the need to *connect* the buried (the nonsynchronous), the disqualified (the minor) and the yet-to-come (the utopian or, better, the desired) in concerted cultural practices. For finally it is this association which can most fully resist major culture, its semiotic appropriations, normative categories and official history.

Photo by Louise Lawler from *A Picture Is No Substitute for Anything*, Sherrie
Levine and Louise Lawler published in *Wedge* 2 (Fall 1982).

The "Primitive" Unconscious
of Modern Art, or
White Skin Black Masks

At once excentric and crucial, *Les Demoiselles d'Avignon* (1907) is
the set piece of the Museum of Modern Art (MOMA): a bridge be-
tween modernist and premodernist painting, a primal scene of
modern primitivism. It is there that a step outside the tradition is
said to coincide with a leap within it. Yet is this æsthetic break-
through not also a breakdown, psychologically regressive, politi-
cally reactionary? The painting presents an encounter in which are
inscribed two scenes: the depicted one of the brothel and the pro-
jected one of the heralded 1907 visit of Picasso to the collection of
tribal artifacts in the Musée d'Ethnographie du Trocadéro. This
double encounter is tellingly situated: the prostitutes in the bor-
dello, the African masks in the Trocadéro, both disposed for recog-
nition, for use.[1] There is, to be sure, both fear and desire of this
other figured here,[2] but is it not desire for mastery and fear of its
frustration?

However ideological, this inscription of the primitive onto
woman as other threatens male subjectivity. As the *Demoiselles*
less resolves than is riven by this threat, it displays both its decen-
tering and its defense. For in some sense Picasso did intuit one
apotropaic function of the tribal objects — and adopted them as
such, as "weapons":

> They were against everything — against unknown threatening
> spirits. . . . I, too, I am against everything. I, too, believe that every-
> thing is unknown, that everything is an enemy! . . . women, chil-

181

dren... the whole of it! I understood what the Negroes used their sculptures for.... All fetishes... were weapons. To help people avoid coming under the influence of spirits again, to help them become independent. Spirits, the unconscious... they are all the same thing. I understood why I was a painter. All alone in that awful museum with the masks... the dusty mannikins. *Les Demoiselles d'Avignon* must have been born that day, but not at all because of the forms; because it was my first exorcism painting — yes absolutely![3]

Apart from the (bombastic) avant-gardism here, Picasso does convey the shock of this encounter as well as the euphoria of his solution, an extraordinary psycho-æsthetic move by which otherness was used to ward away others (woman, death, the primitive) and by which, finally, a crisis in phallocentric culture was turned into one of its great monuments.

In the *Demoiselles* if Picasso transgresses, he does so in order to "mediate" the primitive in the name of the west (and it is in part for this that he remains the hero of the MOMA story of modern art). In this regard, the *Demoiselles* is indeed a primal scene of primitivism, one in which its structure of narcissism and aggressivity is revealed. Such confrontational identification is characteristic of the Lacanian Imaginary, the realm to which the subject returns when confronted with the threat of difference.[4] Here, then, primitivism emerges as a fetishistic discourse, a recognition and disavowal not only of primitive difference but of the fact that the west — its patriarchal subject and socius — is threatened by loss, by lack, by others.

Les Demoiselles d'Avignon was also the set piece of the recent MOMA exhibition-cum-book "'Primitivism' in 20th Century Art: Affinity of the Tribal and the Modern,"[5] in which it was presented, along with African masks often proposed as sources for the demoiselles, in such a way as to support the curatorial case for a modern/ tribal affinity in art (the argument runs that Picasso could not have seen these masks, that the painting manifests an intuitive primitivity or "savage mind"). This presentation was typical of the abstractive operation of the show, premised as it was on the belief that

182

"modernist primitivism depends on the autonomous force of objects" and that its complexities can be revealed "in purely visual terms, simply by the juxtaposition of knowingly selected works of art."[6] Though the exhibition did qualify the debased art-historical notion of causal influence (e.g., of the tribal on the modern), as on another front it demolished the more debased racist model of an evolutionary primitivism, it did so often only to replace the first with "affinity" (in the form of the family of *homo artifex*) and the second with the empty universal, "human creativity wherever found."[7]

Based on the æsthetic concerns of the modern artists,[8] the "Primitivism" show cannot be condemned on ethnological grounds alone. Too often the contextualist rebuke is facile, a compensatory expression of a liberal-humanist remorse for what cannot be restored. It is, after all, the vocation of the modern art museum to decontextualize. (Claude Lévi-Strauss describes anthropology as a *technique du dépaysement:*[9] how much more is this true of art history?) And in the case of the tribal objects on display, the museum is but one final stage in a series of abstractions, of power-knowledge plays that constitute primitivism. Yet to acknowledge decontextualization is one thing, to produce ideas with it another. For it is this absolution of (con)textual meanings and ideological problems in the self-sufficiency of form that allowed for the humanist presuppositions of the show (that the final criterion is Form, the only context Art, the primary subject Man). In this way the show confirmed the colonial extraction of the tribal work (in the guise of its redemption as art) and rehearsed its artistic appropriation into tradition.[10] No counterdiscourse was posed: the imperialist precondition of primitivism was suppressed, and "primitivism," a metonym of imperialism, served as its disavowal.

This abstraction of the tribal is only half the story; no less essential to the production of affinity-effects was the decontextualization of the modern work. It too appeared without indices of its contextual mediations (i.e., the dialectic of avant garde, kitsch and academy, by which it is structured: it is, incidentally, the excision of this dialectic that allows for the formal-historicist model of mod-

ernism in the first place). The modern objects on view, most of which are preoccupied by a primitivist form and/or "look," alone represented how the primitive is thought. Which is to say that the modern/tribal encounter was mapped in mostly positivist terms (the surfaces of influence, the forms of affinity) – in terms of morphological coincidence, not conceptual displacement. (The "transgressivity" of the encounter was largely disregarded, perhaps because it cannot be so readily *seen*.) In this way the show abstracted and separated the modern and the tribal into two sets of objects that could then only be "affined." Thus reduced to form, it is no wonder they came to reflect one another in the glass of the vitrines, and one is tempted to ask, cynically enough, after such a double abstraction, such a double tropism toward modern (en)light(enment), what is left but "affinity"? What part of this hypothesis-turned-show was discovery (of transcultural forms, innate structures and the like) and what part (modernist) invention?

Elective Affinities, or Impressions d'Afrique (et d'Oceanie)

For William Rubin, director of the "Primitivism" show, the idea of "elective affinity" between the tribal and the modern arises from two oracular pronouncements of Picasso: one to the effect that this relationship is similar to that between the Renaissance and antiquity; the other that his own tribal objects were "more witnesses than models"[11] of his art. Innocuous enough, these statements nevertheless suggest how primitivism is conceived to absorb the primitive, in part via the concept of affinity. The renaissance of antiquity is an intrawestern event, the very discovery of a westernness: to pose it as an analogy is almost ipso facto to inscribe the tribal as modern-primitivist, to deny its difference. Moreover, the analogy implies that the modern and the tribal, like the Renaissance and antiquity, are affined in the search for "fundaments." Argued particularly by codirector Kirk Varnedoe,[12] this position tends to cast the primitive as primal and to elide the different ways

in which the fundamental is thought. The other Picasso testimonial, that the tribal objects were witnesses only, sets up in the disavowal of influence the notion of affinity. Yet, if not direct sources, "the Negro pieces" were not, on account of this, mere secret sharers: they were seen, as Picasso remarked to Malraux, as "mediators"[13] — that is, *forms for use*. If the Renaissance analogy poses the tribal as falsely familial, here recognition is contingent upon instrumentality. In this way, through affinity and use, the primitive is sent up into the service of the western tradition (which is then seen to have partly produced it).

The exhibition commenced with displays of certain modernist involvements with tribal art: interest, resemblance, influence and affinity proper — usually of a roughly analogous structure and/or conception.[14] In the inspired pairing of the Picasso construction *Guitar* (1912) and a Grebo mask owned by him, Rubin argued that the projective eyes of the mask allowed Picasso to think the hole of the guitar as a cylinder and thus to use space as form, a surrogate as sign (a discovery proleptic of synthetic cubism). Such affinity, conceptual, "ideographic" not merely formal,[15] was also argued in the juxtaposition of a Picasso painting of superimposed profiles (*Head*, 1928) and a Yam mask with the same element for eyes, nose and mouth, in both of which the "features" appear more arbitrary than naturally motivated. Now the two do share an ideographic relation to the object, and different signifieds may be informed by similar signifiers. But the works are affined mostly in that they differ from another (western "realist") paradigm,[16] and the arbitrariness of the sign (at least with the tribal object) is largely due to abstraction from its code.

Otherwise, the affinities proposed in the show were mostly morphological — or were treated as such even when they appeared metaphorical or even semiological (as in certain surrealist transformations wrung by Picasso). These formally coincidental affinities seemed derived in equal part from the formalist reception of the primitive read back into the tribal work and from the radical abstraction performed on both sets of objects. This production of affinity through projection and abstraction was exposed in the

"Affinities" section, most dramatically in the juxtaposition of a painted Oceanic wood figure and a Kenneth Noland target painting (*Tondo*, 1961), a work which, in its critical context at least, is precisely not about the anthropomorphic and asks not to be read iconographically. What does this pairing tell us about "universals": that the circle is such a form, or that affinity is the effect of an erasure of difference? Here universality is indeed circular, the specular image of the modern seen in the mask of the tribal.

Significantly, the show dismissed the primitivist misreading par excellence: that tribal art is intrinsically expressionistic or even psychologically expressive, when it is in fact ritualistic, decorative, apotropaic, therapeutic, etc. But it failed to question other extrapolations from one set of objects, one cultural context, to the other: to question what is at stake ideologically when the "magical" character of tribal work is read (especially by Picasso) into modern art, or when modern values of intentionality, originality and æsthetic feeling are bestowed upon tribal objects.[17] In both instances different orders of the socius and of the subject, of the economy of the object and of the place of the artist are transposed with violence; and the result threatens to turn the primitive into a specular western code whereby different orders of tribal culture are made to conform to one western typology. (That the modern work can reveal properties in the tribal is not necessarily evolutionist, but it does tend to pose the two as different stages and thus to encompass the tribal within our privileged historical consciousness.)[18]

No less than the formal abstraction of the tribal, this specular code of the primitive produces affinity-effects.[19] For what do we behold here: a universality of form or an other rendered in our own image, an affinity with our own Imaginary primitive? Though properly wary of the terms primitive and tribal, the first because of its Darwinist associations, the second because of its hypothetical nature, the curators used both as "conventional counters"[20] — but it is precisely this conventionality that is in question. Rubin distinguished primitive style from the archaic (e.g., Iberian, Egyptian, Mesoamerican) *diacritically* in relation to the west. The primitive is said to pertain to a "tribal" socius with communal forms and the

archaic to a "court" civilization with static, hieratic, monumental art. This definition, which excludes as much as it includes, seems to specify the primitive/tribal but in fact suspends it. Neither "dead" like the archaic nor "historical," the primitive is cast into a nebulous past and/or into an idealist realm of "primitive" essences. (Thus the tribal objects, not dated in the show, are still not entirely free of the old evolutionist association with primal or ancient artifacts, a confusion entertained by the moderns.) In this way, the primitive/tribal is set adrift from specific referents and coordinates — which then makes it possible to define it in wholly western terms. And one begins to see that one of the preconditions, if not of primitivism, then certainly of the "Primitivism" show, is the mummification of the tribal and the museumification of its objects (which vital cultures like the Zuni have specifically protested against).

The founding act of this recoding is the repositioning of the tribal object as art. Posed against its use first as evolutionist trophy and then as ethnographic evidence, this æstheticization is not entirely value-free, for it allows the work to be both decontextualized and commodified. It is this *currency* of the primitive among the moderns — its currency as sign, its circulation as commodity — that must be thought; indeed, it is this currency, this equivalence, that largely allows for the modern/tribal affinity-effect in the first place. The "Primitivism" show exhibited this currency but did not theorize it. Moreover, it no more "corrected" this primitivist code than it did the official formalist model of modernism. This code was already partly in place by the time of the MOMA "African Negro Art" show in 1935, when James Johnson Sweeney wrote against its undue "historical and ethnographic" reception: "It is as sculpture we should approach it."[21] Apart from anti-Darwinist motives, the imperative here was to confirm the formalist reading and newfound value of the African objects. With the African cast as a specifically plastic art, the counter term — a pictorial art — was institutionally bestowed upon Oceanic work, with the 1946 MOMA exhibition "Arts of the South Seas," directed by René D'Harnoncourt, which, though it did not mention the surrealists directly, noted an "affin-

ity" in the art with the "dreamworld and subconscious."[22] It then remained for Alfred Barr (in a 1950 letter to the *College Art Journal*) to historicize this purely diacritical, purely western system as a "discovery":

> It is worth noting, briefly, the two great waves of discovery: the first might be called cubist-expressionist. This was concerned primarily with formal, plastic and emotional values of a direct kind. The second wave, quasi-surrealist, was more preoccupied with the fantastic and imaginative values of primitive art.[23]

The "Primitivism" show only extended this code, structured as it was around a "Wölfflinian generalization"[24] of African tactility (sculptural, iconic, monochromatic, geometric...) versus Oceanic visuality (pictorial, narrative, colorful, curvilinear...), the first related to ritual, the second to myth, with ritual, Rubin writes, "more inherently 'abstract' than myth. Thus, the more ritually oriented African work would again appeal to the Cubist, while the more mythic content of the Oceanic/American work would engage the Surrealist."[25] This æsthetic code is only part of a cultural system of other paired terms, both within the primitive (e.g., malefic Africa versus paradisal Oceania) and within primitivism (e.g., noble or savage or vital primitive versus corrupt or civilized or enervated westerner), to which we will return. Suffice it to say here that the tribal/modern affinity is largely the effect of a decoding of the tribal (a "deterritorializing" in the Deleuzian sense) and a recoding in specular modern terms. As with most formal or even structural approaches, the referent (the tribal socius) tends to be bracketed, if not banished, and the historical (the imperialist condition of possibility) disavowed.[26]

Essentially, the OED distinguishes three kinds of "affinity": resemblance, kinship and spiritual or chemical attraction ("elective affinity"). As suggested, the affinities in the show, mostly of the first order, were used to connote affinities of the second order: an optical illusion induced the mirage of the (modernist) Family of Art. However progressive once, this election to *our* humanity is now thoroughly ideological, for if evolutionism subordinated the

primitive to western history, affinity-ism recoups it under the sign of western universality. ("Humanity," Lévi-Strauss suggests, is a modern western concept.)[27] In this recognition difference is discovered only to be fetishistically disavowed, and in the celebration of "human creativity" the dissolution of specific cultures is carried out: the Museum of Modern Art played host to the Musée de l'Homme indeed.

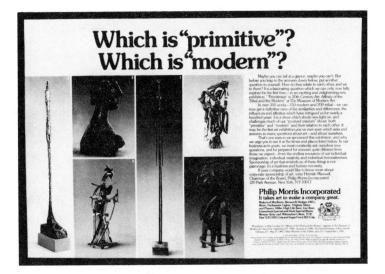

Advertisement courtesy of Philip Morris, Inc.

MOMAism

MOMA has long served as an American metonym of modern art, with the history of the one often charted in terms of the space of the other. This mapping has in turn supported a "historical-transcendental"[28] reading of modernism as a "dialectic" or a deductive line of formal innovations within the tradition. Now in the decay of this model the museum has become open to charges that it represses political and/or transgressive art (e.g., productivism, dada), that it is indifferent to contemporary work (or able to engage it only when, as in the "International Survey of Recent Painting and Sculpture," it conforms to its traditional categories), that it is a period piece, etc. In this situation the "Primitivism" show could not but be overdetermined, especially when billed as a "significant correction of the received history of modern art."[29] What history was corrected here, and in the name of what present? What would be the stake, for example, if MOMA had presented a show of the modern encounter with mass-cultural products rather than tribal objects? Could it map such a *topos* and not violate its formal-historicist premises? Could the museum absorb art that challenges official modernist paradigms as well as institutional media apparatuses as it can incorporate primitivist art? More important, did MOMA in fact pose a new model of modernism here, one based not on transformation within but on transgression without—an engagement with an outside (tribal traditions, popular cultures, etc.) that might disrupt the order of western art and thought?

The conflicted relation of "Primitivism" to the modern and to the present was evident in its contradictory point of view. At once immanent and transcendent, mystificatory and demystificatory, the show both rehearsed the modern reception of the tribal "from the inside" and posited an affinity between the two "from above." It reproduced some modern (mis)readings (e.g., the formal, oneiric, "magical"), exposed others (e.g., the expressionist), only to impose ones of its own (the intentional, original, "æsthetic," problem-solving). The status of its objects was also ambiguous. Though presented as art, the tribal objects are manifestly the ruins of (mostly)

dead cultures now exposed to our archeological probes – *and so too are the modern objects*, despite the agenda to "correct" the institutional reading of the modern (to keep it alive via some essential, eternal "primitivism"?). Against its own intentions, the show signaled a potentially postmodern, posttribal present; indeed, in the technological vacuum of the museum space, this present seemed all but posthistorical.

But the exhibition did more than mark our distance from the modern and tribal objects; it also revealed the epistemological limits of the museum. How to represent the modern/tribal encounter adequately? How to map the intertextuality of this event? Rather than abstractly affine objects point by point, how to trace the mediations that divide and conjoin each term? If primitivism is in part an æsthetic construct, how to display its historical conditions? In its very lack, the show suggested the need of a Foucauldean archeology of primitivism, one which, rather than speak from an academic "postcolonial" place, might take its own colonialist condition of possibility as its object. Such an enterprise, however, is beyond the museum, the business of which is patronage – the formation of a paternal tradition against the transgressive outside, a documentation of civilization not the barbarism underneath. In neither its epistemological space nor its ideological history can MOMA in particular engage those disruptive terms. Instead it recoups the outside dialectically – as a moment in its own history – and transforms the transgressive into continuity. (To be recognized by the moderns, the primitive had to be useful; now, to be recognized by MOMA, it has to conform – to modern art.) With this show MOMA may have moved to revise its formal(ist) model of the modern now adjudged (even by it?) to be inadequate, but it did so only to incorporate the outside in its originary (modern) moment as primitivism. Meanwhile, except for the token, misconstrued presence of Robert Smithson (and perhaps Joseph Beuys), the transgressive in its transfigured (contemporary) moment – in all its disruptions of æsthetic, logocentric categories – was not acknowledged, let alone thought.

This recuperation of the primitive has its own history, which Var-

nedoe in various essays narrates: from "formal quotations" (e.g., the appropriations of most fauves and cubists) to "synthetic metaphor" (the universal languages of several abstract expressionists) to "assimilated ideal" (the primitivism of most of the artists in the contemporary section), the primitive has become primitivist.[30] Reduced to a ghostly affinity outside the tradition, the primitive now becomes an "invisible man"[31] within it. This absorption allows the primitive to be read retroactively almost as an effect of the modern tradition. Cultural preparation – that "the primitive" was also achieved from within modern art – is claimed. This is the basic argument of the classic *Primitivism in Modern Art* (1938, 1966) by Robert Goldwater; its first sentences read: "The artistic interest of the twentieth century in the productions of primitive peoples was neither as unexpected nor as sudden as is generally supposed. Its preparation goes well back into the nineteenth century...."[32] This, too, was essentially the argument of the "Primitivism" show: that modern art was "becoming other" prior to the 1907 Picasso visit to the Trocadéro. Thus the heroes of the show were artists who "prepared" the primitive (Gauguin) and/or incorporated it (Picasso) – artists who turned the "trauma" of the other into an "epiphany" of the same.[33]

That the primitive was recognized only after innovations within the tradition is well documented: but what is the effectivity here, the ratio between invention and recognition, innovation and assimilation? Is the primitive to be thought as a "robinsonnade of a constitutive constituent dialectic"[34] within western tradition, or as a transgressive event visited upon it, at once embraced and defended against? For surely primitivism was generated as much to "manage" the shock of the primitive as to celebrate its art or to use it "counterculturally" (Rubin). As noted, the show argued "affinity" and "preparation"; yet here, beyond the abstraction of the first and the recuperation of the second, the primitive is *superseded:* "the role of the objects Picasso saw on this first visit to the Trocadéro was obviously less that of providing plastic ideas than of sanctioning his even more radical progress along a path he was already breaking."[35] This retrospective reading of the primitive "role" tends not

only to assimilate the primitive other *to* tradition but to recuperate the modernist break *with* tradition, all in the interests of progressive history. (As the very crux of MOMAism, analytical cubism in particular must be protected from outside influence; thus tribal art is assigned "but a residual role"[36] in it.) What, apart from the institutional need to secure an official history, is the motive behind this desired supersession? What but the formation of a cultural identity, incumbent as this is on the simultaneous need and disavowal of the other?

Generally perceived as primal and exotic, the primitive posed a double threat to the logocentric west, the threat of otherness and relativism. It also posed a doubly different artifact, more "immediate," more "magical." We know how the early moderns reclaimed this artifact as art, abstracted it into form; how, also, the "Primitivism" show mitigated its otherness, projected it as affinity. Here we may see how this otherness was further recouped by a reading of the tribal artist that served to recenter the modern artist, rendered somewhat marginal or academic by mass culture, as a shamanistic figure. Meanwhile, the tribal object with its ritual/ symbolic exchange value was put on display, reinscribed in terms of exhibition/sign exchange value. (Could it be that the "magic" perceived in the object was in part its difference from the commodity form, which modern art resisted but to which it was partly reduced?) In this way, the potential disruption posed by the tribal work — that art might reclaim a ritual function, that it might retain an ambivalence of the sacred object or gift and not be reduced to the equivalence of the commodity — was blocked. And the African fetish, which represents a different social exchange just as the modern work aspires to one, became another kind of fetish: the "magical" commodity.

In the "Primitivism" show a transgressive model of modernism was glimpsed, one which, repressed by the formalist account, might have displaced the MOMA model — its "Hegelian" history, its "Bauhausian" ideals, its formal-historicist operation (e.g., of abstraction achieved by analytic reduction within the patriarchal line: Manet... Cézanne... Picasso: of the western tradition). This

displacement, however, was only a feint: this "new" model – that the very condition of the so-called modern break with tradition is a break outside it – was suggested, then occluded, then recouped. With transgression without rendered as dialectic within, the official model of modern art – a multiplicity of breaks reinscribed (by the artist/critic) into a synthetic line of formal innovations – is preserved, as is the causal time of history, the narrative space of the museum.

Seen as a genuine agenda, the show presents this conflicted scenario: MOMA moves to reposition the modern as transgressive but is blocked by its own premises, and the contradiction is "resolved" by a formalist approach that reduces what was to be pronounced. Seen as a false agenda, this cynical scenario emerges: the show pretends to revise the MOMA story of art, to disrupt its formal and narrative unity, but only so as to reestablish it: the transgressive is acknowledged only to be again repressed. As suggested, that this "correction" is presented now is extremely overdetermined. How better, in the unconscious of the museum, to "resolve" these contradictions than with a show suggestive on the one hand of a transgressive modernism and on the other of a still active primitivism? Not only can MOMA then recoup the modern-transgressive, it can do so as if it had rejected its own formalist past. This maneuver also allows it at once to contain the return of its repressed and to connect with a neoprimitivist moment in contemporary art: MOMAism is not past after all! In all these ways, the critique posed by the primitive is contravened, absorbed within the body of modern art: "As if we were afraid to conceive of the Other in the time of our own thought."[37]

Georges Braque in his studio, Paris, 1911.

Primitivism

Historically, the primitive is articulated by the west in deprivative or supplemental terms: as a spectacle of savagery or as a state of grace, as a socius without writing or the Word, history or cultural complexity or as a site of originary unity, symbolic plenitude, natural vitality. There is nothing odd about this Eurocentric construction: the primitive has served as a coded other at least since the Enlightenment, usually as a subordinate term in its imaginary set of oppositions (light/dark, rational/irrational, civilized/savage). This domesticated primitive is thus constructive, not disruptive, of the binary *ratio* of the west; fixed as a structural opposite or a dialectical other to be incorporated, it assists in the establishment of a western identity, center, norm and name. In its modernist version the primitive may appear transgressive, it is true, but it still serves as a limit: projected within and without, the primitive becomes a figure of our unconscious and outside (a figure constructed in modern art as well as in psychoanalysis and anthropology in the privileged triad of the primitive, the child and the insane).

If in the MOMA "Primitivism" production Rubin presented the art-historical code of the primitive, Varnedoe offered a philosophical reading of primitivism. In doing so, he reproduced within it the very Enlightenment logic by which the primitive was first seized, then (re)constructed. There are two primitivisms, Varnedoe argues, a good rational one and a dark sinister one.[38] In the first, the primitive is reconciled with the scientific in a search for fundamental laws and universal language (the putative cases are Gauguin and certain abstract expressionists). This progressive primitivism seeks enlightenment, not regressive escape into unreason, and thinks the primitive as a "spiritual regeneration" (in which "the Primitive is held to be spiritually akin to that of the new man"),[39] not as a social transgression. Thus recouped philosophically, the primitive becomes part of the internal reformation of the west, a moment within *its* reason; and the west, "culturally prepared," escapes the radical interrogation which it otherwise poses.

But more is at stake here, for the reason that is at issue is none

other than the Enlightenment, which to the humanist Varnedoe remains knightlike; indeed, he cites the sanguine Gauguin on the "luminous spread of science, which today from West to East lights up all the modern world."[40] Yet in the dialectic of the Enlightenment, as Adorno and Horkheimer argued, the liberation of the other can issue in its liquidation; the enlightenment of "affinity" may indeed eradicate difference.[41] (And if this seems extreme, think of those who draw a direct line from the Enlightenment to the Gulag.) Western man and his primitive other are no more equal partners in the March of Reason than they were in the Spread of the Word, than they are in the Marketing of Capitalism. The Enlightenment cannot be protected from its other legacy, the "bad-irrational" primitivism (Varnedoe's dramatic example is Nazi Blood and Soil, the swastika ur-sign), any more than the "good-rational" primitivism (e.g., the ideographic explorations of Picasso) can be redeemed from colonial exploration. Dialectically, the progressivity of the one is the regression of the other.

Varnedoe argues, via Gauguin, that "modern artistic primitivism" is not "antithetical to scientific knowledge."[42] One can only agree, but not as he intends it, for primitivism is indeed instrumental to such power-knowledge, to the "luminous spread" of western domination. On the one hand, the primitivist incorporation of the other is another form of conquest (if a more subtle one than the imperialist extraction of labor and materials); on the other, it serves as its displacement, its disguise, even its excuse. Thus, to pose the relation of the primitive and the scientific as a benign dialogue is cruelly euphemistic: it obscures the real affiliations (affinities?) between science and conquest, enlightenment and eradication, primitivist art and imperialist power. (This can be pardoned of a romantic artist at the end of the last century who, immersed in the ideology of a scientistic avant garde, could not know the effectivity of these ideas, but not of an art historian at the end of this century.)

Apart from the violence done to the other in the occlusion of the imperialist connection of primitivism and in the mystification of the Enlightenment as a universal good, this good/bad typology tends to mistake the disruption posed by the primitive and to cast

any embrace of this disruption — any resistance to an instrumental, reificatory reason, any reclamation of cognitive modes repressed in its regime — as "nihilistic," regressive, "pessimistic."[43] (It is thus that the transgressive primitivism of such artists as Smithson is dismissed.) We are left where we began, locked in our old specular code of ethical oppositions. But then we were told all along that the issue was "human creativity wherever found":

> This is the extreme of liberal thought and the most beautiful way of preserving the initiative and priority of Western thought within "dialogue" and under the sign of the universality of the human mind (as always for Enlightenment anthropology). Here is the beautiful soul! Is it possible to be more impartial in the sensitive and intellectual knowledge of the other? This harmonious vision of two thought processes renders their *confrontation* perfectly inoffensive, by denying the difference of the primitives as an element of rupture with and subversion of (our) "objectified thought and its mechanisms."[44]

There is a counterreading of the primitive precisely as subversive, to which we must return, but it is important to consider here what cultural function primitivism generally performs. As a fetishistic recognition-and-disavowal of difference, primitivism involves a (mis)construction of the other. That much is clear; but it also involves a (mis)recognition of the same. "If the West has produced anthropologists," Lévi-Strauss writes in *Tristes Tropiques*, "it is because it was tormented by remorse."[45] Certainly primitivism is touched by this remorse too; as the "elevation" of the artifact to art, of the tribal to humanity, it is a compensatory form. It is not simply that this compensation is false, that the artifact is evacuated even as it is elevated (the ritual work become an exhibition form, the ambivalent object reduced to commodity equivalence), that finally no white skin fond of black masks can ever recompense the colonialist subjection detailed in *Black Skin White Masks* (Frantz Fanon). To value as art what is now a ruin; to locate what one lacks in what one has destroyed: more is at work here than compensation. Like fetishism, primitivism is a system of multiple beliefs, an imaginary resolution of a real contradiction:[46] a repres-

198

sion of the fact that a breakthrough in our art, indeed a regenera-
tion of our culture, is based in part on the breakup and decay of
other societies, that the modernist discovery of the primitive is not
only in part its oblivion but its death. And the final contradiction
or aporia is this: no anthropological remorse, æsthetic elevation or
redemptive exhibition can correct or compensate this loss *because
they are all implicated in it.*

Primitivism, then, not only absorbs the potential disruption of
the tribal objects into western forms, ideas and commodities; it
also symptomatically manages the ideological nightmare of a great
art inspired by spoils. More, as an artistic coup founded on military
conquest, primitivism camouflages this historical event, disguises
the problem of imperialism in terms of art, affinity, dialogue, to
the point (the point of the MOMA show) where the problem ap-
pears "resolved."

A counterdiscourse to primitivism is posed differently at differ-
ent moments: the destruction of racial or evolutionist myths, the
critique of functionalist models of the primitive socius, the ques-
tioning of constructs of the tribal, etc. Lévi-Strauss has argued
most publicly against these models and myths in a culturalist read-
ing that the "savage mind" is equally complex as the western, that
primitive society is indeed based on a nature/culture opposition
just as our own is. Other ethnologists like Marshall Sahlins and
Pierre Clastres have also countered the negative conception of the
primitive as people without god, law and language. Where Lévi-
Strauss argues that the primitive socius is not without history but
thinks it as form, Sahlins writes that paleolithic hunters and gather-
ers, far from a subsistence society, constitute the "first affluent"
one, and Clastres (a student of Lévi-Strauss) contended that the
lack of a state in the primitive socius is a sign not of prehistorical
status, as it may be thought in a western teleology, but of an active
exorcism of external force or hierarchical power: a society not
without but *against* the state.[47]

Such a theoretical displacement is not simply an event internal
to ethnology: it is partly incited by anticolonial movements of the
postwar period and by third-world resistance in our own time; and

it is partly affirmed by a politicization of other disciplines. For if primitivism is a denial of difference, then the countermeasure is precisely its insistence, "opening the culture to experiences of the Other," as Edward Said writes, "the recovery of a history hitherto either misrepresented or rendered invisible."[48] Finally, no doubt, a counterdiscourse can only come through a countermemory, an account of the modern/primitive encounter from the "other" side.[49] But lest this recovery of the other be a recuperation into a western narrative, a political genealogy of primitivism is also necessary, one which would trace the affiliations between primitivist art and colonial practice. It is precisely this genealogy that the MOMA show did not (could not?) attempt; indeed, the issue of colonialism, when raised at all, was raised in colonialist terms, as a question of the accessibility of certain tribal objects in the west.

As for a cultural counterpractice, one is suggested by the "primitive" operation of *bricolage* and by the surrealist reception of the primitive as a rupture. Indeed, the dissident surrealists (Georges Bataille chief among them) present, if not a "counterprimitivism" as such, then at least a model of how the otherness of the primitive might be thought disruptively, not recuperated abstractly. It is well known that several of these surrealists, some of whom were amateur anthropologists, were not as oblivious as most fauves and cubists to the contexts and codes of the primitive, that some politicized rather than æstheticized the primitivist-imperialist connection (in 1931, Louis Aragon and others organized an anticolonial exhibition to counter the official *Exposition coloniale* in the new Musée des Colonies). And when these "ethnographic surrealists" did æstheticize, it tended to be in the interests of "cultural impurities and disturbing syncretisms." Which is to say that they prized in the tribal object not its *raisonnable* form but its *bricolé* heterogeneity, not its mediatory possibilities but its transgressive value. In short, the primitive appeared less as a solution to western æsthetic problems than as a disruption of western solutions. Rather than seek to master the primitive – or, alternatively, to fetishize its difference into opposition or identity – these primitivists welcomed "the unclassified, unsought Other."[50]

It is most likely excessive (and worse, dualistic!) to oppose these two readings of the primitive – the one concerned to incorporate the primitive, the other eager to transgress with it – and to extrapolate the latter into a counterpractice to the former. (Again, such a counterpractice is not for the west to supply.) However, *bricolage* – which Lévi-Strauss, influenced by the surrealists, did after all define as a "primitive" mode – is today posed in the third world (and in its name) as such a resistant operation, by which the other might appropriate the forms of the modern capitalist west and fragment them with indigenous ones in a reflexive, critical montage of synthetic contradictions.[51] Such *bricolage* might in turn reveal that western culture is hardly the integral "engineered" whole that it seems to be but that it too is *bricolé* (indeed, Derrida has deconstructed the Lévi-Strauss opposition *bricoleur*/engineer to the effect that the latter is the product, the myth of the former).[52]

One tactical problem is that *bricolage*, as the inversion of the appropriative abstraction of primitivism, might seem retroactively to excuse it. Indeed, the famous Lévi-Strauss formula for *bricolage* is uncannily close to the Barthes definition of appropriation (or "myth"). In his definition (1962) Lévi-Strauss cites Franz Boas on mythical systems: "'it would seem that mythological worlds have been built up, only to be shattered again, and that new worlds were built from the fragments'"; and adds: "in the continual reconstruction from the same materials, it is always earlier ends which are called upon to play the part of means: the signified changes into the signifying and vice versa."[53] Compare Barthes on myth (1957): "it is constructed from a semiological chain which existed before it: it *is a second-order semiological system*. That which is a sign...in the first system becomes a mere signifier in the second."[54] The difference, of course, is that myth is a one-way appropriation, an act of power, while *bricolage* is a process of textual play, of loss and gain: whereas myth abstracts and pretends to the natural, *bricolage* cuts up, makes concrete, delights in the artificial – it knows no identity, stands for no pretense of presence or universal guise for relative truths. Thus, if it is by a "mythical" reduction of content to form that the primitive becomes primitivist,

by a mythical abstraction of signified into a signifier that African ritual objects, customs, *people* become "Africanity" — if it is by myth that one arrives at affinity and universality — then *bricolage* may well constitute a counterpractice. For in *bricolage* not only may the primitive signified be reclaimed but the western signified may be mythified in turn, which is to say that primitivism (the myths of the African, the Oceanic... that still circulate among us) may possibly be deconstructed and other models of intercultural exchange posed. However compromised by *its* appropriation as an artistic device in the west (superficially understood, *bricolage* has become the "inspiration" of much primitivist art), *bricolage* remains a strategic practice, for just as the concept of myth demystifies "natural" modes of expression and "neutral" uses of other-cultural forms, so too the device of *bricolage* deconstructs such notions as a modern/tribal "affinity" or modernist "universality" and such constructs as a fixed primitive "essence" or a stable western "identity."

The Other is Becoming the Same; the Same is Becoming Different

Below, I want briefly to pose, in fact to collide, two readings of the primitive encounter with the west: that of its progressive eclipse in modern history and that of its disruptive return (in displaced form) in contemporary theory. The first history, as we have seen, positions the primitive as a moment in the "luminous spread" of western reason; the second, a genealogy, traces how the primitive, taken into this order, returns to disrupt it. The difficulty is to think these contrary readings simultaneously, the first aggressively historicist, the second historically enigmatic.

If the identity of the west is defined dialectically by its other, what happens to this identity when its limit is crossed, its outside eclipsed? (This eclipse may not be entirely hypothetical given a multinational capitalism that seems to know no limits, to destructure all oppositions, to occupy its field all but totally.) One effect

is that the logic that thinks the primitive in terms of opposition or as an outside is threatened. (As Derrida noted in the work of Lévi-Strauss or as Foucault came to see within his own thought, such structural terms can no longer be supported even as methodological devices.)[55] In the second narrative, this "eclipsed" or sublated primitive reemerges in western culture as its scandal – where it links up genealogically with poststructuralist deconstruction and politically with feminist theory and practice. In this passage the primitive other is transformed utterly, and here in particular its real-world history must be thought. For the historical incorporation of the outside might well be the condition that compels its eruption into the field of the same as difference. Indeed, the eclipse of otherness, posed as a metaphysical structure of opposites or as an outside to be recovered dialectically, is the beginning of difference – and of a potential break with the phallocentric order of the west.

(This genealogy is not as conjectural as it may seem: connections between certain "ethnographic surrealists" and poststructuralists are there to be traced. The intermediary figures are Lacan, Lévi-Strauss and, above all, Bataille, whose notions of *dépense* and *la part maudite*, developed out of Mauss's theory of the gift, has influenced Baudrillard, and whose notion of transgression has influenced Foucault and Derrida. On this reading, if the early moderns sublated the primitive into reason, the dissident surrealists thought it transgressively; but it was left to poststructuralism and feminism to theorize it, however transformed in position and effectivity. As Rosalind Krauss has suggested, the poststructuralist and feminist deconstruction of phallocentric oppositions is related to the "collapse of differences" – i.e., of *oppositions* between natural and unnatural forms, conscious and unconscious states, reality and representation, politics and art – that is at the heart of surrealist scandal.[56] It is this transgressive enterprise that is dismissed as "arbitrary" and "trivial" in postwar American formalism in which, in a neomodernist moment, crisis is once more recouped for continuity. Indeed, this collapse or rupture is not thought deeply again till the art of the generation of Smithson, in which formalist

criteria give way to a concern with "structure, sign and play," in which, with such devices as the site-nonsite, the form of the exhibition work with expressive origin and centered meaning is displaced by a serial or textual mode "with a concept of limits that could never be located."[57])

On the one hand, then, the primitive is a modern problem, a crisis in cultural identity, which the west moves to resolve: hence the modernist construction "primitivism," the fetishistic recognition-and-disavowal of the primitive difference. This ideological resolution renders it a "nonproblem" for us. On the other hand, this resolution is only a repression: delayed into our political unconscious, the primitive returns uncannily at the moment of its potential eclipse. The rupture of the primitive, managed by the moderns, becomes our postmodern event.[58]

The first history of the primitive encounter with the west is familiar enough: the fatalistic narrative of domination. In this narrative 1492 is an inaugural date, for it marks the period not only of the discovery of America (and the rounding of the Cape of Good Hope) but also of the renaissance of antiquity. These two events — an encounter with the other and a return to the same — allow for the incorporation of the modern west and the instauration of its dialectical history. (Significantly, in Spain, 1492 also marks the banishment of the Jews and Arabs and the publication of the first modern European grammar; in other words, the expulsion of the other within and the "encoding" of the other without.)[59] This, too, is the period of the first museums in Europe and of "the first works on the 'life and manners' of remote peoples" — a collection of the ancients and "savages," of the historically and spatially distant.[60] This collection only expands, as the west develops with capitalism and colonialism into a world-system. By the 18th century, with the Enlightenment, the west is able to reflect on itself "as a culture *in the universal*, and thus all other cultures were entered into its museum as vestiges of its own image."[61]

There is no need to rehearse this "dialectic" here, the progressive domination of external and internal nature (the colonization of the outside and the unconscious), but it is important to note that

this history is not without its representations and contestations in modern theory. Indeed, in 1946 Merleau-Ponty could write:

All the great philosophical ideas of the past century – the philosophies of Marx and Nietzsche, phenomenology, German existentialism and psychoanalysis – had their beginnings in Hegel; it was he who started the attempt to explore the irrational and integrate it into an expanded reason, which remains the task of our century.[62]

There is, however, an obvious paradox here: the western *ratio* is defined against the very unreason that it integrates; its dialectical identity requires the very other that it absorbs, disavows or otherwise reduces to the same. It is this paradox that the notion of transgression, as elaborated by Bataille amidst discussions of both "the end of history" and the otherness of the primitive, addresses. (Bataille attended the lectures on Hegel given by Alexandre Kojève in the 30s; he was also the principal theorist of the primitive as transgressive.) In his essay on Bataille – an essay in which the surrealist concern with the other may be linked to the poststructuralist concern with difference – Foucault opposes the transgressive to the dialectical as a way to think through the logic of contradiction, as a "form of thought in which the interrogation of the limit replaces the search for totality."[63] Yet if transgression challenges the dialectic, the end of history and the incorporation of the primitive other, it also presupposes (or at least foreshadows) them. Which is to say that the transgressive appears as a stopgap of the dialectical; it recomposes an outside, an other, a sacred, if only in its absence: "all our actions are addressed to this absence in a profanation which at once identifies it, dissipates it, exhausts itself in it, and restores it in the empty purity of its transgression."[64] Transgression is thus bound by a paradox of its own: it remarks limits even as it violates them, it restores an outside even as it testifies to its loss. It is on the borderline between dialectical thought and the becoming of difference, just as the structuralism of Lévi-Strauss is on the borderline between metaphysical oppositions and deconstruction.

There is no question that today we are beyond this border, that we live in a time of cancelled limits, destructured oppositions,

"dissipated scandals"[65] (which is not to say that they are not recoded all the time). Clearly, the modern structures in which the western subject and socius were articulated (the nuclear family, the industrial city, the nation-state...) are today remapped in the movement of capital. In this movement the opposition nature/culture has become not only theoretically suspect but practically obsolete: there are now few zones of "savage thought" to oppose to the western *ratio*, few primitive others not threatened by incorporation. But in this displacement of the other there is also a decentering of the same, as signalled in the '60s when Foucault abandoned the logic of structural or dialectical oppositions (e.g., reason/unreason) in favor of a field of immanent relations, or when Derrida proclaimed the absence of any fixed center or origin, of any "original or transcendental signified...outside a system of differences."[66] It was this that led Foucault to announce, grandly enough, the dissolution of man in language. More provocative, however, was his suggestion, made at the same moment (1966), that "modern thought is advancing toward the region where man's Other must become the Same as himself."[67] In the modern episteme, Foucault argued, the transparent sovereign *cogito* has broken down, and western man is compelled to think the unthought ("to represent the unrepresentable," Lyotard would say). Indeed, his very truth is articulated in relation to the unconscious and the other; thus the privilege granted psychoanalysis and ethnology among the modern human sciences. The question returns then: What happens to this man, his truth, when the unconscious and the other are penetrated — integrated into reason, colonized by capital, commodified by mass culture?

Tellingly, it was in the '30s and '40s, after the high stage of imperialism and before the anticolonial wars of liberation, that the discourse of the other was most thoroughly theorized — by Lacan, of course, and Lévi-Strauss (who, in *Tristes Tropiques*, pondered "the ethnological equivalent of the mirror stage")[68] but also by Sartre, who argued that the other was necessary to the "fusion" of any group, and Adorno and Horkheimer, who elaborated the role of otherness in Nazism. I mention these latter here to suggest that,

however decentered by the other, the (western) subject continues to encroach mercilessly upon it. Indeed by 1962 (when Lévi-Strauss wrote that "there are still zones in which savage thought, like savage species, is relatively protected"),[69] Paul Ricoeur could foresee in detail "a universal world civilization." To Ricoeur, this moment was less one of the imperialist "shock of conquest and domination" than one of the shock of disorientation: for the other a moment when, with the wars of liberation, the "politics of otherness" had reached its limit, and for the west a moment when it became "possible that there are just *others*, that we ourselves are an 'other' among others."[70]

This disorientation of a world civilization is hardly new to us today. In 1962 Ricoeur argued that to survive in it each culture must be grounded in its own indigenous tradition; otherwise this "civilization" would be domination pure and simple. Similarly, in our own time Jürgen Habermas has argued that the modern west, to restore its identity, must critically appropriate its tradition – the very project of Enlightenment that led to this "universal civilization" in the first place.[71] Allegories of hope, these two readings seem early and late symptoms of our own postmodern present, a moment when the west, its limit apparently broached by an all-but-global capital, has begun to recycle its own historical episodes as styles together with its appropriated images of exotica (of domesticated otherness) in a culture of nostalgia and pastiche – in a culture of implosion, "the internal violence of a saturated whole."[72]

Ricoeur wrote presciently of a moment when "the whole of mankind becomes a kind of imaginary museum."[73] It may be this sense of closure, of claustrophobia that has provoked a new "primitivism" and "Orientalism" in recent theory: e.g., the Baudrillardian notion of a primitive order of symbolic exchange that "haunts" our own system of sign exchange, or the Deleuzian idea of a "savage territoriality" now deterritorialized by capital; Barthes's Japan cast as the "possibility of a difference, of a mutation, of a revolution in the propriety of symbolic systems," or Derrida's or Foucault's China seen as an order of things that "interrupts" western logocentrism.[74] But rather than seek or resuscitate a lost or dead other, why not

turn to vital others within and without – to affirm *their* resistance to the white, patriarchal order of western culture? For feminists, for "minorities," for "tribal" peoples, there are other ways to narrate this history of enlightenment/eradication, ways which reject the narcissistic pathos that identifies the death of the Hegelian dialectic with the end of western history and the end of that history with the death of man, which also reject the reductive reading that the other can be so "colonized" (as if it were a zone simply to occupy, as if it did not emerge imbricated in other spaces, to trouble other discourses) – or even that western sciences of the other, psychoanalysis and ethnology, can be fixed so dogmatically. On this reading the other remains – indeed, as the very field of difference in which the subject emerges – to challenge western pretenses of sovereignty, supremacy and self-creation.

Lothar Baumgarten, *Monument for the Indian Nations of South America*, Document 7, 1982.

Third floor plan of the Museum of Modern Art (before renovation) as reproduced in *Artforum* (November 1974).

Notes

Introduction

1. Jean-François Lyotard, *The Postmodern Condition: A Report on Knowledge*, trans. G. Bennington and B. Massumi (Minneapolis: University of Minnesota Press, 1984), xxiii.
2. See Paul de Man, "Criticism and Crisis," in *Blindness and Insight* (Minneapolis: University of Minnesota Press, 1983).
3. The risk of the first, æstheticist approach is to turn criticism into judgment, that of the second, ideological-critical method is to mystify it as "scientific"; the danger of the third, hermeneutic approach is to reduce the text to the signified of one interpretation or intention, and that of the fourth, structuralist method is to impose a logic on the work that is then "discovered" to be its structure.
4. See the first chapter ("On Interpretation") of Fredric Jameson, *The Political Unconscious* (Ithaca: Cornell University Press, 1981).
5. See "Intellectuals and Power: A Conversation Between Michel Foucault and Gilles Deleuze," in Foucault, *Language Counter-Memory, Practice*, ed. Donald F. Bouchard (Ithaca: Cornell University Press, 1977), 205–17.
6. I borrow this term from Jacques Attali; see his *Noise*, trans. Brian Massumi (Minneapolis: University of Minnesota Press, 1985), 5.
7. Edward W. Said, "Opponents, Audiences, Constituencies and Community," in *The Anti-Æsthetic: Essays on Postmodern Culture*, ed. Hal Foster (Port Townsend: Bay Press, 1983), 157.
8. Jürgen Habermas has written extensively on both these conditions; however, the historicity of "the public sphere" in his formulation remains problematic. I am indebted here to Terry Eagleton, *The Function of Criticism* (London: Verso, 1984).
9. Habermas, "Modernity – An Incomplete Project," in *The Anti-Æsthetic*, 9–11.
10. The term is Habermas's; see Richard Wolin, "Modernism versus Postmodernism," *Telos* 62 (Winter 1984–85): 27.

11. Said, 155. Eagleton elaborates on "literary humanist discourse": "Its role was to *be* marginal: to figure as that 'excess,' that supplement to social reality which in Derridean style both revealed and concealed a lack, at once appending itself to an apparently replete social order and unmasking an absence at its heart where the stirrings of repressed desire could be faintly detected. This, surely, is the true locus of 'high culture' in late monopoly capitalism: neither decorative irrelevance nor indispensable ideology, neither structural nor superfluous, but a properly marginal presence, marking the border where that society both encounters and exiles its own disabling absences" (pp. 91–92).

12. Eagleton, 10–11.

13. These considerations are not as historically abstract as they may seem, nor as removed from artistic practice. Two different examples: In his documentary projects Hans Haacke has exposed "public culture" to be largely synonymous with corporate (state) "public relations" – the manipulation of art to create the illusion of a public culture which then serves to conceal real political differences and destructive private interests. For his part Richard Serra has refused to figure or convene a public in his large urban sculptures – a "negation" far truer to the present status of the public (let alone the historicity of art) than the manipulative figurative sculpture and *architecture parlante* that passes for "populist" and "contextual." In effect, Serra transforms the absence of a consensual public into form, or rather provides a counterform to our fragmentary body politic. The recent decision of the General Services Administration to remove his site-specific sculpture *Tilted Arc* (a government commission) from the federal plaza in lower Manhattan, moreover, supports many of the above considerations: the erosion of a public for art and its conflation with populism, the forced marginality of art and the dismissal of critical competence (the decision was made "on the basis of the record" of a public hearing, though the great majority of the speakers favored retention of the sculpture on its site), etc.

14. Eagleton, 69.

15. Far from evolutionary or even historicist, this conception of the involvement of cultural object and critical text allows for structural change that is at once (semi)autonomous to both fields and responsive to social history. Peter Bürger glosses this basic recognition of Marx in *Theory of the Avant-Garde*, trans. Michael Shaw (Minneapolis: University of Minnesota Press, 1984), li–lii.

16. Roland Barthes, "Change the Object Itself," in *Image-Music-Text*, trans. Stephen Heath (New York: Hill and Wang, 1977), 166.

17. See Benjamin H. D. Buchloh, "Allegorical Procedures: Appropriations and Montage in Contemporary Art," *Artforum* (September 1982): 43–56.

18. See Craig Owens, "The Allegorical Impulse: Toward a Theory of Postmodernism," *October* 12 and 13 (Spring and Summer 1980); reprinted in *Art After Modernism: Rethinking Representation*, ed. Brian Wallis (New York/Boston: New Museum of Contemporary Art/David R. Godine, 1985).

19. Barthes, 169.

20. Jean Baudrillard, "'Fetishism and Ideology," in *For a Critique of the Political Economy of the Sign*, trans. Charles Levin (St. Louis: Telos Press, 1981), 92.

21. See also Fredric Jameson, "Postmodernism, or the Cultural Logic of Late Capitalism," *New Left Review* 146 (July-August 1984). Whether "postmodernism" signals a new recognition of cultural differences or is simply "the latest proper name of the west" (Gayatri Spivak) remains to be debated.
22. There are many more. Besides a tendency to reduce specific objects to so many signs and symptoms, there is my parochial choice of subjects. Most troublesome for me is my relative inattention to (political) art groups outside the purview of the art world and to critical abstract art. Yet if the former suggests my situational limits as a critic mostly removed from political activity, the latter is outside my conjunctural focus here.
23. Work by these and other artists, as well as related video and film, had its first major American presentation in the show "Difference: On Representation and Sexuality," curated for the New Museum by Kate Linker and Jane Weinstock. See the catalogue (New York: The New Museum, 1984); also see the issue of *Afterimage* (April 1985) devoted to the show.
24. This is also the strategy of several feminist theorists; the best example is Jane Gallop, *Feminism and Psychoanalysis: The Daughter's Seduction* (Ithaca: Cornell University Press, 1982).
25. Martha Rosler, "Notes on Quotes," *Wedge* 2 (Fall 1982): 72.
26. Michel Foucault, *The History of Sexuality*, vol. 1, trans. Robert Hurley (New York: Pantheon, 1978), 83. For Foucault, whose antagonism for the Lacanians was reciprocated, the Lacanian notion of "the law" is no less problematic than the Freudian "thematics of repression": "They both rely on a common representation of power which, depending on the use made of it and the position it is accorded with respect to desire, leads to two contrary results: either to the promise of 'liberation,' if power is seen as having only an external hold on desire, or, if it is constitutive of desire itself, to the affirmation: you are always-already trapped."
27. This possibility is clearly voiced within feminism (which I hardly intend to "speak for" here). "Perhaps it is becoming necessary," Jane Weinstock writes in the "Difference" catalogue, "to move closer to what has been called the French 'essentialism' in order to escape a position of perpetual otherness" (p. 44). I take this not as a call to any essentialism as such but as the need, in "the postnatural world of late capitalism" (Jameson) in which patriarchal structures are continually recoded, to move beyond the opposition nature/culture to a genuine order of difference.

Against Pluralism

1. Lionel Trilling, "On the Teaching of Modern Literature," *Beyond Culture* (New York and London: Harcourt Brace Jovanovich, 1965), 23.
2. Herbert Marcuse, *One-Dimensional Man* (Boston: Beacon Press, 1964), 61.
3. Achille Bonito Oliva, *The Italian Trans-Avantgarde*, trans. Gwen Jones and Michael Moore (Milan: Giancarlo Politi Editore, 1980), 28, 32 and passim.
4. Though it is evident that much contemporary art dialectically revises minimalism and so in some sense derives from it.
5. Edit deAk, "A Chameleon in a State of Grace," *Artforum* (February 1981): 40.

6. Benjamin H. D. Buchloh, "Figures of Authority, Ciphers of Regression: Notes on the Return of Representation in European Painting," *October* 16 (Spring 1981): 54.
7. Marcuse, 72–79.
8. See Douglas Crimp, "The Photographic Activity of Postmodernism," *October* 15 (Winter 1980): 91–101.
9. See Rosalind Krauss, "Sense and Sensibility: Reflections on Post-'60s Sculpture," *Artforum* (November 1973): 43–55.
10. See Carter Ratcliff, "Robert Morris: Prisoner of Modernism," *Art in America* (October 1979): 96–109.
11. Craig Owens has extended this notion of ambivalence in this way: "It seems to me that contemporary artists simulate schizophrenia as a mimetic defense against increasingly contradictory demands – on the one hand, to be as innovative and original as possible; on the other, to conform to established norms and conventions" ("Honor, Power and the Love of Women," *Art in America* [January 1983]).
12. Theodor W. Adorno, "On the Fetish-Character in Music and the Regression of Listening," in *The Essential Frankfurt School Reader*, ed. Andrew Arato and Eike Gebhardt (New York: Urizen Books, 1978), 280.
13. Much art today plays with literal and pastiched references to art history and pop culture alike. On the analogy with architecture, it may be termed post-modern. Such art, however, must be distinguished from postmoder*nist* art which is posed theoretically against modernist paradigms. Whereas post-modern art refers so as to elicit a given response and regards the reference as natural, the return to history as certain, postmoder*nist* art refers to question the truth-value of representation. For more on this difference – and its possible collapse – see "(Post)Modern Polemics" elsewhere in this volume.
14. See Peter Bürger, *Theory of the Avant-Garde*, trans. Michael Shaw (Minneapolis: University of Minnesota Press, 1984).
15. Quoted in deAk, 40.
16. See "Readings in Cultural Resistance" elsewhere in this volume.
17. Jean Baudrillard, *For a Critique of the Political Economy of the Sign* (1972), trans. Charles Levin (St. Louis: Telos Press, 1981), 50.
18. Harold Rosenberg, *Discovering the Present* (Chicago: University of Chicago Press, 1973), xi.
19. This involution must finally be posed in relation to the present, all but global penetration of capital: as the world market shifts production to its periphery, a reverse migration flows into its urban nodes and is there internally marginalized.
20. See Roland Barthes, "Change the Object Itself," *Image-Music-Text*, trans. Stephen Heath (New York: Hill and Wang, 1977), 166–67.
21. See Kenneth Frampton, "Intimations of Tactility," *Artforum* (March 1981), 52–58.
22. See Fredric Jameson, *Fables of Aggression: Wyndham Lewis, the Modernist as Fascist* (Berkeley: University of California Press, 1979), 62–80.
23. Robert Venturi provided the basis for such an argument vis-à-vis postmodern architecture, and Donald Kuspit has argued such a line vis-à-vis recent art

(specifically new image); see Kuspit, "Stops and Starts in Seventies Art and Criticism," *Arts* (March 1981): 98.

24. See Charles Jencks, *The Language of Post-Modern Architecture* (London: Architectural Design, 1977).
25. Kuspit, 98.
26. See Serge Guilbault, *How New York Stole the Idea of Modern Art*, trans. Arthur Goldhammer (Chicago: University of Chicago Press, 1983).
27. Oliva, 11.
28. Oliva, 28.

Between Modernism and the Media

1. Clement Greenberg, "Avant-Garde and Kitsch," in *Art and Culture* (Boston: Beacon Press, 1961), 8. My reading of this essay is influenced by T. J. Clark's "Clement Greenberg's Theory of Art," *Critical Inquiry*, vol. 9, no. 1 (September 1982): 139–56.
2. Ibid., 5.
3. Quoted in Walter Benjamin, *Charles Baudelaire: A Lyric Poet in the Era of High Capitalism*, trans. Harry Zohn (London: NLB, 1973), 14.
4. See in particular Thomas Crow, "Modernism and Mass Culture in the Visual Arts," in *Modernism and Modernity*, ed. B. Buchloh, S. Guilbault, D. Solkin (Halifax: Press of the Nova Scotia College of Art and Design, 1983), 215–64.
5. Craig Owens, "The Problem of Peurilism," *Art in America* (Summer 1984): 162–63. On the gentrification of the East Village see Rosalyn Deutsche and Cara Gendel Ryan, "The Fine Art of Gentrification," *October* 31 (Winter 1984): 91–111.
6. For more extensive discussions of this "troubling" see T. J. Clark, "Preliminaries to a Possible Treatment of 'Olympia' in 1865," *Screen*, vol. 21, no. 1 (Spring 1980), and Norman Bryson, *Vision and Painting* (New Haven: Yale University Press, 1983), 143–48.
7. Benjamin H. D. Buchloh, "Figures of Authority, Ciphers of Regression," *October* 16 (Spring 1981): 53. My remarks on "regression" are influenced by this essay.
8. Buchloh writes: "The question for us now is to what extent the rediscovery and recapitulation of these modes of figurative representation in present-day European painting reflect and dismantle the ideological impact of growing authoritarianism, or to what extent they simply indulge and reap the benefits of this increasingly apparent political practice; or, worse yet, to what extent they cynically generate a cultural climate of authoritarianism to familiarize us with the political realities to come" ("Ciphers," 40).
9. Sigmund Freud, "The Origin and Development of Psychoanalysis" (1910), in *A General Selection from the Works of Sigmund Freud*, ed. John Rickman (Garden City: Doubleday, 1957), 31.
10. See Freud, "Character and Anal Erotism" (1908) and "On the Transformation of the Instincts with Special Reference to Anal Erotism" (1917), in *Character and Culture*, ed. Philip Rieff (New York: MacMillan Publishing Co., 1963). In *Civilization and Its Discontents* (New York: W. W. Norton, 1961), Freud

215

writes: "Anal erotism...succumbs in the first instance to the 'organic repression' which paved the way to civilization" (pp. 52–53).
For Freud the first step on this way was the repression of the olfactory and the privilege granted the visual when man adopted an erect posture.

11. See Owens, "Honor, Power and the Love of Women," *Art in America* (January 1983). On the historicity of modes and materials see Buchloh, "Michael Asher and the Conclusion of Modernist Sculpture," in *Performance, Text(e)s & Documents*, ed. Chantal Pontbriand (Montreal: les editions Parachute, 1981), 55–65

12. As Buchloh argues in "Ciphers," these references are also national(ist); that is, they support a certain protection of cultural products and anachronism of cultural categories (thus the Italian painters may revive "southern" modes like fresco, while the German neoexpressionists resurrect "northern" ones like woodcuts).

13. For the Bloch/Lukács exchange on expressionism, originally published in 1938, see *Æsthetics and Politics* (London: NLB, 1977), 16–59. Bloch's response is to Lukács's 1934 essay "Expressionism: Its Significance and Decline," in *Essays on Realism*, ed. Rodney Livingstone, trans. David Fernbach (Cambridge: MIT Press, 1980), 76–113.

14. Lukács, "Expressionism," 102–03, 109, 89.

15. Jean Baudrillard, "Fetishism and Ideology: the Semiological Reduction," in *For a Critique of the Political Economy of the Sign*, trans. Charles Levin (St. Louis: Telos Press, 1981), 92.

16. Buchloh, "Ciphers," 62.

17. Régis Debray, *Teachers, Writers, Celebrities: the Intellectuals of Modern France*, trans. David Macey (London: NLB, 1981), 243–44.

18. See Baudrillard, "Requiem for the Media," in *For a Critique of Political Economy of the Sign*.

19. For this art recoding of graffiti see Rene Ricard, "The Radiant Child," *Artforum* (December 1981).

20. Baudrillard, "Kool Killer ou l'insurrection par les signes," in *L'échange symbolique et la mort* (Paris: Editions Gallimard, 1976), 122. My discussion of graffiti is indebted to this essay.

21. Ibid.

22. See Thomas Lawson, "Last Exit: Painting," *Artforum* (October 1981). This essay takes its point of departure and attack from Douglas Crimp's discussion of Daniel Buren in "The End of Painting," *October* 16 (Spring 1981).

23. See Greenberg, "Modernist Painting," *Art and Literature*, vol. 4 (Spring 1965): 193–201; also see Michael Fried, "Art and Objecthood," *Artforum* (Summer 1967).

24. See "Intellectuals and Power: A Conversation with Michel Foucault and Gilles Deleuze," *Language, Counter-Memory, Practice*, ed. Donald Bouchard (Ithaca: Cornell University Press, 1977), 209. Also see Owens' "The Discourse of Others: Feminists and Postmodernism," in *The Anti-Æsthetic: Essays on Postmodern Culture*, ed. Hal Foster (Port Townsend: Bay Press, 1983).

25. Benjamin, "The Author as Producer," in *The Essential Frankfurt School Reader*, ed. Andrew Arato and Eike Gebhardt (New York: Urizen Books, 1978), 261.

26. See Fredric Jameson, *The Political Unconscious* (Ithaca: Cornell University Press, 1981), 77ff.; also see "Readings in Cultural Resistance" elsewhere in this volume.
27. See "Images That Understand Us: A Conversation with David Salle and James Welling," LAICA *Journal*, vol. 27 (June – July 1980).
28. Theodor Adorno, "Looking Back on Surrealism," in *The Idea of the Modern in Literature and the Arts*, ed. Irving Howe (New York: Urizen Books, 1967), 223; quoted in Martin Jay, *Adorno* (Cambridge: Harvard University Press, 1984), 129.

The Expressive Fallacy

1. Theodor Adorno, "Cultural Criticism and Society," *Prisms*, trans. Samuel and Shierry Weber (Cambridge: MIT Press, 1981), 31.
2. Louis Marin, "Toward a Theory of Reading the Visual Arts: Poussin's *The Arcadian Shepherds*," in *The Reader in the Text*, ed. S. Suleiman and I. Crosman (Princeton: Princeton University Press, 1980).
3. This may be less the case in abstract-expressionist painting where the material elements are said to exist "as such" – but do they not then encode or represent "flatness," etc.?
4. Of course, not all nonnaturalistic marks are expressionist; here the coded act of freeing or canceling should be stressed.
5. This intuition of Greenberg's ("After Abstract Expressionism"), revised by Michael Fried ("Art and Objecthood"), remains true: the canvas signals a representational paradigm first. (And if this paradigm is superseded, it may be by a textual rather than an abstract model – the canvas as Rauschenbergian "site.")
6. Paul de Man, *Allegories of Reading* (New Haven: Yale University Press, 1979), 107.
7. Quoted in de Man, 108.
8. "It is not only man who speaks, but...in man and by man it [id] speaks,...his nature becomes woven by the effects where the structure of language, whose material he becomes, is recovered" (Jacques Lacan, *Ecrits* [Paris: 1966], 688–89).
9. Michel Foucault argues that "the author" is a "functional principal...by which one *impedes* the free circulation...of fiction" (italics added) in "What Is an Author?" in *Textual Strategies*, ed. Josué V. Harari (Ithaca: Cornell University Press, 1979), 159. This historical function is the inverse of the conventional conception of the "expressive" artist – which suggests that this figure is an ideological one.
10. In "Gesture and Signature: Semiurgy in Contemporary Art" in *For a Critique of the Political Economy of the Sign*, trans. Charles Levin (St. Louis: Telos Press, 1981), Jean Baudrillard argues that with the transcendent orders of God and nature abolished, the oeuvre becomes its own original, its own referent, with the consequence that each mark, each painting is read according more to its difference from other marks, other paintings within a body of work than to its verisimilitude or to its expressiveness. (This "reflexivity" is also demonstrated in the paintings of Charles Clough.)

11. See "The 'Primitive' Unconscious of Modern Art, or White Skin Black Masks" elsewhere in this volume.
12. Adorno, "Notes on Kafka," *Prisms*, 262.
13. Baudrillard, *Simulacres et simulation* (Paris: Edition Galilée, 1981), 52.
14. Adorno, "On the Fetish-Character in Music and the Regression of Listening" (1938) in *The Essential Frankfurt School Reader*, ed. Andrew Arato and Eike Gebhardt (New York: Urizen Books, 1978), 280.
15. These ideas are developed by Roland Barthes primarily in "The Photographic Message," "Rhetoric of the Image" and "The Third Meaning" in *Image-Music-Text*, trans. Stephen Heath (New York: Hill and Wang, 1977). In a sense Casebere operates between photography and drawing or "writing." Barthes: "The photograph, message without a code, must thus be opposed to the drawing which, even when denoted, is a coded message."
16. "The simulacrum implies great dimensions, depths, and distances which the observer cannot dominate. It is because he cannot master them that he has an impression of resemblance. The simulacrum includes within itself the differential point of view, and the spectator is made part of the simulacrum, which is transformed and deformed according to his point of view" (Gilles Deleuze, "Plato and the Simulacrum," trans. Rosalind Krauss, *October* 27 [Winter 1983]: 49).
17. In his 1919 essay on the uncanny Freud cites as typically uncanny the confusing of live and dead, of real and imaginary, and the usurping of things by symbols — precisely the effects of Casebere's images. In general for Freud, the uncanny (or *unheimlich*) is a familiar (or *heimlich*) event that, estranged through repression, returns to us in the form of the dreaded, the bizarre. This return obeys the principle of the repetition-compulsion, which governs our instinctual tendency to regress to a prior state. Whatever reminds us of this inner compulsion — which is at work in play, dreams and neuroses — is also perceived as uncanny; and therein lies the uncanniness of Casebere's simulacra. For more on these matters, see my "Uncanny Images," *Art in America* (November 1983): 202–04.
18. See Michel Foucault, *The History of Sexuality*, vol. 1, trans. Robert Hurley (New York: Pantheon, 1978).
19. Adorno, *The Jargon of Authenticity*, trans. Knut Tarnowski and Frederic Will (Evanston: Northwestern University Press, 1973), 99.
20. The artist meanwhile is often an exception: in the novel he is allowed to cross class lines. *Allowed*: this is his function: to attest to the (false) liberality of the system. For a "proto-neoconservative" discussion of these matters see Lionel Trilling, *Sincerity and Authenticity* (Cambridge: Harvard University Press, 1972).
21. Baudrillard, *Simulacres et simulation*, 52.
22. See Jonathan Crary, "Gretchen Bender at Nature Morte," *Art in America* (April 1984): 189–90.
23. De Man, "Criticism and Crisis," in *Æsthetics Today*, ed. M. Philipson and P. Gudel (New York: New American Library, 1980), 345.

Contemporary Art and Spectacle

1. See Jean Baudrillard, *Simulacres et simulation* (Paris: Editions Galilée, 1981), 69–76.
2. In *Our Hitler* Syberberg presents Hitler as "the final attempt of Europe to realize itself through its ancient traditions" and as "the greatest filmmaker of the 20th century." See Hans-Jürgen Syberberg, *Hitler: A Film from Germany* (New York: Farrar, Straus, Giroux, 1982).
3. Baudrillard, 20.
4. Program notes for *Empire* are published in *Wedge* 1 (Summer 1982); also see the fine essay on the performance by Brian Wallis in the same issue.
5. Guy Debord, *Society of the Spectacle* (1967; Detroit: Black & Red, 1977), note 2.
6. Theodor W. Adorno, *In Search of Wagner*, trans. Rodney Livingstone (London, NLB, 1981), 91–92.
7. Carl E. Schorske, *Fin-de-Siècle Vienna: Politics and Culture* (New York: Vintage Books, 1981), 3.
8. If "Empire" simulates a society in chaos, "Iron Voices" simulates an authoritarian return to order. Two soldiers drill on either side of a film of lumpenurbanites as a row of saxophonists and floodlights advance upon the audience — as if it were time to pay for our own spectacular seduction with an all-too-real submission. The final moment in this very ideological, very Spenglerian cultural history has apparently come. In April 1985, Longo presented "Sound Distance," "Surrender" and a new performance, "Marble Fog," at the Brooklyn Museum. This title again suggests a (fascist) mix of the traditional and the phantasmagorical, but the performance goes beyond the spectacular to approach the schizophrenic.
9. Adorno, 119.
10. See Rosalind Krauss, *Passages in Modern Sculpture* (Cambridge: MIT Press, 1977), 7.
11. Baudrillard, 26.
12. *Roland Barthes by Roland Barthes* (New York: Hill and Wang, 1977), 81.
13. Fassbinder is a major influence on Longo: they share a cult of style, a fascination with fascism, an interest in nostalgia and melodrama.
14. Baudrillard, 24.
15. Fredric Jameson, "On Diva," *Social Text* 5 (1982): 118.
16. See Jameson, "Postmodernism and Consumer Society," in *The Anti-Æsthetic: Essays on Postmodern Culture*, ed. Hal Foster (Port Townsend: Bay Press, 1983).
17. Baudrillard, 66.
18. Walter Benjamin, "The Work of Art in the Age of Mechanical Reproduction," in *Illuminations*, ed. Hannah Arendt, trans. Harry Zohn (New York: Schocken Books, 1968), 224. All Benjamin quotations are from this source.
19. Adorno, 90.
20. Thomas Elsaesser, "Myth as the Phantasmagoria of History: H. J. Syberberg, Cinema and Representation," *New German Critique* 24-25 (Fall/Winter 1981–82): 132. In an important recent essay, Jonathan Crary argues that the

logic of the commodity-spectacle may soon be transformed by the new nexus of the computer; see his "Eclipse of the Spectacle," in *Art After Modernism: Rethinking Representation*, ed. Brian Wallis (New York/Boston: The New Museum of Contemporary Art/David R. Godine, 1985), 282–94. Also see Baudrillard, "The Ecstasy of Communication," in *The Anti-Æsthetic*, 126–34.

21. See Jameson, "On Diva," 119.

22. The work of Longo and others also suggests a new "spectacular" model of the artist. For Benjamin the function of the artist as creator, as origin and subject of his work, was "incidental" to a system of art based on exhibition/exchange value. Art based on spectacle/sign exchange value might portend a new artistic function. Given the generic or serial form of so much contemporary art and the way it is "subcontracted," produced by specialists (the division of labor has penetrated even this last enclave), this cultural epitome might well be the artist not as producer (as Benjamin hoped) but as director, *Hollywood* director.

23. Robert Longo, "Voices for Solid Life," in *Beauty and Critique*, ed. Richard Milazzo (New York: TSL, 1982), 33.

24. "It is important at this point to return to the comparison between the different 'cultural revolutions' of Syberberg and Godard. Both filmmakers are involved, as we have noted, in attempts to de-reify cultural representations. The essential difference between them, however, is in their relationship to what is called the 'truth content' of art, its claim to possess some truth or epistemological value. This is, indeed, the essential difference between post- and classical modernism (as well as Lukács's conception of realism): the latter still lays claim to the place and function vacated by religion, still draws its resonance from a conviction that through the work of art some authentic vision of the world is immanently expressed. Syberberg's films are modernist in this classical, and what may now seem archaic, sense. Godard's films are, however, resolutely postmodernist in that they conceive of themselves as sheer text, as a process of production of representations that have no truth content, are, in this sense, sheer surface or superficiality. It is this conviction which accounts for the reflexivity of the Godard film, its resolution to use representation against itself to destroy the binding or absolute status of any representation" (Jameson, "'In the Destructive Element Immerse': Hans-Jürgen Syberberg and Cultural Revolution," *October* 17 [Summer 1981]: 111). Longo's work exists in the contradiction between these two positions.

25. See Elsaesser, 147. The notion of an allegorical use of "dream-kitsch" is his.

26. Barthes, 58–59.

27. Jameson, "Destructive Element," 111.

28. Karl Marx, *Critique of Hegel's Philosophy of Right* (Cambridge: Cambridge University Press, 1970), 131.

29. Jameson has articulated this project most clearly; see, among other texts, his *The Political Unconscious* (Ithaca: Cornell University Press, 1981), 281–99, and his "Reification and Utopia in Mass Culture," *Social Text* 1 (Winter 1979): 130–48.

30. Jameson, "Destructive Element," 106.

Subversive Signs

1. See Benjamin H. D. Buchloh, "Allegorical Procedures: Appropriation and Montage in Contemporary Art," *Artforum* (September 1982): 43–56.
2. See in particular Daniel Buren, "Function of the Museum," *Artforum* (September 1973).
3. See Peter Bürger, *Theory of the Avant-Garde*, trans. Michael Shaw (Minneapolis: University of Minnesota Press, 1984). First published in 1974, this important essay takes no account of the artists mentioned here who are involved in institutional critique.
4. Buren, "Function of the Museum." Duchamp may have "accepted" this system, but he was certainly aware of its function. In *La Boite en Valise* (1936–41), a collection of miniature reproductions of his works, he in effect acculturated his own art in his own museum allegorically and before the fact.
5. See Douglas Crimp, "The End of Painting," *October* 16 (Spring 1981): 69–86; and Buchloh, "Michael Asher and the Conclusion of Modernist Sculpture," in *Performance, Text(e)s & Documents*, ed. Chantal Pontbriand (Montreal: les editions Parachute, 1981), 55–65.
6. Yet this remains the measure of art devoted to institutional critique: "the ambition, not of fitting in more or less adequately with the game, nor even of contradicting it, but of abolishing its rules by playing with them, and playing another game, on another or the same ground, as a dissident" (Buren, *Reboundings*, trans. Philippe Hunt [Brussels: Daled & Gevært, 1977], 73).
7. Walter Benjamin, "The Work of Art in the Age of Mechanical Reproduction," in *Illuminations*, ed. Hannah Arendt, trans. Harry Zohn (New York: Schocken Books, 1969), 225.
8. See Andrea Fraser, "In and Out of Place," *Art in America* (June 1985); the notion "sumptuary expenditure" is derived from Jean Baudrillard ("Art Auction: Sign Exchange and Sumptuary Value," in *For a Critique of the Political Economy of the Sign*, trans. Charles Levin [St. Louis: Telos Press, 1981], 112–22). In her work Lawler seems to catch out a new motivation or emphasis in art patronage – beyond noble social obligation or subtle cultural legitimation to outright economic manipulation.
9. See Craig Owens, "Allan McCollum: Repetition and Difference," *Art in America* (September 1983): 130–32.
10. Allan McCollum quoted in press release for 1985 Cash/Newhouse Gallery show.
11. Buchloh, "Allegorical Procedures," 48. The analogy below between the art world and the race track is hinted at by Baudrillard in "Art Auction."
12. See Rosalind Krauss, "Sculpture in the Expanded Field," in *The Anti-Æsthetic: Essays on Postmodern Culture*, ed. Hal Foster (Port Townsend: Bay Press, 1983).
13. Fraser, "In and Out of Place." I disagree with her representation of this work as a "*counter*practice."
14. Apropos this remark, Norman Bryson writes of Roland Barthes: "analysis omits the essential term of *transformation through labour* on which any theory of practice worthy of the name must rest; an omission accomplished

by conceiving the signs within the social formation (discourse) as a finite mass, subject only to redistribution: this is a *mercantilist* theory of the signifying economy" (*Vision and Painting: The Logic of the Gaze* [New Haven: Yale University Press, 1983], 141).

15. Roland Barthes, "Lecture in Inauguration of the Chair of Literary Semiology, Collège de France," *October* 8 (Spring 1979): 5.
16. Ibid.
17. Dan Graham, "Signs," *Artforum* (April 1981): 39.
18. Some of the *Essays* were published in the *Black Book* (a parody of the manuals of messianic leaders?), others with the *Truisms* in *Abuse of Power Comes As No Surprise* (Halifax: The Press of the Nova Scotia College of Art and Design, 1983).
19. Barthes, *Writing Degree Zero*, trans. Annette Lavers and Colin Smith (New York: Hill and Wang, 1978), 25.
20. See "The Expressive Fallacy" elsewhere in this volume.
21. Michel Foucault, "The Subject and Power," *Critical Inquiry* 8 (Summer 1982), reprinted in *Art After Modernism: Rethinking Representation*, ed. Brian Wallis (New York/Boston, New Museum of Contemporary Art/David R. Godine, 1985), 420.
22. Barbara Kruger, *Screen*, vol. 23, no. 1 (1982).
23. Ibid.
24. Laura Mulvey, "Visual Pleasure and Narrative Cinema," *Screen*, vol. 16, no. 3 (Autumn 1975); reprinted in *Art After Modernism*, 366. For important essays on Kruger and related matters, see Craig Owens, "The Medusa Effect, or The Specular Ruse," and Jane Weinstock, "What She Means, to You," in *We Won't Play Nature to Your Culture* (London: Institute of Contemporary Arts, 1983), 5–16; and Kate Linker, "Representation and Sexuality," *Parachute* 32 (Fall 1983), reprinted in *Art After Modernism*.
25. Mulvey, 368.
26. Anika Lemaire, *Jacques Lacan*, trans. David Macey (London: Routledge & Kegan, Paul, 1979), 60.
27. Ibid., 129.
28. Owens, "Medusa Effect," 7.
29. Bryson, 88.

(Post)Modern Polemics

1. For the historical sources cited in the Glass House, see Philip Johnson, *Writings* (New York: Oxford, 1979), 212–26. Among these sources are projects by Le Corbusier, Mies van der Rohe and Ledoux and paintings, by Malevich and van Doesburg: in other words, the utopian, the visionary, the socialist returned to the private estate.
2. In "On the Fetish Character in Music and the Regression of Listening," in *The Essential Frankfurt School Reader*, ed. Andrew Arato and Eike Gebhardt (New York: Urizen Books, 1978), 274, Adorno writes: "The promise of happiness, once the definition of art, can no longer be found except where the mask has been torn from the countenance of false happiness." Adorno's essay is a critique, from a modernist position of "negative commitment," of the

processes of fragmentation and fetishization that the present essay seeks to address, as it were, from the other side.

3. See Craig Owens, "Honor, Power and the Love of Women," *Art in America* (January 1983).

4. This diagnosis of neoconservative postmodernism owes much to Jürgen Habermas, "Modernity — An Incomplete Project," in *The Anti-Æsthetic: Essays on Postmodern Culture*, ed. Hal Foster (Port Townsend: Bay Press, 1983).

5. See Robert Stern, "The Doubles of Post-Modern," in *Harvard Architectural Review* (1980).

6. See Manfredo Tafuri, *Architecture and Utopia: Design and Capitalist Development* (Cambridge: MIT Press, 1976).

7. Jameson concludes, "On any dialectical reading, these two seemingly so distinct positions are really one and the same, and Tafuri's rigorous pathos is at one with the celebrations of postmodernism. Perhaps, in that case, something is to be said for the search — beyond the closure of this particular double-bind — for a properly Gramscean architecture after all." A revised version of this paper, "Architecture and the Critique of Ideology," is published in *Architecture, Criticism, Ideology*, ed. J. Ockman et al. (Princeton: Princeton Architectural Press, 1985).

8. Tafuri, 137.

9. On the implications of pastiche, so pervasive in cultural production today, see Jameson, "Postmodernism and Consumer Society," in *The Anti-Æsthetic*.

10. For more on this, see Hal Foster, "Re:Post," in *Rethinking Representation: Art After Modernism*, ed. Brian Wallis (New York/Boston: New Museum/David R. Godine, 1985).

11. Jameson, *Fables of Aggression: Wyndham Lewis, the Modernist as Fascist* (Berkeley: University of California Press, 1979), 20.

12. Roland Barthes, "The Death of the Author," in *Image/Music/Text*, trans. Stephen Heath (New York: Hill and Wang, 1977). Also see "From Work to Text" in the same volume.

13. Clement Greenberg, "Modernist Painting," *Art and Literature* (Spring 1965).

14. Greenberg, "Avant-Garde and Kitsch," in *Art and Culture* (Boston: Beacon Press, 1961).

15. See Jameson, "Postmodernism and Consumer Society."

For a Concept of the Political in Contemporary Art

1. See, for example, Fredric Jameson, "Postmodernism and Consumer Society," in *The Anti-Æsthetic: Essays on Postmodern Culture*, ed. Hal Foster (Port Townsend: Bay Press, 1983).

2. See André Gorz, *Farewell to the Working Class* (Boston: South End Press, 1982).

3. Ernesto Laclau, "'Socialism,' the 'People,' 'Democracy': The Transformation of Hegemonic Logic," *Social Text* 7 (Spring and Summer 1983).

4. Walter Benjamin, "The Author as Producer," in *The Essential Frankfurt School Reader*, eds. Arato and Gebhardt (New York: Urizen Books, 1978), 268. The worker-model of the artist is also, of course, a *male* model.

5. Ibid.
6. Roland Barthes, "Myth Today," *Mythologies*, trans. Annette Lavers (New York: Hill and Wang, 1972), 149.
7. Jean Baudrillard, *The Mirror of Production*, trans. Mark Poster (St. Louis: Telos Press, 1981), 60, 21.
8. See Baudrillard, *For a Critique of the Political Economy of the Sign*, trans. Charles Levin (St. Louis: Telos Press, 1981). "This is the process of *consumption* considered *as a system of sign exchange value*: not consumption as traditional political economy defines it (reconversion of economic exchange value into use value, as a moment of the production cycle), but consumption considered as the conversion of economic exchange value into sign exchange value" (p. 113).
9. The Marxist model explains patriarchy and racism as structural elements of older modes of production and social formations residual but active in our own. See Jameson, *The Political Unconscious* (Ithaca: Cornell University Press, 1981), 89–102.
10. Louis Althusser, "Ideology and Ideological State Apparatuses," in *Lenin and Philosophy*, trans. Ben Brewster (New York: Monthly Review Press, 1971), 127.
11. Levin, "Introduction," in *Political Economy of the Sign*, 5.
12. This is no doubt a perverse way to read the Althusserian statement "History is a process without a *telos* or a subject" – i.e., that it is without both a given productive dynamic and a specific class character.
13. See in particular Althusser, *Reading Capital*, trans. Ben Brewster (London: NLB, 1970), chapter 9.
14. See Marshall Sahlins, *Culture and Practical Reason* (Chicago: University of Chicago Press, 1976).
15. Baudrillard, *Political Economy of the Sign*, 147–48.
16. Sahlins, 211. "For us the production of goods is at the same time the privileged code of symbolic production and transmission. The uniqueness of bourgeois society consists not in the fact that the economic system escapes symbolic determination, but that the economic symbolism is structurally determining." This Baudrillardian statement can also be read in a Marxian way. For Althusser, that the economic is "the ultimately determining instance" does not necessarily mean that the economic is always determinant *per se*, but that it determines what "instance" or realm in the social formation is *dominant* – in our case, this instance is evidently the cultural.
17. The classic example is the erosion of use value by exchange value in the abstract equivalence imposed by a money economy. Baudrillard has related such erosion to the erosion (in structuralism) of the referent and (in poststructuralism) of the signified: "all that remains" culturally and economically is a "play" of signifiers (celebrated by such cultural programs as *Tel Quel's*). On the relation between capital and the critique of representation also see Jameson, "Periodizing the Sixties," in *The '60s without Apology*, ed. Sayres, Stephanson, Aronowitz, Jameson (Minneapolis: University of Minnesota Press, 1984).
18. T. J. Clark, "Clement Greenberg's Theory of Art," *Critical Inquiry*, vol. 9, no. 1 (September 1982), 145, 154–55.

19. See Manfredo Tafuri, *Architecture and Utopia: Design and Capitalist Development* (Cambridge: MIT Press, 1976); also see "(Post)Modern Polemics" elsewhere in this volume.
20. Clark, 148.
21. Jean-François Lyotard, *Des dispositifs pulsionnels* (Paris: 10/18, 1973), 37. For Lyotard, capitalism is far more radical than socialism since socialism is imbued with revolutionary values that are almost religious in zeal (and intent): capital kneels before no such beliefs. And as for its "crises," Gilles Deleuze scoffs: "No one has ever died from contradictions. And the more [capitalism] breaks down, the more it schizophrenizes, the better it works, the American way." See *Anti-Œdipus* (New York: Viking Press, 1977), 151.
22. In this sense, the cultural strategy of the avant garde is as anachronistic as the political strategy of the Leninist vanguard party and its seizure of the state.
24. See *The History of Sexuality*, vol. 1 (New York: Pantheon, 1978). Foucault is crucial to a grasp of this passage from avant-garde transgression (in language, i.e., of cultural and social conventions) to resistance to subjection (by disciplines, i.e., the forms of knowledge by which power *knows* its subjects), for it is remarked in the trajectory of his own thought (from the early books on madness and Roussel to the later ones on sexuality and prisons). In particular, Foucault details how subjection is about the constitution not of coherent subjects but of disciplines, reticulated throughout a social system, whereby bodies are ordered. Also see "Readings in Cultural Resistance" elsewhere in this volume.
25. See Jameson, "Periodizing the Sixties."
26. This conjuncture was presented in these terms by Perry Anderson in "Modernity and Revolution," a paper delivered at the conference "Marxism and the Interpretation of Culture," Urbana, Ill., July 1983.
27. See Ernst Mandel, *Late Capitalism* (London: NLB, 1978), 387.
28. The post-'60's reversal of these revolts at the hands of a revitalized capitalism is an issue that cannot be adequately addressed here.
29. Of course there was also protest art in the '60s, but even this was less about the presentation of (class) demands than the occupation of institutional space in the name of marginal groups: blacks, women, the young, the poor, the victims of war.
30. This is not to denigrate the importance of such representation as a means to convoke a political group; there is, as Jameson has stressed, a utopian moment in all ideology.
31. See Barthes, "Political Writing," *Writing Degree Zero* (New York: Hill and Wang, 1968).
32. Jameson, *Fables of Aggression: Wyndham Lewis, the Modernist as Fascist* (Berkeley: University of California Press, 1979), 17.

Readings in Cultural Resistance

1. For very different examples of such diagnoses see Jürgen Habermas, *Legitimation Crisis*, trans. Thomas McCarthy (Boston: Beacon Press, 1975), and Jean-François Lyotard, *The Postmodern Condition: A Report on Knowledge*, trans. G. Bennington and B. Massumi (Minneapolis: University of Minnesota Press, 1984).

2. J. C. F. von Schiller, *On the Æsthetic Education of Man*, trans. Reginald Snell (New York: Unger Publishing Co., 1965), 45.

3. Franco Moretti, *Signs Taken for Wonders*, trans. Fischer et al. (London: NLB, 1983), 30–31.

4. Cf. Herbert Marcuse, "The Affirmative Character of Culture," in *Negations* (Boston: Beacon Press, 1968).

5. The classic text of the first position is "Modernist Painting" in which Clement Greenberg "conceive[s] of Kant as the first real Modernist." The best reference in English for the second is now *Theory of the Avant-Garde* by Peter Bürger who, however, tends to disregard the properly political productivist attempt to *transform* the institution of art.

6. See Greenberg, "Avant-Garde and Kitsch," in *Art and Culture* (Boston: Beacon Press, 1961).

7. Thomas Crow, "Modernism and Mass Culture in the Visual Arts," in *Modernism and Modernity*, ed. B. Buchloh, S. Guilbaut and D. Solkin (Halifax: The Press of the Nova Scotia College of Art and Design, 1983).

8. Moretti, 237.

9. Jean Baudrillard, *For a Critique of the Political Economy of the Sign*, trans. Charles Levin (St. Louis: Telos Press, 1981), 141. As Felix Guattari writes, "What capitalizes capital is semiotic power."

10. I am indebted here to John Brenkman, "Mass Media: From Collective Experience to the Culture of Privatization," *Social Text* 1 (Winter 1979): 94–109, and T. J. Clark, "Clement Greenberg's Theory of Art," *Critical Inquiry*, vol. 9, no. 1 (September 1982): 139–56.

11. See Brenkman, 104: "The *universal culture* that the triumphant bourgeoisie originally announced became instead an ongoing process of *cultural homogenization....*"

12. Karl Marx, *The Eighteenth Brumaire of Louis Bonaparte*, in *Surveys from Exile*, ed. David Fernbach (New York: Vintage Books, 1974).

13. Baudrillard, 115–16.

14. This formulation of the problematic owes much to Clark and Brenkman.

15. Greenberg, "Avant-Garde and Kitsch."

16. Walter Benjamin, *Charles Baudelaire, A Lyric Poet in the Era of High Capitalism*, trans. Harry Zohn (London: NLB, 1973), 106.

17. Habermas, "Modernity — An Incomplete Project," in *The Anti-Æsthetic: Essays on Postmodern Culture*, ed. Hal Foster (Port Townsend: Bay Press, 1983), 11.

18. Bürger, 87.

19. Theodor Adorno, letter to Benjamin, 18 March 1936, in *Æsthetics and Politics* (London: NLB, 1977), 123.

20. Clark, 147. This formulation also owes much to Fredric Jameson, "Reification and Utopia in Mass Culture," *Social Text* 1 (Winter 1979): 130–48.
21. Henri Lefebvre, *Everyday Life in the Modern World* (London: Allen Lane, 1971).
22. Roland Barthes, *Mythologies* (1957), trans. Annette Lavers (New York: Hill and Wang, 1975), 151.
23. Dick Hebdige, *Subculture* (London: Methuen, 1979), 94.
24. Barthes, 114.
25. Brenkman, 105.
26. Barthes, 133.
27. Barthes, "Change the Object Itself," in *Image-Music-Text*, trans. Stephen Heath (New York: Hill and Wang, 1977), 166; Michel Foucault, *Power/Knowledge*, ed. Colin Gordon (New York: Pantheon, 1980), 100.
28. See Baudrillard, "Requiem for the Media," in *Political Economy of the Sign.* The new technology of the computer only *seems* to open up the possibility of reciprocality.
29. Barthes, *Mythologies*, 135.
30. There are of course less critical uses of appropriation in recent art, two of which should be noted here. The first practice follows a "historicist" æsthetic. Its appropriations, even when extra-artistic, are subsumed under the discourse of art or fashion and so æstheticize rather than politicize. This æstheticization is finally a mask: "an auratic disguise for the commodity" (Benjamin Buchloh) and/or an avant-gardist alibi for turning the historical into a consumable. The other use of appropriation also æstheticizes, but under the critical guise of "textuality." Though it may reappropriate signs, it fails to reground them materially. Thus displaced from its original system but *not* to a countermythical one, the sign becomes a mere signifier in a textual play of the same. This "play" – an ideological aspect of (post)structuralism – ignores the materiality of meaning and so repeats the abstraction of myth in another register; it also, as we will see, replicates the "circulation of signs" characteristic of our cultural-political economy.
31. See "For a Concept of the Political in Contemporary Art" elsewhere in this volume. As Norman Bryson writes (in *Vision and Painting* [New Haven: Yale University Press, 1983], 151): "Artistic practice cannot take its own disruptions of the various signifying conventions as somehow rooted, automatically, in the struggle to control and position the body in political and ideological terms; it has to articulate the relations between its own minor acts of disobedience and the major struggles – which define the body and dismantle and renew its representations; otherwise its acts will be insignificant."
32. Hebdige, 116.
33. Baudrillard, 50–51.
34. Ibid, 150: "Only ambivalence (as a *rupture* of value, as another side or beyond of sign value, and as the *emergence of the symbolic*) sustains a challenge to the legibility, the false transparency of the sign....*It brings the political economy of the sign to a standstill.*"
35. Jacques Attali, "Introduction to *Bruits*," *Social Text* 7 (Spring and Summer 1983): 7.
36. Baudrillard, 65.

37. Ibid., 115–116.
38. Ibid., 113–114.
39. Ibid., 66.
40. Ibid., 163.
41. Ibid., 159.
42. Ibid., 92.
43. Fredric Jameson has decoded the structuralist and poststructuralist moments in terms of capital in this way: "In the first moment, reification 'liberated' the Sign from its referent, but this is not a force to be released with impunity. Now, in a second moment, it continues its work of dissolution, penetrating the interior of the Sign itself and liberating the Signifier from the Signified, or from meaning proper" ("Periodizing the 60s," in *The Sixties without Apology*, ed. Sayres, Stephanson, Aronowitz and Jameson [Minneapolis: University of Minnesota Press, 1984], 200).
44. Baudrillard, 92.
45. See Gilles Deleuze and Felix Guattari, "What is a Minor Literature," trans. Robert Brinkley, *Mississippi Review* 31 (Winter and Spring 1983): 16–27. "A minor literature is not the literature of a minor language but the literature a minority makes in a major language" (p. 16).
46. See Jameson, *The Political Unconscious* (Ithaca: Cornell University Press, 1981), 96–97.
47. Deleuze and Guattari, 18.
48. Ibid., 27.
49. Lyotard, *Rudiments paiens* (Paris: 1977), 116.
50. Deleuze and Guattari, 27.
51. Ernst Bloch, "Nonsynchronism and Dialectics," *New German Critique* 11 (Spring 1977): 31.
52. Baudrillard, 120. I am indebted here to Jameson.
53. See Jameson, 98–99.
54. Foucault, 81.

The "Primitive" Unconscious of Modern Art, or White Skin Black Masks

1. As is well known, an early study included two customers of the demoiselles, a medical student and a sailor, and was thus distanced as a narrative; with these surrogates removed, the painting becomes a direct address for its masculine subject. As for the Trocadéro, western man, its source of projection, is absent from it: "What was not displayed in the Musée de l'Homme was the modern West, its art, institutions, and techniques. Thus the orders of the West were everywhere present in the Musée de l'Homme, except on display" (James Clifford, "On Ethnographic Surrealism," *Comparative Studies in Society and History*, vol. 23, no. 4 [1981]: 561).
2. See William Rubin, "Picasso," in *"Primitivism" in 20th Century Art: Affinity of the Tribal and the Modern*, ed. Rubin (New York: MOMA, 1984), 252–54. Hilton Kramer, who celebrates the ability of bourgeois culture to negate the primitive "assault," finds this important connection between primitivism and

"fear of women" "trivializing"; see his "The 'Primitive' Conundrum," *The New Criterion* (December 1984): 5.

3. Quoted in André Malraux, *Picasso's Mask*, trans. June and Jacques Guicharnaud (New York: Holt, Rinehart and Winston, 1976), 10–11.

4. My discussion of primitivism as a fetishistic colonial discourse is indebted to Homi K. Bhabha, "The Other Question," *Screen*, vol. 24, no. 6 (November/December 1983): 18–36.

5. The show, sponsored by Philip Morris Inc., included some 150 modern and 200 tribal works, most often set in pairs or comparative ensembles. Curated by William Rubin, Director of the Department of Painting and Sculpture in collaboration with Kirk Varnedoe of the Institute of Fine Arts, it claimed to be "the first exhibition to juxtapose tribal and modern objects in the light of informed art history." MOMA also published a two-volume catalogue with 19 essays by 16 scholars on diverse aspects of "primitivism."

6. Kirk Varnedoe, "Preface," in "*Primitivism*," x.

7. Ibid.

8. On the one hand, this is a legitimate restriction: to focus on the "appreciation" of tribal art by modern artists, who "generally did not know its sources or purposes" (exhibition pamphlet). On the other, it is a curatorial alibi that obscures the ideology of primitivism.

9. Claude Lévi-Strauss, "Archaism in Anthropology," in *Structural Anthropology*, vol. 1, trans. Claire Jacobson (New York: Basic Books, 1963), 117.

10. "We owe to the voyagers, colonials, and ethnologists the arrival of these objects in the West. But we owe primarily to the convictions of the pioneer modern artists their promotion from the rank of curiosities and artifacts to that of major art, indeed, to the status of art at all" (Rubin, "Modernist Primitivism: An Introduction," in "*Primitivism*," 7)

11. Quoted by Rubin, "Introduction," 17.

12. See in particular his essay on Gauguin in "*Primitivism*," 179–209.

13. Quoted in Malraux, 10.

14. To claim affinity, the curators must disprove influence or direct contact, an "argument from silence," which, as others have pointed out, is difficult to make.

15. Rubin, "Introduction," 25.

16. See James Clifford, "Histories of the Tribal and the Modern," *Art in America* (April 1985): 166.

17. The "tribal artists" are also called "problem-solving" (Rubin, "Introduction," 25). Though this term imputes an almost formalist orientation, it also suggests a possible "affinity" — of art and artifact as an imaginary resolution of social contradiction. This definition allows for different signifieds of similar signifiers. It also leads one to wonder what contradiction modernist "primitivism" resolves.

18. "Bourgeois society is the most developed and the most complex historic organization of production. The categories which express its relation, the comprehension of its structure, thereby allows insights into the structure and relations of production of all the vanished social formations out of whose ruins and elements it built itself up, whose partly still unconquered remnants are carried along with it, whose mere nuances have developed explicit signifi-

cance within it, etc. Human anatomy contains a key to the anatomy of the ape. The intimations of higher development among the subordinate species, however, can be understood only after the higher development is already known" (Karl Marx, *Grundrisse*, trans. M. Nicolaus [London: Pelican, 1973], 105).

19. "Affinity" seems at once a cultural concept and a natural (or at least transcultural) property — a logical scandal, as Lévi-Strauss said of the incest prohibition. But just as Derrida argued that Lévi-Strauss's "scandal" was an *effect* of his own structuralist system, so might the modern/tribal "affinity" be an effect of its formalist presentation at MOMA.

20. See Rubin, "Introduction," 74.

21. James Johnson Sweeney, *African Negro Art* (New York: MOMA, 1935), 21.

22. Rene D'Harnoncourt, preface to *Arts of the South Seas* (New York: MOMA, 1946).

23. Alfred Barr, Jr., letter in *College Art Journal*, vol. 10, no. 1 (1950): 59.

24. Rubin, "Introduction," 47.

25. Ibid., 55.

26. The process is strangely reminiscent of *Impressions of Africa* in which, by a code of his own, Raymond Roussel produces an "Africa" which totally occludes Africa — but nevertheless makes us aware of western myths of Africa as he does so.

27. See Lévi-Strauss, "Race and History," in *Structural Anthropology*, vol. 2, trans. Monique Layton (Chicago: University of Chicago Press, 1976), 329.

28. "The historical-transcendental recourse: an attempt to find, beyond all historical manifestation and historical origin, a primary foundation, the opening of an inexhaustible horizon, a plan which would move backward in time in relation to every event, and which would maintain throughout history the constantly unwinding plan of an unending unity" (Michel Foucault, "History, Discourse and Discontinuity," *Salmagundi* 20 [Summer/Fall 1972]: 227).

29. Rubin, "Introduction," 71. The exclusion of neoexpressionism from the contemporary section of the show appeared almost as a disavowal of one of its subtexts. The work in this section, though not traditional in medium, is so in the way it fashions "the primitive" as an ahistorical process or as a primitivistic look.

30. See in particular his "Abstract Expressionism," in "*Primitivism*," 614–659.

31. In his "Preface" Rubin terms primitive art the "invisible man" of modern art scholarship, a trope that exceeds his suggestion that its minor status in the MOMA history of art is corrected by this show. For not only does it call to mind another repressed figure, the invisible woman artist, it also suggests that the "correction" of primitive art occurred long ago, when via "cultural preparation" and artistic incorporation it was first rendered a ghostly presence, an invisible man, within the tradition.

32. Robert Goldwater, *Primitivism in Modern Art* (New York: Vintage Books, 1966), 3.

33. See Rubin, "Picasso," in "*Primitivism*," 240–343. "The changes in modern art at issue were already under way when vanguard artists first became aware of tribal art" (Rubin, "Introduction," 11).

34. Lévi-Strauss, "History and Dialectic," in *The Savage Mind* (Chicago: University of Chicago Press, 1966), 264.
35. Rubin, "Picasso," 265.
36. Ibid., 309. A residual role but perhaps a real "affinity": for it could be argued that cubism, like some tribal art, is a process of "split representation." See Lévi-Strauss, "Split Representation in the Art of Asia and America," in *Structural Anthropology*, vol. 1, 245–268.
37. Michel Foucault, *The Archæology of Knowledge* (New York: Harper & Row, 1972), 12.
38. See Varnedoe, "Gauguin," 201–203, and "Contemporary Explorations," 652–653.
39. Ibid., 202.
40. Ibid.
41. Max Horkheimer and Theodor W. Adorno, *Dialectic of the Enlightenment*, trans. John Cumming (New York: Seabury Press, 1972).
42. Varnedoe, "Gauguin," 203.
43. See, for example, Varnedoe, "Contemporary Explorations," 665, 679.
44. Jean Baudrillard, *Mirror of Production*, trans. Mark Poster (St. Louis: Telos Press, 1975), 90. The reference is to Lévi-Strauss's claim, in *The Raw and the Cooked* (trans. John and Doreen Weightman [New York: Harper & Row, 1969], 13–14), that "it is in the last resort immaterial whether in this book the thought processes of the South American Indians take shape through the medium of my thought or whether mine take place through the medium of theirs. What matters is that the human mind, regardless of the identity of those who happen to be giving it expression, should display an increasingly intelligible structure...."
45. Lévi-Strauss, *Tristes Tropiques*, trans. John and Doreen Weightman (New York: Atheneum, 1978), 389.
46. This definition of art (see note 17) was developed by Lévi-Strauss in relation to a tribal form, Caduveo face painting; see *Tristes Tropiques*, 196–197.
47. See, in general, Marshall Sahlins, *Culture and Practical Reason* (Chicago: University of Chicago Press, 1976), and Pierre Clastres, *Society Against the State*, trans. Robert Hurley (New York: Urizen Books, 1974).
48. Edward W. Said, "Opponents, Audiences, Constituencies and Community," in *The Anti-Æsthetic: Essays on Postmodern Culture*, ed. Hal Foster (Port Townsend: Bay Press, 1983), 158.
49. As for a western text that involves this "other" account, an example is provided by the Jean Rouche film *Les Maîtres Fous*, a documentary of the trauma of imperialist subjection ritually worked through by the Hauka, an African tribe. In a trance the tribesmen are one by one "possessed" by white colonial figures, the Crazy Masters — an exorcism that inverts the one in the *Demoiselles*. For here though the image of the other is used to purge the other, the objectification is reversed: it is the white man who appears as the other, the savage, the grotesque. At the end of the film the tribesmen return to the colonial city and once again assume subject-positions — in the army, in road crews, in "the native population."
50. Clifford, "On Ethnographic Surrealism," 564.

51. This strategy was posed by Abdellah Hammoudi at a symposium (November 3–4, 1984) at MOMA held in conjunction with the show.

52. Jacques Derrida, "Structure, Sign and Play," in *Writing and Difference*, trans. Alan Bass (Chicago: University of Chicago Press, 1978), 285. In *Of Grammatology* (trans. Gayatri Chakravorty Spivak [Baltimore: The Johns Hopkins University Press], 105), Derrida writes of Lévi-Strauss: "At once conserving and annulling inherited conceptual oppositions, this thought, like Saussure's, stands on a borderline: sometimes within an uncriticized conceptuality, sometimes putting a strain on the boundaries, and working toward deconstruction."

53. Lévi-Strauss, *The Savage Mind*, 21.

54. Roland Barthes, "Myth Today," in *Mythologies* (1957), trans. Annette Lavers (New York: Hill and Wang, 1972), 114. In *For a Critique of the Political Economy of the Sign* (trans. Charles Levin [St. Louis: Telos Press, 1981], 96), Baudrillard writes: "This semiological reduction of the symbolic property constitutes the ideological process."

55. See Derrida, "Structure, Sign and Play," and Foucault, "History, Discourse and Discontinuity." Fredric Jameson has suggested in this regard that one "referent" of French deconstruction may well be American capital. See his "Pleasure: A Political Issue," in *Formations*, ed. Victor Burgin et al. (London: Routledge and Kegan Paul, 1984).

56. Rosalind Krauss, paper delivered at the MOMA symposium, November 4, 1984.

57. Ibid.

58. Such "delays" are common enough: for example, the critique of representation that, undertaken in cubism and collage, returns in a different register in postmodernist art.

59. See Tzvetan Todorov, *The Conquest of America*, trans. Richard Howard (New York: Harper & Row, 1984), 123. Todorov argues that the conquest of America was largely a "linguistic" one.

60. Ibid., 109.

61. Baudrillard, "Mirror," 88–89.

62. Maurice Merleau-Ponty, *Sense and Nonsense*, trans. Hubert and Patricia Dreyfus (Evanston: Northwestern University Press, 1964), 109–10; quoted in Vincent Descombes, *Modern French Philosophy* (Cambridge: Cambridge University Press, 1980), 11.

63. Foucault, "A Preface to Transgression," in *Language, Counter-Memory, Practice*, ed. Donald F. Bouchard (Ithaca: Cornell University Press, 1979), 50.

64. Ibid., 31.

65. The phrase is Robert Smithson's; see *The Writings of Robert Smithson*, ed. Nancy Holt (New York: New York University Press, 1979), 216. Apropos this cancelled limit, Descombes asks: "Is the beyond of the 'logic of identity' a dialectical beyond or a beyond the dialectic?" (Descombes, 147).

66. Derrida, "Sign, Structure and Play," 280.

67. Foucault, *The Order of Things* (New York: Vintage Books, 1970), 328.

68. Catherine Clément, *The Lives and Legends of Jacques Lacan*, trans. Arthur Goldhammer (New York: Columbia University Press, 1983), 76.

69. Lévi-Strauss, *The Savage Mind*, 219.

70. Paul Ricoeur, "Universal Civilization and National Cultures," in *History and Truth*, trans. Charles A. Kelbley (Evanston: Northwest University Press, 1965), 278. Also see Jameson, "Periodizing the Sixties," in *The 60s Without Apology*, ed. Sayres, Stephanson et al. (Minneapolis: University of Minnesota Press, 1984), 186–188.

71. See Jürgen Habermas, "Modernity – An Incomplete Project," in *The Anti-Æsthetic*, 3–15.

72. Baudrillard, "The Beaubourg Effect," trans. Rosalind Krauss and Annette Michelson, *October* 20 (Spring 1982): 10.

73. Ricoeur, 278. What clearer sign of this implosion – when mankind is treated as a museum of the west – can there be than the "Primitivism" show? If the "universality" of the Enlightenment positioned the west in a transcendental relation to the primitive, then the "globality" of multinational capital (as represented by Philip Morris) may put us in a transcendental relation to our own modernity.

74. See Baudrillard, *For a Critique of the Political Economy of the Sign*, passim; Gilles Deleuze and Felix Guattari, *Anti-Œdipus*, trans. Hurley, Seem and Lane (New York: Viking Press, 1977), 139–271; Barthes, *Empire of Signs*, trans. Richard Howard (New York: Hill and Wang, 1982),3–4; and Derrida, *Of Grammatology*, 77–93.

Daniel Buren. *Baile Is in Manhattan*, 1975.

Index

242